Glamour of the Gods

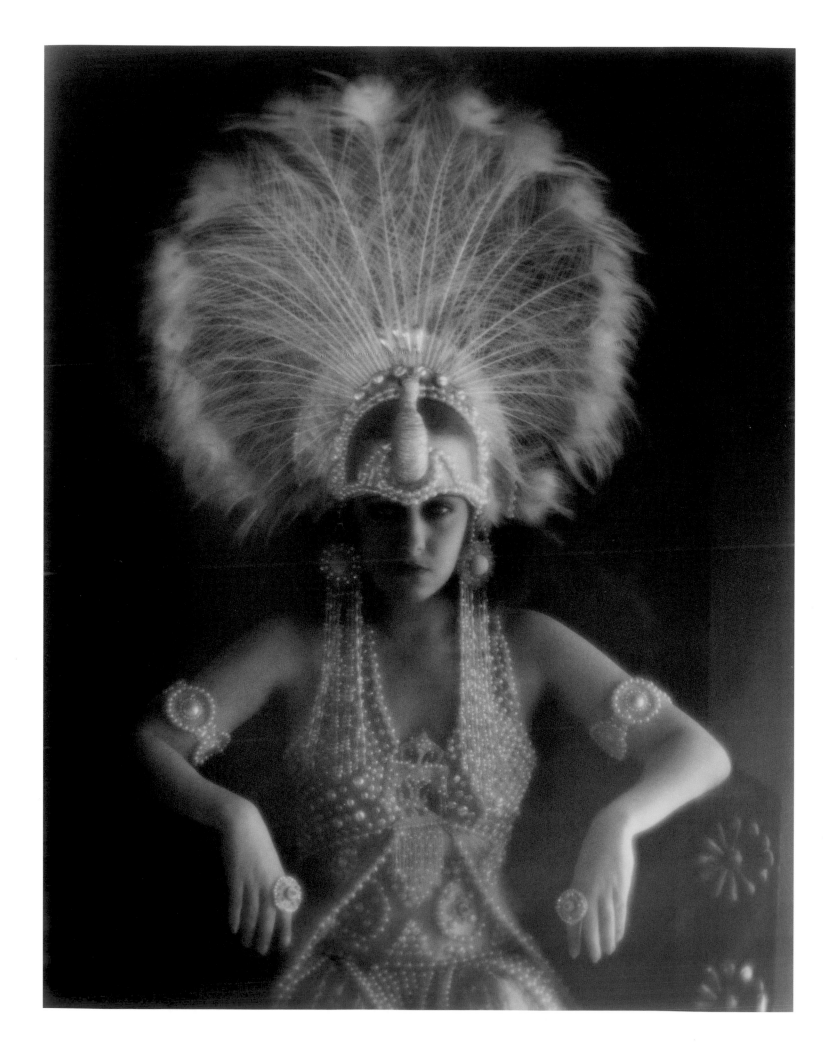

Gloria Swanson for *Male & Female*, Paramount Pictures. KARL STRUSS, 1919

Glamour of the Gods

Photographs from the John Kobal Foundation

Robert Dance

With an introduction by John Russell Taylor

Steidl

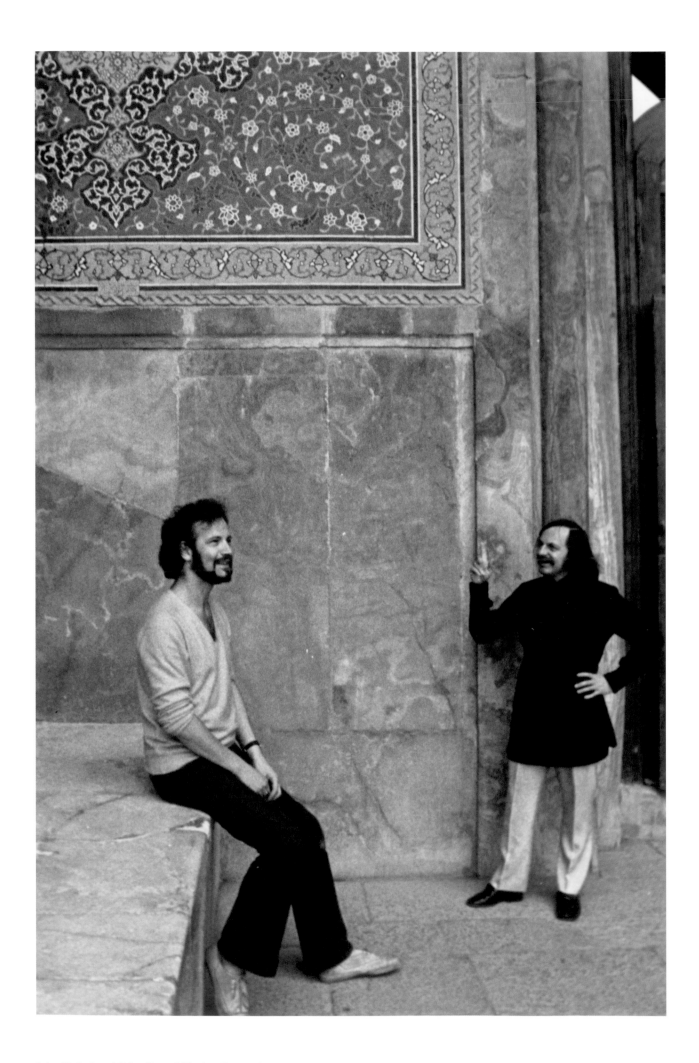

John Kobal and John Russell Taylor, Delhi. Satyajit Ray, 1969

John Kobal: Collector Extraordinaire
by John Russell Taylor

Somewhere in Los Angeles. John Kobal, just arrived from London, and I are sitting in the back of a limousine generously provided by none other than Mae West, who sits between us. John is his usual ebullient self, babbling happily away. 'Mae, Mae,' he bellows; 'You look fabulous. What are you doing now?' 'Oh, I'm working on a television version of *Catherine Was Great*.' 'That's great,' says John. 'Who will play Catherine?' Mae does not turn a hair. 'Why, I will, dear. I can do that. I still look like Mae West.'

The encounter was sort of typical. It was not even John's first potential gaffe with Mae. Always happy to retail stories against himself, he told me that when he had visited the set of *Myra Breckinridge*, which Mae, according to the record books aged seventy-eight, was cheerfully taking over from a faint-hearted director, he was absolutely bowled over by her appearance. 'Mae,' he cried; 'You look incredible! You don't look … a day over twenty-nine.' 'I'm *supposed* to look twenty-six,' Mae replied magisterially, and swept off to supervise another camera set-up.

And continued to adore him: hence the limo. John was so genuinely besotted with his senior ladies of Hollywood that they could not but respond in kind. When he was a handsome, gangly eighteen-year-old, he had his first direct contact with a real star. He read that the fabled Marlene Dietrich was to perform in Toronto, and decided that he must at all costs see her. Once there, with all his resources exhausted by the fare and the ticket, he laid siege to Dietrich's publicity lady, presenting himself as an out-of-town journalist, edged past her more or less tactful evasions, and managed somehow to wriggle his way first into the after-show party and finally into the presence of the diva herself – primarily by calling out something complimentary in German, a language supposedly taboo around her.

Before the evening was out she had sung *Falling In Love Again* in German, just for him, he had been carried off to her hotel suite, fed in her best *hausfrau* style and put to bed on her living room couch. Having crept out, as instructed, before she was up and about, he hung around the following morning and went back to conduct his first real interview with a superstar over lunch, before returning, his new Tyrolean hat ('it made me feel more adult') still clamped on his teenage head, to his family home in Ottawa.

He had been settled in London for about four years before he finally arrived in New York. Typically, he did not know anyone there, but fell on his feet when he recognised Nancy Carroll in the street (bizarrely, since he knew the fan pictures but had never seen any of her films) and was carried off to her apartment to conduct a rather fact-bereft interview. She seemed to take it all in good part, and towards the end said thoughtfully 'Call Tallulah Bankhead, you'd like her.' So he did, and ended up camping out in Tallulah's apartment for several weeks before, as he put it, she quite incidentally opened the doors of Hollywood to him.

Much later in life, after raving on for an hour or so about the wonders of the latest veteran star he had visited ('She always was my favourite.' 'But John, I thought you said Carole Lombard was your favourite?' 'Well, she is my favourite – in screwball comedies made in 1936–37.'), he could somehow, like Thurber's lady who had 'the true Emily Dickinson spirit,

John Kobal. TED ALLAN, 1981

except she gets fed up occasionally', be heard to mutter 'Oh, what am I doing with all these drunken old broads?' Nevertheless, his basic delight in them remained unshakable.

What has this to do with his amassing the unique collection of film stills, Hollywood studio photography and ancillary movie memorabilia that was to make his name known to the wider world? Everything. From childhood he was the ultimate film fan, ever since the magic moment when he peered through a gap in the rafters in the loft of his grandmother's house in Austria and saw, playing for American Occupation troops in the cinema next door, a scene from a film starring Rita Hayworth. Could it have been *Cover Girl*? Certainly it was in colour, and thus began a lifelong devotion that in 1978 gave rise to his first substantial book, a surprisingly serious and well-researched biography of Hayworth subtitled *The Time, the Place and the Woman*.

That first revelatory experience took place in Salzburg just after the war. Though later on John fancied himself as a man of mystery, and tended to be vague about where, and above all when, he was born, he in fact first saw the light of day in Linz, Austria, in 1940, of an Austrian Catholic mother and a Ruthenian Orthodox father. During the occupation of Austria John's father worked as an electrician for the Canadian forces, and consequently had the opportunity to emigrate to Canada on a preferential basis in 1948. He went ahead of his family, and for two years seemed to be hanging back from sending for John, his mother and sister. This created an atmosphere of uncertainty in the family, and John started to take refuge increasingly in the world of films. By the time they all arrived in Canada in 1950 his preference of a fantasy world in film over the real world around him was firmly established.

As a schoolboy in Ottawa, John seems to have picked up English very quickly, and to have developed into a surprisingly extrovert teenager, a nervous show-off who sought approval from his peers by throwing himself into amateur dramatics and other high-profile activities. At the same time he devoured fan magazines and developed cults of his favourite stars by amassing cuttings concerning them and writing off, in the fan mode of the times, for the "signed" photographs which Hollywood studios sent out by the thousand. From these humble and fairly routine beginnings sprang the unique archive that was the Kobal Collection – not to mention John's own personal collection, which gradually took on a life of its own.

Throughout his life John was self-conscious about what he felt to be his lack of formal education. Nevertheless he envisaged the possibility, while still in his teens, of being a writer, though one suspects that at that point the idea of interviewing movie stars was more a means of gaining personal access to his idols than a token of serious literary ambition. Whatever it may have then been, it was what first took him, formally at least, to Hollywood in 1964. He later recalled:

It was Tallulah Bankhead who unlocked Hollywood for me. One night she called George Cukor and said 'Dahling George' and after they gossiped forever, she remembered why she had called him in the first place and said, 'I have this diviihhhne young man here, and he's going to Hollywood and he doesn't know anyone and you know everyone; and he's really a most serious young man.' She looked at me to make sure, and then mortified me by telling Cukor that I was broke 'but presentable, dahling. And he knows everything about everybody's movies.'

And once arrived in Hollywood, posing as, he thought, rather than being a journalist and film historian, his career as a collector and archivist took a great leap forward. He met, largely through Cukor's influence, an amazing collection of senior stars, mostly the female objects of his adoration, and many of them became close friends for the rest of their, and his, life. The moment he arrived in Los Angeles in later life he would be on the phone to the likes of Loretta Young, Eleanor Powell, Mae West or Irene Dunne, talking for hours and arranging loving reunions.

And in the process cross-questioning them, adding to his magpie collection of miscellaneous information and garnering relics of their earlier careers. He was also lucky with his timing, in that he chose to visit Los Angeles regularly in a period of dissolution for the major studios, and well before those that remained had realised that the physical relics of their great days could possibly have some commercial value (which arguably happened with the setting-up of an MGM nostalgia shop in the new MGM Grand hotel, Las Vegas, when it opened in 1973). Consequently, their vast libraries of stills from their old movies were regarded as just a waste of space, and John was often invited to take his pick on visits to the studios, or would be tipped off when truck loads of photographs were on their way to the dump, where he could follow and fill his hired car with discarded material.

Not that it was relevant to John at the time, but during the thirties and forties these photographs were sent out in their thousands, with the sole purpose of getting them reproduced as widely as possible in newspapers and magazines, as a form of free publicity. Therefore many of them are stamped on the back 'Copyright Free', and if that was not explicitly stated, it was automatically understood as a condition of their distribution. When, much later, the remaining studios wanted to contest the Kobal Collection's right to hold these images and hire them out for a fee, they soon discovered that this was a concession which could not be retrospectively withdrawn. Some, such as Paramount when it planned to give a theatrical reissue to some De Mille classics, even found that they had no alternative but to pay the Kobal Collection to hire back the publicity material they had dispensed so freely two or three decades earlier.

In any case, at this stage in his life John was merely a collector, though an unusually intense and determined one. When he arrived in England in 1960, he already carried considerable baggage, physical and mental, with him. He never completely explained why he came to England. At that time he still nurtured ideas of fame as an actor, and even got a couple of jobs in touring companies, though according to his own good-natured account his disaster-strewn progress round the less notable provincial theatres soon disabused him of any hopes he might nurture that he could ever achieve a star on his dressing-room door.

In his early days in England John was living, when not on tour, on a houseboat on London's Chelsea Reach and leading a hand-to-mouth bohemian life. His charm and crazed enthusiasm had not deserted him, and somehow he got to know virtually everyone on the British film scene, garnering the reluctant respect of even those – not a few – who distrusted or even detested him. The detestation always surprised me, for while John was decidedly a handful, inevitably the largest, loudest and most expansive person in any company, he was also, for all his gleeful façade of Ebenezer Scrooge, the most kindly and generous of men. Ironically, it was his generosity that led eventually to his quite lucrative career as an archivist and, in consequence of that, as a prolific and respected writer.

First, the archive for hire. In his very early days in London the people he knew rapidly became aware of his constantly growing accumulation of star portraits and significant production stills. And most of his acquaintances, before he had ever considered doing likewise, were busy writing or editing books and articles on film. All of which required illustration. And why should not the illustrations be borrowed from this obliging fellow, who seemed to have all of everything at his command? So John began to lend out his pictures, and soon found that at least some of them never came back. In self-defence he had to do something, and thought of charging a small deposit, just to ensure the pictures' return.

Suddenly, almost without its creator's being aware of it, the Kobal Collection had become a public-access archive, and then his main source of income. But not for long his sole source. Among his friends at this time was Raymond Durgnat, then the new kid on the block of film studies. Durgnat was an eccentric, a self-appointed outsider who laid about him with a

broad sword, acrimoniously dismissing all current theories of film, whether of the 'auteur' persuasion or the subsequently fashionable Structuralist variety. He involved John, largely as a provider of illustrative material, in his 1965 pocketbook on *Greta Garbo*, and when, three years later, there was call for a volume in the same series on *Marlene Dietrich*, he suggested that John should supply the text as well as the illustrations, and persuaded John that he could do it alone.

John was, in fact, a brilliant writer – within his limitations. The main, indeed probably the only, limitation was that he had little or no built-in quality control, let alone relevance control. His output of written words was, like his output of spoken words, titanic. Reading his first drafts was a nerve-racking experience: after two or three pages of incoherent babble one would be just about to throw the manuscript across the room in sheer frustration when suddenly, with no advance warning, up would come two pages of dazzling clarity and precision. And, what was even more important, of absolute originality. All that was needed was a firm editorial hand that John could trust to pare down sympathetically all the vamp-till-ready material. 'Sympathetically' meaning that the editor had to recognise that the essence of John's writing frequently lay in his apparent digressions and his gift for sublimely relevant irrelevances.

Firm editorial supervision needed to continue all through the progression of the text, from manuscript to final print. John was the only writer I have ever known, and probably the only one since Marcel Proust, who loved reading his galley-proofs, and often, left to himself, would double the length of text in the process. At least Proust carried out his elaborations in a cork-lined room, whereas John, alarmingly, was sometimes to be encountered in the street, having popped out for a pint of milk and completely forgotten what he went out for, wandering blindly along, pen in one hand and a bundle of proofs in the other, gleefully adding detail after detail to the already overcrowded margins.

This passion for over-elaboration also had, I believe, something to do with his insecurity about his own education. When one remonstrated with him about the relevance of last-minute asides along the lines of 'A generation later her half-brother's second son was to achieve modest prominence as the regular production assistant of …', he would reply pleadingly 'But if I don't put that in people will think I don't know it.' Despite a series of (immaculately edited) books to his credit, he never achieved sufficient confidence in his own powers to say 'Well, let them and be damned!'

Even after the success of the text-driven biography of Rita Hayworth, for some years John's books, such as his history of the Hollywood musical, *Gotta Sing, Gotta Dance*, were primarily picture-books created out of material from his constantly growing collection, with a mere introduction or flimsy accompanying text by John. Others were handed over to other writers: I myself wrote brief biographies of Ingrid Bergman and Vivien Leigh, and large-format books on such nebulous subjects as *50 SuperStars*, *Great Movie Moments* and *Portraits of the British Cinema*. When it was conceived, *The Art of the Great Hollywood Portrait Photographers* (1980) must have been imagined in much the same terms. But along the way John himself had grown and changed, and so, without deliberate volition on his part, the quality and value of his writing had changed too.

It has to be said that, whatever his unreliability as a critic of his own writing, his taste in photographs was always immaculate. This seems to have been inbuilt from the start. He always knew intuitively which were the masterpieces and, with those that were less than masterpieces, what could be done in the way of retouching, cropping or cleaning to remedy their deficiencies. At first he cared only for the subjects of the photographs, and the creators of these images were mere names. But then gradually his endless curiosity made him wonder about the people behind the names.

John Kobal. ANDY WARHOL, 1986

His inquiries rapidly told him that a surprisingly large number of those who had been photographing the gods and goddesses in the thirties – a notoriously long-lived breed – were still around, usually living a sort of Sunset Boulevard life as forgotten greats. Of course, once he knew who they were and where they lived, he had to meet them, and as the only one who had taken an interest in maybe twenty years, he soon forged links of affection and respect with such men as Clarence Sinclair Bull, Garbo's favourite photographer; George Hurrell, who had captured the definitive early images of Joan Crawford; Laszlo Willinger, who succeeded Hurrell at MGM; Bob Coburn, Goldwyn's portrait photographer *en titre*; and Ted Allan, important not only because of his own work, but also as John's guardian angel when it came to reprinting the works of photographers no longer around to supervise for themselves.

Inevitably, through all these contacts John became interested in and finally very knowledgeable about the technique of studio photography. He also became friendly with younger photographers, such as Eve Arnold, trained in very different traditions, and with artists who used photography in the elaboration of their artwork tangentially, such as Bill Jacklin or, crucially, Andy Warhol. Through the years, John supplied Warhol with many of the show-business photographs on which some of Warhol's best-known works were based, and in exchange received a remarkable collection of Warhol artist's proofs, as well as finally an original Warhol painting of himself which, characteristically, he at first rejected because, Warhol or no Warhol, he didn't like it.

In any case, by the time he came to write *The Art of the Great Hollywood Portrait Photographers*, he had done a tremendous amount of original research on the subject in general as well as on the individual figures. There was no way the book was going to be just a book of pretty pictures. And indeed, when it appeared, it was to prove a revelation to orthodox photographic historians, opening up a whole new area of studies in photographic art. Naturally this was reflected in John's own collecting: he had acquired many hitherto neglected original prints, and continued to add prime examples as he encountered other survivors and learned more and more about it all.

Early in his collecting and writing activities, John's interest was almost exclusively in Hollywood and, in a more covert fashion (he was, after all, masquerading as a 100-per-cent Canadian), in German-language cinema. But through the years his interests widened considerably. He loved film festivals, as one might imagine, and went to as many as he could. He also took every opportunity that offered to add creatively to his collection. I remember particularly the Delhi Festival in 1969, where I was on the jury and John came along for the ride. There were three film-makers on the jury with me (Mai Zetterling being there, as yet only as an actress): Satyajit Ray; the veteran Russian Alexander Zharki; and the Argentine Leopoldo Torre Nilsson. John suddenly conceived the idea of getting all three to take photographs of us, to see whether any fingerprints of *auteur*-ship would manifest themselves. Sadly, the Zharki and Torre Nilsson pictures could have been taken by anyone. But Ray's pictures, taken in black-and-white with his own camera, instantly look like stills from one of his own films; he even manages in some mysterious way to make John and me look Indian.

John had, in fact, not only the obsessiveness but also the almost supernatural instinct of the true collector. He once found an early and original Disney cel in excellent condition in a wayside junk store while driving somewhere in New England. More spectacularly, while we were holidaying with a friend at that time resident in Panama, John got wind of a cache of original movie posters going back to the early thirties, stored in the annexe to a small cinema in Colon. For three days he determinedly took the train each morning from Panama City, blithely ignoring all warnings about the dangers to life and limb of going alone to Colon, and systematically went through these forgotten treasures before buying the cream of the collection. When our friend remonstrated with him, explaining how there was a network

John Kobal. ABE FRAJNDLICH, 1986

of organised muggers who would pass on to one another details of the whereabouts of any stranger coming off a train, he replied 'Oh, I wondered what all those whistles from rooftop to rooftop meant. I suppose they just thought I looked too crazy to be worth tackling.'

John's appreciation of the wonders in his collection was not only profound but in many ways daringly experimental. He was fascinated by the idea of the picture that might lie behind or beneath the picture we all knew. Consequently he would eagerly strip away retouching to reveal the unmitigated image beneath. Retouching might involve something as straightforward as shaving off several inches from Mae West's waistline. But it could also be something quite radical, such as the elimination of Joan Crawford's freckles; John's removal of retouching from some Hurrell images of Crawford in her thirties MGM heyday reveals a totally new personality, stripped of all her usual big-star defences. George Cukor once told me that Aldous Huxley described Crawford at this era as looking like 'an as yet unnamed Dupont product'. If he had ever seen these uncensored images it just might have changed his mind.

Ironically, John's biggest triumph as a writer was the least-illustrated of all his books. *People Will Talk*, a mammoth collection of his interviews through the years, was grandiloquently described by one reviewer as embodying 'the Periclean Age of Hollywood'. The individual sections are introduced and commented, to the extent that the book amounts almost to an autobiography – selective admittedly, but then which autobiography is not? Among the crowds of stars, film-makers, choreographers, designers and other notables in front of and behind the cameras, we find two studio photographers, Laszlo Willinger and Bob Coburn. Not only does this indicate the star status John accorded the photographers, but it throws a lot of light on John's relations with his photographers of choice, and how his knowledge of the role they played in the star-making and -remaking process developed. For their part, the delight these veterans felt at being rediscovered and revalued is very patent: one understands exactly how and why John's charm and enthusiasm, even his apparent craziness, secured him the respect and affection of his cinematic loved ones.

John's last years, overshadowed by illness, were occupied mainly by another enormous project, the definitive life of Cecil B. DeMille. Despite the doubts of his editor, John was insistent that DeMille, then deeply unfashionable, was such a central and commanding figure in the history of Hollywood that he deserved, nay required, a massive two-volume treatment. John could have made things easier for himself, in his inexorably weakening condition, if he had been prepared to settle for a less extensive and demanding project, but his will was indomitable. And indeed, the work entailed seemed to many around him to be what was quite literally keeping him alive. At the time of his death in 1991 he had completed the first volume, and assembled the material for and largely written the second. Radical editing was, as usual, needed, especially since his publishers felt that, for economic reasons if no other, the reams of text had to be reduced to a single volume; but it is a major loss to film history, not to mention the gaiety of nations, that this vastly entertaining and informative work has yet to reach publication.

So what is John Kobal's final place in the history of cinema and cinema studies? However it may be judged, it is certainly unique. Undeniably he wrote two classic books, *The Art of the Great Hollywood Portrait Photographers* and *People Will Talk* – three if you include the DeMille biography. It is relatively easy to evaluate a writer's work, but how do you define the importance of an archivist? Of John it can be said with certainty that he did something no one else at that time had thought to do. Initially it was by accident. Thousands, possibly millions, of crazed film fans in the forties and fifties must have collected every scrap of information, verbal and pictorial, about their special objects of veneration. But only John had interests so extensive, and an acquisitiveness so obsessive, that he could put together such an all-embracing collection, entirely for his own delectation.

Equally, the Kobal Collection as it features in the credits of practically every nostalgically-inclined film programme on television arose initially by accident, and it took John a long time to recognise its business potential. By that time, in any case, he was internationally recognised, much to his own surprise, as a scholarly expert in his field, so that in 1979, for instance, he was commissioned to organise and catalogue the picture archive of the Deutsche Kinemathek in Berlin. Without doubt, his major achievement in this field was the rediscovery and documentation of the classic studio photographers during the Golden Age of Hollywood.

Serendipity played some part in this, too: by accident, John's timing was spot on. When he became interested in the men behind the images, almost all of them were still alive and reachable. But it was John who realised their importance, sought them out, and was ready to acquire, preserve and protect hundreds of the original negatives at a time when no one else gave a damn about them. For those who knew him, John regularly tops their lists of 'The Most Memorable Person I Ever Met'. For those who didn't, one can best quote Sir Christopher Wren's tombstone: If You Seek His Monument, Look Around You.

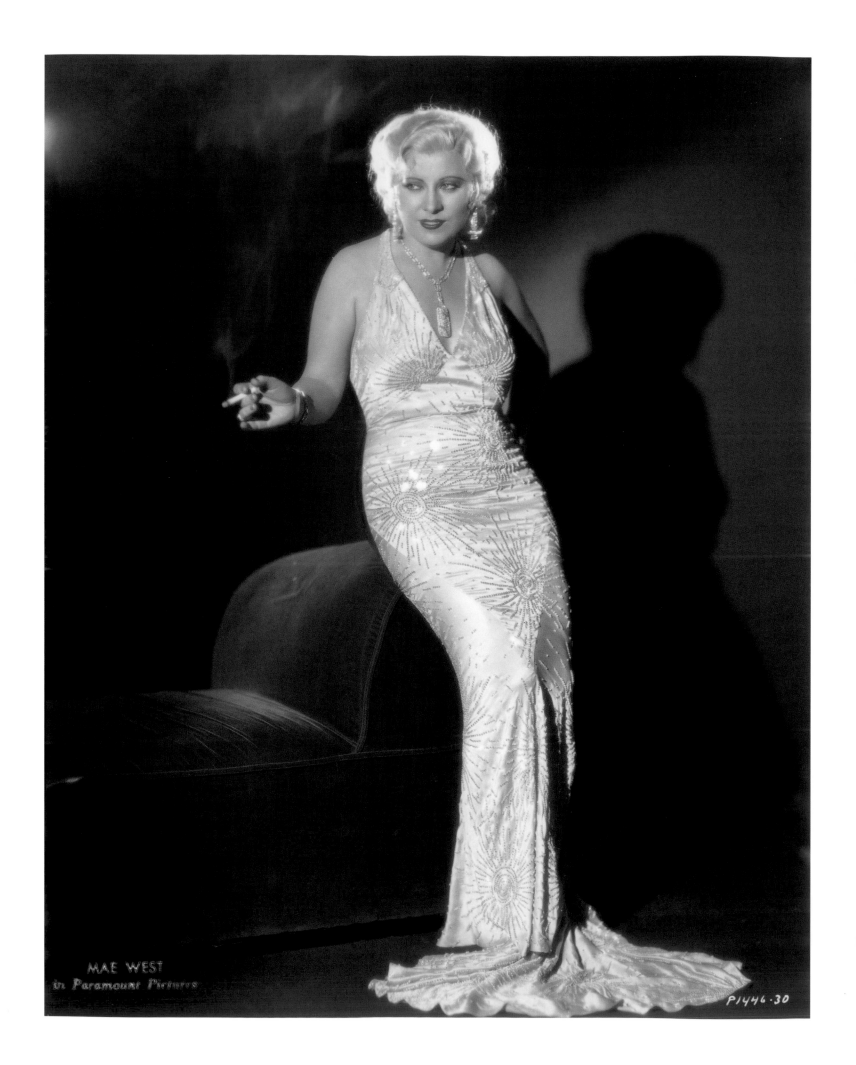

Mae West, Paramount Pictures. Eugene Robert Richee, 1932

John Kobal and Hollywood Photography
by Robert Dance

'… no one, including the men, ever said, "This isn't me".' Laszlo Willinger

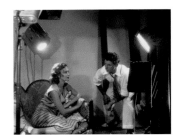

George Hurrell with Dorothy
Jordan, MGM. UNIDENTIFIED MGM
PHOTOGRAPHER, 1932

Like so many stories about John Kobal, the one about his notable role as a connoisseur, collector and chronicler of Hollywood photography begins with a movie star. Working as a journalist in 1969, Kobal visited the set of *Myra Breckinridge* with the goal of interviewing screen legend Mae West. His reporter's credentials granted him access to the set and, while awaiting the summons from Miss West, Kobal had the opportunity to meet members of the film's crew. Making small talk with an on-set photographer, he learned the man's name was George Hurrell. This surprised Kobal, for he recognised the name from the credit marks embossed or stamped on many of the Hollywood photographs he had collected since childhood. But those photographs were from the 1920s and 1930s, and were images of the greatest of Hollywood's stars, Davis, Garbo, Gable, Harlow. Could it be the same man almost four decades later, still practising his craft on a movie set?

Hurrell had been shooting portraits in Hollywood since January 1930, when he began a three-year stint at MGM recording all the studio's great faces, most notably Joan Crawford's. From 1938 to 1940 he was employed by Warner Brothers. Otherwise he worked independently, available to anyone who would pay his stiff fee. So extraordinary were Hurrell's photographs that he may be said to have revolutionised the depiction of Hollywood actors. His inventive use of strong contrasts of black and white gave his subjects an almost sculptural quality and added a masculinity to his male subjects that was consistent with the new tough-guy image associated with stars like Gable and Cagney. His radical re-touching of his negatives' surfaces made women glow like never before. Before Hurrell, Norma Shearer was an attractive actress; in front of his lens she became a screen siren. Looking back on the photographers from the studio system's first two decades, Hurrell stands out as the best, and his transformative images have come to define an era.

Thirty-nine years after beginning his Hollywood career Hurrell was still at it – called upon this time to do the impossible: to make an ageing Mae West sexy. No other photographer had a chance. Hurrell understood his camera's magic and he could see through the miasma of years and make-up to evoke again the essence of West's (once captivating) appeal. Make no mistake, Hurrell was approaching artifice with artifice, her carefully contrived illusion with his ability as an alchemist.

Following this auspicious meeting, Kobal and Hurrell forged a friendship which allowed the young man to learn from a first-hand source precisely how Hollywood's glamour was constructed. Always interested in photography, especially pictures of his favourite stars, Kobal collected any images he could find. What had the most resonance for Kobal, however, were original portraits, the 11 x 14-inch silver prints that froze in time for him a moment in American cultural life when glamour dominated the movies. They were a tangible connection

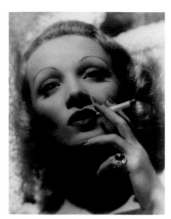

Marlene Dietrich, MGM. CLARENCE
SINCLAIR BULL, 1944

to the past and he gobbled them up wherever he could find them. Now he had the chance to learn from one of the masters the secrets behind the magic.

Kobal's acquaintance with Hurrell began at a time when curiosity about old Hollywood was at its nadir. The studio system was long dead and television had effectively drawn audiences away from movie theatres. The nostalgia craze of the baby boomers was still a decade away. During the 1960s five of Hollywood's eight major studios – MGM, Paramount, Warner Brothers, Universal and United Artists – were sold off to conglomerates, the men in suits having little interest in the history of the businesses they were acquiring. Desilu had bought RKO in 1958. Only Columbia and 20th Century Fox remained as independent studios. Kobal wrote in 1971, 'At least the barons who once ran the studios were movie barons. Today they come from the oil fields and the stockmarket and couldn't care less about films.'[1] A collective insanity swept through Los Angeles during this period of consolidation, and many studios shed treasure troves of publicity and promotional material created to support the films that had entertained audiences since the 1920s.

Kobal first started seriously examining and acquiring Hollywood portraits and stills in the 1960s when this material was considered nothing more than insignificant Hollywood ephemera. Only a few film enthusiasts, including Kobal, scrambled and competed to acquire original studio photographs. Kobal did, however, collect better than the others, and in the end used his extraordinary collection in the service of restoring the reputations of the photographers who had helped create the stars in the first place.

As his collecting grew more ravenous and expanded into acquiring original negatives as well as photographs, he persuaded Hurrell to print his classic images once again. Vintage Hollywood would come alive in the darkroom as stars' faces re-emerged in the developing baths to be introduced to a new generation of film enthusiasts. And it was his acquaintance with Hurrell that gave Kobal the idea to look up surviving members of the circle of great Hollywood photographers, whose accumulated work is perhaps the most perfect record available of the history of Hollywood's first fifty years.

A love affair with the movies began when Kobal was a boy in Austria in the late 1940s and continued when his family emigrated to Canada in the 1950s. He later wrote that '[Hollywood] exerted a powerful charm on the imagination of a young man used to living in emotional isolation.'[2] Magazines and newspapers kept Kobal up to the minute on the latest Hollywood news and gossip, and current with the latest photographs released. Like most fans of his generation, Kobal kept scrapbooks of Hollywood favourites, 'pictures cut out of fan magazines; stars looking great next to slogans telling you that nine stars out of ten used Lux; ads for films, those pages in the front of fan magazines; picture spreads.'[3]

Kobal's first brush with the tinsel-town glamour he had read and fantasised about came when he was twenty. Marlene Dietrich was to give a concert in Toronto. For the first time one of his idols from the screen would appear before him in person. The anticipation was intoxicating and Kobal was determined not only to see the legend on stage but to meet her as well. The charm that served him well throughout his life must have been in full force the day he invaded the press office of Toronto's O'Keefe Theater. Claiming to be a reporter from Ottawa (his hometown), he tried to secure an interview. Impossible. In fact he would not even be able to go backstage after the performance. But he did get backstage by following a crush of well-wishers, and he did meet his idol.

The whole story of this encounter is recorded in Kobal's delightful collection of interviews with Hollywood's nobility, *People Will Talk* (1986). That evening with Dietrich (and the day that followed) foretold what would become a lifetime of making friends with many of the celebrated giants of the screen, especially the ladies whom he held in utter fascination and who became just as fascinated by him. Dietrich was the subject of his second

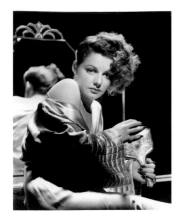

Ann Sheridan, Warner Brothers.
GEORGE HURRELL, 1940

book, *Marlene Dietrich*, published in 1968. *Greta Garbo* (1965) was his first subject, although Garbo, retired since 1941, was one of the few Hollywood greats who never consented to a Kobal interview.

'For me,' wrote Kobal, 'the "movie star" was always the most remarkable thing about the movies.'[4] And by movie star Kobal meant the great faces that graced cinema from its beginnings, through film noir and into the 1950s. Like all fans, Kobal loved the movies, but in the period before video and DVD there were few opportunities to see old films. He shared with fans from the decades before he was born an insatiable desire to learn as much as he could about his favourites and consumed every tidbit offered in fan magazines and any other promotional material he could find. When Kobal moved to New York in 1964, and later to Los Angeles, he was overwhelmed by the fact that television showed movies throughout the day and night, albeit often butchered to slip a two-hour movie into a ninety-minute slot including commercials. Here Kobal was introduced to more of the great faces of the past, many long dead, retired or now decades past their prime. Meeting the stars whose faces flickered on late-night television became his holy grail.

Glamour was, as it were, the siren's song that drew Kobal to New York, Hollywood and London. Unabashed by his thralldom to the stars, he was sometimes caught short when a legend did not meet his expectations. Meeting Ann Sheridan for the first time when she agreed to an interview, he expected Hollywood's original Oomph Girl of the 1940s, not an unadorned woman with gray strands filtering through her hair. Still, they became friends, and in the course of one of their conversations she told him that oomph 'was just a publicity stunt with me'.[5] Publicity stunt or not, it was the vision that Kobal and millions of others carried around, and Sheridan was astute enough to recognise that she had disappointed her new young admirer. The last time they met, shortly before she left for Los Angeles to film a television series that was halted by her untimely death, was in a New York restaurant. Sheridan was resplendent, the movie star of Kobal's imagination. 'You prefer it like this, don't you darlin'?', she asked. 'You know, darlin', I did this for you.'[6]

Marlene Dietrich and Ann Sheridan were among the many great stars Kobal met and interviewed and, although he became both deliberate and strategic in tracking down his favourites, an element of kismet also accompanied him throughout his life. Kobal wrote of his chance encounter with Paramount star Nancy Carroll in *People Will Talk*, and acknowledged the importance of good luck. '"Excuse me, you're Nancy Carroll, aren't you?" I was standing in front of St. Pat's Cathedral, thinking of going in, when she walked past with the rush-hour mob. "Why, yes, how did you know?" "Because you haven't changed. I'd recognize you anywhere. I've got hundreds of portraits of you and I adore you."'[7] He requested and was granted an interview, which he claimed wasn't very good, but out of that afternoon with Carroll came an introduction to another legendary figure who opened the gates of paradise to Kobal. Carroll's daughter, Patricia Kirkland, who acted occasionally on television, was at the time of the interview working at a talent agency that handled Tallulah Bankhead. 'Nancy said, "Call her, you'd like her." You wonder sometimes. For instance, if I hadn't agreed to do an interview with nightclub comics Martin and Rossi to put Hy Smith in the mood to let me go through the drawer of yet one more filing cabinet outside his office, which is the one that contained the pictures of Nancy Carroll that turned me on to photography because I found myself fascinated by a woman I'd not yet even seen in a film, and if I hadn't met her, would I have ever gotten to meet Tallulah Bankhead? And it was Tallulah who unlocked Hollywood for me.'[8]

Once the doors of Hollywood were open to Kobal, obsessive accumulation became the hallmark of his acquisition of star portraits. He acquired single prints, small collections and, when the opportunity arose, a star's or photographer's archives. These images were after all an important currency of Hollywood. A successful portrait session could introduce a new

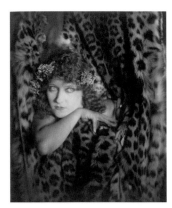

Gloria Swanson for *Male and Female*, Paramount Pictures. KARL STRUSS, 1919

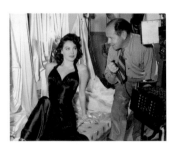

Ava Gardner with photographer Clarence Sinclair Bull, MGM. UNIDENTIFIED MGM PHOTOGRAPHER, 1944

face to moviegoers and pave the path to stardom. The careers of legendary figures such as Crawford, Gable and Cooper, Kobal suggested, 'were made possible through photography and would probably not have existed without'.[9] For these veteran performers and other stars, portraits remained an essential link to the ticket buying public who anxiously awaited new pictures each month. Studios distributed these images by the hundreds of thousands, mostly through the mail to fans, and a selection of *exclusive* portraits was sent to movie magazines and newspapers to feed a gluttonous appetite for the latest shot. Long before the *paparazzi* snaps, which replaced the portrait in the 1960s as the fan's favourite vehicle of connection to the stars, studio-controlled publicity photos chronicled the lives of stars on screen and off. Although these might seem artificial in contrast to the lively intrusion of the rapid-fire triggers of today's digital cameras, they recorded an era when fans looked up to the stars as templates of manners and fashion.

All Hollywood photography fell under the domain of the studio's publicity departments and every photograph taken served, in one way or another, the promotion of a film or star and, by association, the studio's brand. As Gloria Swanson told Kobal in 1964, 'Audiences make stars; either they like you or they don't.'[10] Once a man or woman emerged as a star, the studios ensured that the public was saturated with images of favourites. In 1928, if we can believe industry reports, fans sent stars something in the range of 32,500,000 fan letters, the majority requesting a photograph.[11] Even if this number is wildly exaggerated (and it might not be), an astonishing number of letters was received by the studios and a huge quantity of photographs was sent in reply. Shirley Vance Martin, one of Hollywood's earliest still photographers, wrote in 1928 that an actress 'knowing the value to herself of still pictures frequently plac[ed] single orders of 50,000 and 100,000 prints from one negative, all to be sent to admirers.'[12]

Studio portraits taken at MGM and Paramount were available in the greatest numbers, as Hollywood's top two studios competed with one another for stars and publicity. Kobal may not have consciously selected MGM as his area of greatest interest, but the combination of availability of images and the coincidence of his relationships with George Hurrell and especially Clarence Sinclair Bull gave him an unprecedented access to MGM material. This resulted in Kobal acquiring a practically encyclopaedic collection of portraits of MGM stars and featured players. There might also have been something different about MGM photographs, as longtime studio photographer Bud Graybill suggests: 'One thing about MGM, though, was that the idea behind the stars was to make them more glamorous, more remote, not so accessible.'[13]

As Kobal met one great lady after another from Hollywood's glory days and assiduously collected the portraits that helped each become a star, he began to understand the complexity of not only creating, but sustaining, glamour. In a typical Kobal turn of phrase he noted, 'Glamour had been sparks thrown off by the giants in their play, and it was those electrical flashes that made them fascinating.'[14] Discussing portraiture with Kobal, one of those giants, Loretta Young, recounted, 'We all thought we were gorgeous because by the time they finished with us we were gorgeous.'[15] Young was, perhaps, being unnecessarily modest, but it is true that even the most beautiful actress received from the hands of her photographer an extra polish and shimmer. 'The individuals who were the source of the sparks', according to Kobal, 'could never be manufactured, but they had been harnessed to burn as a flame which was controlled by the studio.'[16]

This did not occur accidentally or haphazardly. 'What happened in the galleries', wrote Kobal, 'was an extraordinary thing, something that was beyond the ken of the studios and owed nothing to contracts, scripts or the publicity department.'[17] Performers worked as hard, or, as Kobal saw it, perhaps even harder, in the portrait studio than on the set. 'To achieve

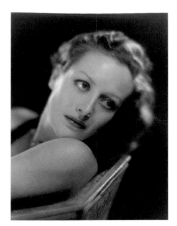

Joan Crawford, MGM. CLARENCE
SINCLAIR BULL, 1933

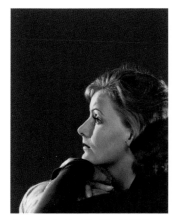

Greta Garbo for *The Kiss*, MGM.
CLARENCE SINCLAIR BULL, 1929

the effects of the great portraits, it was necessary for the sitters to reach a state of trust with the photographers so total that they would unconsciously reveal the very hunger that had driven them to the place where they now found themselves.'[18] 'I photographed better than I looked,' Joan Crawford told Kobal, 'so it was easy for me … I let myself go before the camera. I mean, you can't photograph a dead cat. You have to offer something.'[19] Greta Garbo, whose languid style belies words like 'hunger' and 'driven', was nevertheless as great a portrait subject as she was a film actress. Kobal would have us understand that whatever it was that made Garbo Hollywood's greatest film star was also working at full throttle in the portrait studio. Katharine Hepburn put it succinctly: 'If you are in the business of being photographed, you must like to have your picture taken, otherwise you shouldn't be doing it. It's part of your work.'[20]

Although movie stars were catnip to Kobal, after meeting Hurrell he became almost as voracious in locating and interviewing Hollywood photographers. By the 1970s a majority of the photographers who had worked in the twenties and thirties, like their subjects, were retired, and a few had died. What made Kobal's task even more complicated was the issue of photographer's credit that surrounded studio photography. While many portraits were embossed or stamped with the photographer's name, scene-stills were almost never credited. Slowly, and later frantically, Kobal set about attempting to discover just who had taken what picture. Kobal did not meet everyone who shot portraits and stills in Hollywood, but he was the first who tried to make sense of their important contribution to movie-land history. In his quest to discover the whereabouts of the surviving stillsmen, Kobal came to know, along with Hurrell and Bull, Laszlo Willinger, Robert Coburn, William Walling and Ted Allan. Each would share his memories and print from his negatives. In return Kobal started what became his most important work – publishing the anthologies of the photographers' work that resuscitated forgotten careers.

Along with taking the star portraits, studio photographers recorded every aspect of a film's production and followed the players off screen as well as on. 'How many movies …', wrote Kobal, 'had I first seen and never forgotten because of the still man's art?'[21] Stills traced the continuity of filming and are the principle document for the thousands of lost silent films. Stills were also a principle marketing tool for the studios and usually served as the basis for lobby cards and posters. Stills are often the images we conjure up when we remember our favourite moments from *Gone with the Wind* or *Casablanca*. Katharine Hepburn is an example of one actress who respected the stills photographers and helped whenever she could. 'I used to pose for them in the scene and off the set because of my interest in stills. Otherwise the poor man on the set, they'd be telling him, "Oh, for God's sake, you don't want a still of that! We can't wait for a still." But I always used to encourage the still man and I'd protect him.'[22]

Kobal recognised the important role studio photographers had in developing the images of the stars, and he chronicled this previously ignored aspect of film history in a succession of books beginning with *Hollywood Glamour Portraits: 145 Photos of Stars 1926–1949*, published in 1976. His most important work, *The Art of the Great Hollywood Portrait Photographers* (1980), was the first serious systematic study of the genre and had the added bonus of being both magnificently illustrated and sumptuously produced. In that book he charted the terrain of Hollywood glamour and provided glimpses of the (mostly) ladies who sat before the cameras and the workings of the (mostly) men who created the illusions. In total Kobal authored, co-authored or edited thirty-three books, many illustrated from his own holdings. When he acquired a large collection of original negatives taken by Nelson Evans, they formed the basis for his book *Hollywood: The Years of Innocence* (1985). His friendship with Clarence Sinclair Bull, along with the treasure trove of Bull's prints and negatives he had collected, formed the

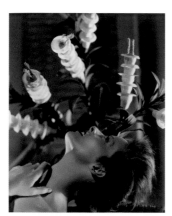

Katharine Hepburn, RKO. Ernest
Bachrach, 1936

foundation of the book and exhibition *The Man Who Shot Garbo* (1989). Collaborating with others, Kobal turned to the best film writers and critics, such as Kevin Brownlow (*Hollywood: The Pioneers*, 1979), Raymond Durgnat (*Sexual Alienation in the Cinema*, 1972), Terence Pepper (*The Man Who Shot Garbo*, 1989) and John Russell Taylor (*Portraits of the British Cinema: Sixty Glorious Years 1925–1985*, 1985). Following his books on Garbo and Dietrich he wrote two more star biographies, *Marilyn Monroe* (1974) and *Rita Hayworth: the Time, the Place and the Woman* (1977). In particular, Kobal's book on Hayworth is an especially insightful and sensitive addition to the large corpus of star biographies that proliferates. His ebullient personality – almost everyone liked him – allowed Kobal to become the impresario of the history of Hollywood photography. In addition to writing books, he served as general editor of (and contributor to) an excellent pictorial history of stars *Cooper* (1985), *Bergman* (1985), *Gable* (1986), *Crawford*, (1986), engaging writers such as Richard Schickel and James Card to write essays for individual volumes. Along with writing, Kobal curated exhibitions of Hollywood photographs and built one of the pre-eminent portrait and film-still libraries, one that continues today as the Kobal Collection.

Kobal was the first to organise museum shows focusing on Hollywood portraiture. His inaugural effort was at the Victoria and Albert Museum in London in 1974, a show he described as 'the first exhibition devoted to the Hollywood group.'[23] This was followed by shows he mounted at The Museum of Modern Art (New York), as well as the National Portrait Galleries in Washington and London. The first museum exhibition devoted to the career of one Hollywood photographer was *The Man Who Shot Garbo*, a monographic exhibition on Clarence Sinclair Bull that opened at London's National Portrait Gallery in 1989. It is apt that Bull's career should be the first thus to be explored, because no photographer shot as many famous Hollywood faces. Katharine Hepburn wrote the foreword to the accompanying eponymously titled book, *The Man Who Shot Garbo*. She called Bull 'one of the greats', and ended her comments with 'Clarence Bull! And the National Portrait Gallery! WOW!'

Bull's tenure at MGM, 1924–1961, matched the period now defined by the old chestnut, Hollywood's Golden Age. There is no question that it was the golden age of Hollywood portraiture. The year Bull retired, 1961, a new sort of photography was beginning to creep into the mainstream of studio film promotion and the Hollywood press. The candid would soon replace the portrait as the type of image fans most wanted to see. Magazines started publishing snaps of Elizabeth Taylor between planes and yachts, and Greta Garbo as seen beneath a floppy hat through a telephoto lens. Is it a coincidence that Bull left MGM the year Fellini's *La Dolce Vita* introduced to the world the character Paparazzo, and the paparazzi were born?

Kobal recognised this shift in attitude toward Hollywood photography, and largely limited his collecting to work created before 1960. He identified the years 1925–1940 as the scope of his book *The Art of the Great Hollywood Photographers* and argued that it is from those years that the greatest innovations took place. 'After 1939,' wrote Kobal, '... [the] effects of fine photography still lingered on, even as film got faster, lenses sharper, cameras more manageable, and negatives smaller, but by the beginning of the 1940s, much of the great work was over.'[24] In earlier books, Kobal had chronicled Hollywood photography from the 1940s and 1950s, including the pioneering use of colour, but after that decade he was largely silent. The paparazzi held no allure in the Hollywood fantasy so perfectly described by Kobal.

Eric Stone (a Paramount Studio
photo negative retoucher),
Paramount Pictures. DON ENGLISH,
1934

1 John Kobal, *Gotta Sing, Gotta Dance*, p.300
2 John Kobal, *People Will Talk*, p.709
3 Ibid, p.342
4 Ibid, p.709
5 Ibid, p.420
6 Ibid, p.425
7 Ibid, p.xv
8 Ibid, p.xvi
9 John Kobal, *Gary Cooper*, p.109
10 Kobal, *People Will Talk*, p.16
11 Alexander Walker, *Stardom*, NY: Stein and Day, 1970, p.250
12 Shirley Vance Martin, "Still Pictures and Why they are Made",
 Opportunities in the Motion Picture Industry, Photoplay Research Society, 1922, p.49
13 John Kobal, *The Art of the Great Hollywood Portrait Photographers*, p.84
14 Kobal, *People Will Talk*, p.709
15 Ibid, p.401
16 Ibid, p.709
17 Kobal, *The Art of the Great Hollywood Portrait Photographers*, p. 87
18 Ibid
19 Ibid, p.109
20 Kobal, *People Will Talk*, p.330
21 Ibid, p.349
22 Kobal, *The Art of the Great Hollywood Portrait Photographers*, p.70
23 Ibid, p.8
24 Ibid, p.121

Clarence Sinclair Bull and his team of MGM stills photographers, MGM. UNIDENTIFIED MGM PHOTOGRAPHER, 1928 20

The Hollywood Studio Photographers
by Robert Dance

The cinema's glamour machine that takes waitresses, debutantes, actresses, schoolgirls and their masculine parallels and by adroit veneering makes of them the dream children of the silver screen is a complex lot of wheels and cams. One small unit is hidden away on every lot. Its product thunders from newspaper and magazine pages, from billboards and theater lobbies. Its prime purpose is to make the customer go to the ticket window and lay down money. It must give the appearance of genius to very ordinary people. It must conceal physical defects and give the illusion of beauty and personality should none exist. It must restore youth where age has made its rounds. It must give warmth to neutral or rigid features. It is, in short, the still department.

D.V.C., "Catching the Highlights", *The New York Times*, 6 September 1936

Metro-Goldwyn-Mayer

Elizabeth Taylor with photographer Clarence Sinclair Bull, MGM. Unidentified MGM photographer, 1956

Clarence Sinclair Bull's long association as a photographer with the studio that would become Metro-Goldwyn-Mayer began when producer Samuel Goldwyn hired him in 1919. Managing to survive the commotion of the consolidation of the Hollywood studios in the early and mid-1920s, Bull found himself at the helm of MGM's stills department when the studio was formed in 1924, and stayed there until retiring in 1961. The enormity of MGM's output of films in the 1920s – they advertised a new feature every week – saw Bull's domain grow. He was responsible for managing MGM's staff of photographers and the large support crew of technicians needed to develop, re-touch, print and collate the hundreds of thousands of prints distributed annually by MGM's publicity department. At least one photograph from the 1920s shows Bull with twelve stillsmen who juggled the task of shooting photos on as many as a dozen films that might be concurrently in production. At MGM, like the other studios, these men – and it was an almost exclusively male profession – worked six days a week and often long hours each day. Generally one photographer was assigned to a production and, as filming was underway, he would document each scene using an 8 x 10 view camera. These cameras not only had lenses with sharp resolution, but contact prints could be made from the negatives quickly and in enormous quantities. The stills made for each film were numbered sequentially and gathered together in a book. Stills photographers also created the images used for poster art, lobby cards and other forms of advertising conceived by imaginative publicity chiefs and their staffs.

John Kobal developed a close relationship with Bull and his wife Jeanne, and one result of the time they spent together is that we know more about Bull's life and career than practically any other Hollywood photographer. Kobal not only collected Bull's photographs and negatives and quizzed him endlessly about studio life, but he also inherited Bull's scrapbooks and albums of photographs, including work that had nothing to do with Hollywood.

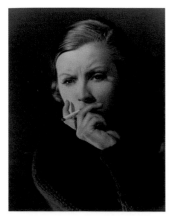

Greta Garbo for *Anna Christie*,
MGM. CLARENCE SINCLAIR BULL,
1929

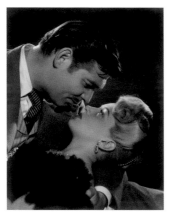

Clark Gable and Lana Turner
for *Honky Tonk*, MGM. CLARENCE
SINCLAIR BULL, 1942

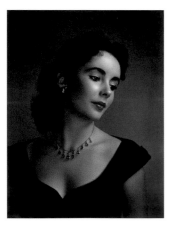

Elizabeth Taylor, MGM. CLARENCE
SINCLAIR BULL, 1948

Bull took portraits throughout the 1920s, although administrative duties curtailed (but did not eliminate) his availability for time-consuming gallery sessions, especially after Ruth Harriet Louise was hired in 1925 as MGM's portrait photographer. This was not a demotion for Bull, as Louise reported directly to Pete Smith, the head of publicity, and Bull's duties remained unchanged. Still, Louise and Bull seem not to have got along, and he never mentioned her in interviews or his writings after she left MGM in late 1929. Louise's work, however, did influence Bull, who started to emulate her soft-focused pictorialism in 1927. Perhaps challenged by Louise's talent and craft, by the end of the 1920s Bull had matured as a photographer. Though sometimes outshone by Louise in the late 1920s, and later by his colleague Hurrell in the early 1930s, at his best Bull was equal to both. Bud Graybill, who shot stills under Bull's supervision for over twenty years starting in the mid-1930s, described him in a letter to Kobal (dated 29 January 1978) as 'the quintessence of photographers.' 'His negatives were near perfect in exposure … the imaginative work he did over a period of roughly 40 years was never to be topped.' After Louise left MGM at the end of 1929, Bull distinguished himself as Garbo's principal photographer, which must have made him the envy of his peers regardless of studio.

Chances are, if you have seen a portrait of Greta Garbo other than Edward Steichen's iconic image, it is the work of Bull. With the exception of one session, Bull and the reclusive actress worked together exclusively in the portrait studio from 1929 to 1941 and their collaboration resulted in a body of imagery unmatched in Hollywood photography. Reminiscing with Kobal, Bull spoke of Garbo's extraordinary concentration and described her working methods as 'businesslike'.[1] She was 'his easiest subject', surprising given Garbo's status as the studio's biggest star. Garbo was one of Kobal's favourites, and he took care to understand her sittings with Bull and the way Bull carefully shaped her image through the years. Kobal worked with Bull to produce a limited-edition portfolio of five Garbo photographs printed under Bull's supervision from his original negatives. Bull died in 1979, just as the first portfolios were being prepared.

It seems that every star who worked at MGM was photographed by Bull at least once. Paramount's biggest male attraction, Gary Cooper, was loaned to MGM in 1934 to co-star with Marion Davies in *Operator 32* (1934). Bull and Cooper had a short session together on 17 April 1934 and the results were splendid. He infused Cooper with a sleek, polished glamour that was as unusual for male subjects as was the cigarette dangling from his lips. Old timers and newcomers all had the chance to work with Bull, including vaudeville alumna Marie Dressler, who for a short time in the early 1930s was Hollywood's number one draw, and ingénue Lana Turner, who at twenty was co-starring with Clark Gable in *Honky Tonk*. Bull started experimenting with colour photography in the late 1930s, making a colour exposure of Garbo first in 1936 and again in 1941. In the late 1940s and throughout the 1950s he worked extensively in colour recording, among others, Elizabeth Taylor at the moment she was being considered for adult roles.

Bull presided over a team of talented stills photographers, some of whom occasionally made portraits, generally on the set. The finest were Milton Brown, William Grimes, James Manatt and, for a short time in the mid-1920s, Bert Longworth. Longworth took the stills for Garbo's first three pictures and his images of Garbo and John Gilbert in a clinch for *Flesh and the Devil* (1926) are the quintessence of old-time movie romance. He left MGM in 1927 for Warner Brothers. James Manatt was Marion Davies' favourite photographer and, in addition to working on all her films, he made the lion's share of her portraits. Otto Dyar, who worked at Paramount in the 1920s and at Fox in the 1930s, later moved to MGM.

Stills photographers were responsible for the often dazzling images taken to promote upcoming films. During brief breaks in filming, these photographers were accorded minutes,

Lillian Gish for *The Wind*, MGM.
ATTRIBUTED TO MILTON BROWN, 1927

Joan Crawford and photographer
Ruth Harriet Louise, MGM.
CLARENCE SINCLAIR BULL, 1928

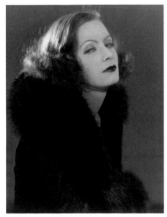

Greta Garbo, MGM. RUTH HARRIET
LOUISE, 1928

and if their complaints are accurate sometimes just seconds, to snap a picture that would titillate fans with a dramatic or poignant moment, or encapsulate the narrative of the film. Unfortunately most of these photographs were never credited, so in many cases it is impossible to identify the maker. Anonymous stills photographers made many affecting star portraits that were shot on the set. Lillian Gish is depicted, in one masterfully composed still, engulfed in a sand-swept landscape while on location during the filming of *The Wind* (1927). For *Go West* (1925), Buster Keaton poses between two ice-laden boxcars in a frozen landscape, his huddled form and still face projecting a sense of isolation and despair. A portrait of Vivien Leigh, taken during a dramatic moment from *Gone with the Wind*, (1939) typifies the persona of Scarlet O'Hara.

What must have been the most fun was shooting stills for spectacles like *Ben-Hur* (1925) and the musicals which became an MGM speciality in the 1930s. One of the studio's earliest *All Singing, All Dancing* efforts was *Hollywood Review of 1929* (1929). The ambitious *March of Time* was never completed, but surviving film clips and stills show the extraordinary sets created. Throughout the 1930s and into the 1940s the production numbers got more elaborate and, with stars of the calibre of Eleanor Powell and Judy Garland, the genre has probably never been bettered.

Among the important MGM photographers the only one who Kobal did not meet was the studio's (and Hollywood's) only female portrait artist, Ruth Harriet Louise. Louise's brief reign as portrait studio chief lasted from mid-1925 to the end of 1929. To Louise goes the credit of being the photographer who fashioned Garbo's face into the timeless visage still immediately recognisable worldwide. Just twenty-two when she joined MGM in the summer of 1925, Louise lost her job to George Hurrell four years later. Throughout the 1930s she occasionally took private commissions photographing stars such as Anna Sten (in 1932) and Myrna Loy (in 1935).

Louise died in childbirth in 1940, the year Kobal was born, utterly forgotten by an industry she had worked assiduously to document. Kobal avidly collected her original prints and acquired hundreds of her negatives. Of all the photographers he introduced in *The Art of the Great Hollywood Portrait Photographers*, Louise's career was most in need of rehabilitation. Even her gender, which set her apart from all her contemporaries, had been insufficient reason to keep her memory alive.

Louise was among the first Hollywood photographers to break away from the old-fashioned convention of staid portrait shots and introduce the nuance of her sitter's personality. When she photographed stars in costume she attempted to find something of the character being portrayed. Kobal noted that she was 'in the vanguard of the photographers who would revolutionize Hollywood portrait photography.'[2] Hollywood portraiture before Louise documented strong personas: Swanson's glamour, Chaplin's tramp, Pickford's waif. Louise took the screen personas of her favourite sitters, such as Lon Chaney and Joan Crawford, and in her photographs humanised them while never letting their star lustre diminish. 'There is about Louise's work,' wrote Kobal in 1980, "a delicacy, a shy, appealing privacy, that established an immediate bond with the viewer."[3] Her subjects liked her and trusted her, including the elusive Garbo. The two young women worked together, starting with Garbo's first portrait session in Hollywood, two months before she appeared on the set, through her ascent as MGM's greatest female draw. Louise's sensitive touch, along with the work of MGM's brilliant cinematographers, combined to create the face that enthralled moviegoers.

There has been discussion in Hollywood literature as to how much Louise relied on full-length shots, which she would then crop to make half-length or close-up portraits. Kobal may have started this notion when he wrote about Louise. Although cropping was and remains a useful tool in most photographers' practice, in fact Louise took as many close-up and

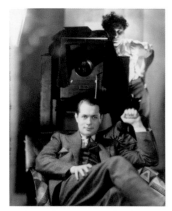

Robert Montgomery and photographer George Hurrell, MGM. GEORGE HURRELL, 1937

Joan Crawford, MGM. GEORGE HURRELL, 1934

Marlene Dietrich. GEORGE HURRELL, 1937

(especially) medium shots as any of her contemporaries. Kobal identified correctly that many of Louise's famous compositions were derived from cropped negatives that found their final form in the darkroom. But Louise's surviving negatives (numbering in the thousands) demonstrate without question that Louise shot regularly in close-up and medium shots, and these also formed the basis for many of her most important photographs.

George Hurrell started work at MGM at the beginning of 1930 and almost immediately transformed Hollywood photography. Brought to MGM at the insistence of Norma Shearer, his task was to make his subjects, especially women, sexy. Not only did he succeed but his work, in this respect, has never been bettered. Norma Shearer was an attractive and talented actress, who through determination and fortitude, not to mention marriage to MGM's top producer Irving Thalberg, managed to secure most of the studio's choicest female roles. But she found herself increasingly cast as the nice girl or sophisticated matron when she wanted the racier roles given to Joan Crawford and Greta Garbo. Hurrell changed Shearer's appearance, at least in the portrait gallery, and there is no question that the lovely lady portrayed by Ruth Harriet Louise took on a new and smouldering guise when seen through Hurrell's lens. Hurrell's very best work was saved for Joan Crawford who probably enjoyed being photographed more than any actress before Marilyn Monroe. Of the approximately 100,000 photographs that were coded by MGM's publicity department between 1924 and 1942, Crawford's face appears more often than that of any other star. Hurrell and Crawford enjoyed an extraordinary collaboration, beginning at MGM and continuing after he went independent in late 1932. Hurrell could be almost brutal with his sitters, subjecting them variously to strong lights, extreme close-ups, and complicated positions. Crawford survived all of Hurrell's antics and her allure was only heightened by his inventive camerawork.

Glamour was Hurrell's hallmark and he saved the best for his ladies. Harlow reached her peak of sexual allure in front of Hurrell's lens, as did Carole Lombard and Veronica Lake when he shot portraits for Paramount. As good as Hurrell was in the 1930s, his 1943 photographs of Jane Russell in the hay, taken to promote *The Outlaw*, are probably his most famous and frequently reproduced.

Hurrell did not have the temperament to last long as part of a studio team. He remained available to MGM on a contract basis throughout the 1930s, photographing Harlow, Gable and Crawford, among others, both at his studio and at MGM. MGM seemed to have been grooming Harvey White to take Hurrell's place, but he lasted at the studio less than a year. The work by White that survives includes copious shots of Jean Harlow on set for *Dinner at 8*.

Kobal and Hurrell must have enjoyed swapping tales about Marlene Dietrich, who, when Kobal met her in 1960, was in the midst of a second career as a concert performer. A quarter of a century earlier she was one of Hollywood's reigning queens and for six years, beginning when she came to Hollywood in 1930, Dietrich's star shone brightly, especially in a series of films made at Paramount and directed by Joseph von Sternberg. But two duds released in 1937, *Knight Without Armour* and *Angel*, saw her value sink rapidly and she was dropped from the Paramount roster. Strategically, and in an attempt to bolster her career, she commissioned a series of portraits from Hurrell. The feathered hat and chiffon dress she selected for the session obviously pleased both actress and photographer, and the results proved that, although her film career might be faltering, she was as beautiful as ever. Two years later she was back with one of her greatest hits, *Destry Rides Again* – but it was a western and made at Universal, something of a comedown for a Paramount star. Might Hurrell's dazzling portraits have helped her secure the role?

Ted Allan is remembered as one of the best-liked studio photographers. He printed extensively from his negatives for Kobal and was respected for his superb darkroom technique. Allan took over Hurrell's gallery at MGM and stayed for four years until 1937. During those

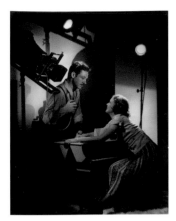

Eleanor Powell with photographer
Ted Allan, MGM. UNIDENTIFIED
MGM PHOTOGRAPHER, 1937

John Garfield, MGM. LASZLO
WILLINGER, 1946

Judy Garland and Mickey Rooney
for *Strike Up The Band*, MGM.
ATTRIBUTED TO ERIC CARPENTER,
1942

years he was Jean Harlow's primary portrait photographer. Allan also had a particularly good rapport with male stars. Unlike Hurrell and Bull, whose reputations rest with women, Allan brought an appealing masculinity to subjects as diverse as Robert Taylor, James Stewart and the Marx Brothers.

Kobal also tracked down Laszlo Willinger, Ted Allan's successor, who was living a quiet retirement in Los Angeles. Hungarian-born Willinger came to MGM in 1937 as part of the studio's last European sweep for talent before the outbreak of the Second World War. Hedy Lamarr and Luise Rainer were signed at the same time. At first Willinger was reticent about speaking of the past because he felt there was little interest in the Hollywood of the 1930s and 1940s. Kobal convinced Willinger that he was interested, and the two developed a friendship.

Willinger brought a fresh look to MGM and Hollywood photography – his prints have a crisp luminescence and his compositions often orient his subjects on the diagonal, which gives them a modern, European sophistication. 'I tried to make a photograph as dramatic as possible', Willinger wrote in 1986, 'by lighting dramatically.'[4] As he did with Hurrell, Kobal anxiously queried the veteran photographer about photographic practices. Willinger recounted to Kobal, 'Loads of photos were taken and the negatives were sitting around, but they were never used because the stars vetoed them.'[5] Even though MGM's first lady, Norma Shearer, wanted Willinger to make all her portraits after 1937, and he did photograph her beautifully for *Marie Antoniette* (1937) and later films including *The Women* (1939), that didn't guarantee the road would be easy. 'If Shearer liked 10 per cent of a sitting,' Willinger told Kobal, "you were going great. With Crawford you could figure 80 per cent would be okay."[6] "The one I liked best to work with was Vivien Leigh. She was a thorough professional."[7]

Along with Leigh, Willinger photographed the new stars that MGM cultivated in the early 1940s to replace old-timers such as Garbo and Shearer who were retiring or Crawford who was being forced out of the studio. Looking back on his career, Willinger wrote, 'I photographed what there ought to be.'[8] Stars hired by MGM in the 1940s, such as Donna Reed and John Garfield, gave him pretty good raw material. So too did tireless cinema veteran Marlene Dietrich. Willinger's 1942 portrait reveals that Paramount's great star of the 1930s had lost none of her authority with the camera.

Eric Carpenter worked at MGM, aside from a couple of short breaks, from 1933 to the 1960s. Elevated from office boy to Bull's assistant, he finally became a portrait photographer at precisely the moment when MGM was cultivating a new crop of stars – Lana Turner, Esther Williams and the popular team Judy Garland and Mickey Rooney. A decade later Carpenter photographed Marilyn Monroe when she made *The Asphalt Jungle* (1950). He 'photographed her', wrote Kobal[9] 'in a pose and clinging dress similar to what he'd successfully used with Lana Turner, most of whose poses had been variations of those dreamed up for Harlow.' In an interview after he retired, Carpenter told Kobal, 'The stars were about the only ones who appreciated what you were trying to do. As far as the producers and executives were concerned, it was just publicity. They couldn't have cared less.'[10]

MGM's last portrait photographer was Virgil Apger. He started as Bull's assistant in 1930, took over the portrait gallery in 1947 and left in 1969. As Hollywood photography changed in the 1950s and especially the 1960s, and sharp lenses, flat light and stiff poses became the norm, Apger continued true to the MGM tradition. When Elvis Presley came to MGM to make *Jailhouse Rock* in 1957, he got the studio's typical glamour treatment, including a portrait session with Apger. By the late 1950s, however, after MGM's last great productions, like the 1959 re-make of *Ben-Hur*, glamour was over in Hollywood and Apger's departure in 1969 coincided with MGM's takeover by Kirk Kerkorian, which closed the door on the past forever.

Manslaughter, Paramount Pictures.
Donald Biddle Keyes, 1922

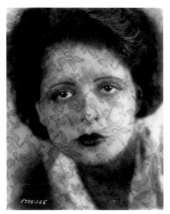

Clara Bow, Paramount Pictures.
Eugene Robert Richee, 1927

Marlene Dietrich being
photographed by Eugene Robert
Richee with assistant John
Engstead (sitting), Paramount
Pictures. Unidentified Paramount
photographer, 1935

Paramount

The Art of the Great Hollywood Photographers at first glance appears to be a tribute to Marlene Dietrich and the team of Paramount photographers who worked with her and director Joseph von Sternberg to create one of Hollywood's most glamorous presences. But a more careful reading (and looking) reveals a far more subtle agenda. For Kobal, Dietrich provides merely one case study of the way photographers can work their magic. He might have chosen Garbo, or Carol Lombard, or Gloria Swanson, actresses who, like Dietrich, were photographed time and again, and responded magically to the camera (and each of whom retains a loyal – even fanatical – following decades after ending her film career). Kobal decided to shine the light on Dietrich – *The Art of the Great Hollywood Photographers* begins with her, and her face graces the longest photographer's portfolio at the book's conclusion.

Paramount (then known as Famous Players—Lasky) was the first studio to set aside a permanent gallery for portrait photography. Donald Biddle Keyes, who had been working as a stills photographer for the studio, suggested this consolidation to alleviate the increasing burden of hiring contract photographers to supply an ever-increasing need of photographic services. By the mid-1920s Paramount had a lively stills and portraits department with dozens of employees. MGM followed suit immediately after its creation in 1924. At the end of the decade all major studios were handling stills and portraiture in-house. The top portrait artists helped shaped his or her studio's style as much as any cinematographer.

Eugene Robert Richee headed Paramount's portrait studio from its inception, and he worked with a talented coterie of associates including William Walling and Don English. Richee remains the least examined among the top Hollywood photographers although he was one of the finest – one needs to look no further than his sensational portraits of Paramount stars Anna Mae Wong, Clara Bow, Louise Brooks and Marlene Dietrich for evidence. Even a tireless researcher like Kobal had difficulty uncovering biographical information about Richee, and it is only after Kobal's death that a few details have emerged about Richee's life, including his 1896 birth in Colorado. He started at Paramount in 1921 and stayed for twenty years, after which he left he left to take a job at Warner Brothers. Richee died in 1972, just before Kobal began exploring seriously the careers of Hollywood portrait photographers. Like Ruth Harriet Louise, Richee left scant biographical information behind but, again like Louise, he left a corpus of extraordinary work that may be seen as emblematic of the best of Hollywood photography.

Richee was an inventive photographer and when working with starlets he sometimes incorporated props made of plastic, glass or even mirrors, giving his prints a sparkling reflective quality. Portraits of the top stars always had a sheen that was consistent with the studio's image of smart sophistication. When he photographed Clara Bow, the studio's number one sexpot took on a polished veneer. Richee has the distinction of being the first photographer to record Veronica Lake and her distinctive blonde locks in his portraits for *I Wanted Wings* (1940), the film that brought her worldwide fame.

Gary Cooper had made more than thirty films over five years when he was cast in 1930 as Dietrich's first Paramount co-star in *Morocco* (1930). He was the first male Hollywood star to bridge the opposing forces of masculinity and beauty. Plenty of handsome men had great careers before Cooper, but none so perfectly fused what had always been considered opposites. Richee photographed him extensively, beginning when he was a touch too beautiful young man, and followed his transformation to the exemplar of male virility. According to Bob Coburn, who worked principally at Columbia, Cooper was 'embarrassed a little bit at constantly being photographed. He preferred to be in movement in front of the camera.'[11]

Gary Cooper, Paramount Pictures.
EUGENE ROBERT RICHEE, 1934

Audrey Hepburn for *Funny Face*,
Paramount Pictures. BUD FRAKER,
1956

Clara Bow, Paramount Pictures.
OTTO DYAR, 1930

Perhaps Richee's most famous work is a 1928 portrait of Louise Brooks wearing a long string of pearls. Few photos capture better the zeitgeist of the Roaring '20s. Simplicity is the hallmark of this photograph, along with masterful composition. Brooks stands, face in profile and wearing a simple long-sleeved black dress, against a black background, her face, hands and pearls alone illuminated. Her bob, with its razor-sharp line across the white skin of her jaw, was widely copied and became one of the last century's most potent fashion statements. Brooks's career had intermittent highs and lows, but she was one of Hollywood's great portrait subjects and was never better served than by Richee.

At the top of his game and for reasons unknown, Richee left Paramount in 1941 to go to Warner Brothers. A.L. 'Whitey' Schafer, who had been in the top position at Columbia, replaced Richee. This change indicated that Paramount's image was shifting away from the opulent glamour that had typified publicity material released during the two previous decades. During Schafer's first years at Paramount he took most of Veronica Lake's portraits, and at the beginning of the next decade worked with many new stars, such as Elizabeth Taylor and Montgomery Clift when they made *A Place In The Sun*, before his death in 1951. Bud Fraker began working at Columbia in the early 1930s where his brother William ran the portrait studio. He remained at Columbia until 1942, when he moved to Paramount as Schafer's assistant. At Schafer's death Fraker became director of still photography for Paramount, a job he kept for a decade. Although he photographed many of Paramount's top stars, his most enduring work records Audrey Hepburn during the production of her first two films as star, *Roman Holiday* (1953) and *Sabrina* (1954).

Stills photographers often created the most durable images of a film scene or star, and this was especially the case at Paramount where the romantic atmosphere on many sets lent itself to luscious photography. William Walling, who served as Paramount's second portrait photographer in the 1930s, also made stills for Dietrich's films *The Scarlet Empress* (1934) and *Devil is a Woman* (1935). Kobal noticed that he had a particular affinity for working with younger, upcoming stars. In the 1940s and 1950s Walling worked at Universal. Later, he was one of the photographers who printed for Kobal from his original negatives. Don English, Paramount's premier stills photographer, took some of the most memorable and seductive portraits of Dietrich on the set of *Dishonored* (1931) and *Shanghai Express* (1932).

John Engstead and Otto Dyar started their careers at Paramount during the 1920s. Engstead was hired as an office boy in the publicity department in 1926 and worked his way up to the important post of supervisor in charge of stills. Engstead achieved this position when he asked Otto Dyar, working at Paramount as a still photographer, to make portraits of Clara Bow on the beach. Engstead failed to clear this session with his superiors in the publicity department who were protective of major stars like Bow. What saved Engstead's job and ultimately secured his promotion were the marvelous results of the Dyar–Bow session. Dyar left for Fox Pictures in 1933 and, probably not coincidentally, Engstead started taking pictures on his own, using Cary Grant as his first model.[12] He stayed at Paramount until he lost his job during the restructuring of the stills department in 1941. Leaving Paramount, Engstead opened his own portrait studio and became one of Hollywood's most successful independents, serving as Dietrich's principal photographer when she started her concert career in the 1950s. Called to Warner Brothers to photograph Marlon Brando during the filming of *A Streetcar Named Desire*, he made the great star's finest portraits.

Marlon Brando for *A Streetcar Named Desire*, Warner Brothers. JOHN ENGSTEAD, 1950

Director Lloyd Bacon with Ruby Keeler and Joan Blondell with chorus girls for *42nd Street*, Warner Brothers. BERTRAM 'BUDDY' LONGWORTH, 1933

James Cagney for *Angels With Dirty Faces*, Warner Brothers. SCOTTY WELBOURNE, 1938

Warner Brothers

Paramount and MGM were Hollywood's two most prestigious studios, and promoted glamour above all. Warner Brothers, constantly vying for top honours, became known for gritty dramas, action and adventure movies, and made some of the era's most memorable musicals. Like MGM and Paramount, Warner Brothers cultivated stars, but character often counted for more than beauty and the studio was known for actors with distinctive faces and personalities – men like Jimmy Cagney, Paul Muni, Edward G. Robinson, and women such as Barbara Stanwyck, Olivia de Havilland and especially Bette Davis. Although glamour was not Warner's main product, the studio none the less needed a smart and careful photographer, and Elmer Fryer served his studio and subjects well from 1929 until 1940.

Rarely do we see in Fryer's work the other-world quality often found in portraits taken at MGM and Paramount. He made Bette Davis beautiful but she always looked like Bette Davis. The tough-guy swagger of Warner's leading men never vanished in the re-touching room. Imaginative shots were generally limited to the glamour girls, who had an earthy sexiness that always seemed to distinguish Warner's female contract players from their counterparts at other studios.

Bert Longworth, who worked for three years at MGM (with a short stop at Paramount), was recruited by Warner Brothers in 1929, and stayed at the studio for more than a decade. Always one of the most inventive of the stills photographers, he became an action specialist working on Warner's musicals, including the spectacles directed by Busby Berkeley. Longworth was the first Hollywood photographer to produce a book of his photographs, *Hold Still Hollywood*, published in a limited edition in 1937.

Madison Lacy worked at Warner's in the 1930s. He was interviewed by Kobal shortly before his death in 1978 and, during that conversation, discussed the mores of the era, especially in light of the Hayes Office and the puritanical Motion Picture Code. Lacy recounted the inherent difficulties in making girls sexy under the watchful eyes of the censors. 'You'd deliberately make some things more erotic than others. They'd kill the most erotic ones, and you'd still have some that were reasonable by comparison.'[13]

George Hurrell was tempted by the offer of a lucrative contract to return to studio work and spent two years (1939–40) at Warner's, adding a polish to the portrait studio's offerings. Pity that Hurrell did not stay long enough to work with Joan Crawford, when she came to the studio in 1945 after MGM dropped her contract. Crawford left (most of) the glamorous gal behind and, in the films she made at Warner Brothers, became one of Hollywood's greatest dramatic actresses. She did have the chance to work with Richee, but the two seemed to have lost their fire; Paramount's top photographer of the 1930s coupled with MGM's most vivid portrait subject produced only routine pictures together.

Mickey Marigold started shooting stills at Universal in the early 1930s before coming to Warner Brothers in about 1935, where he remained for more than a decade. Working at Warner's gave Marigold the opportunity to photograph future American president Ronald Reagan, in costume for perhaps his best known role as football hero Knute Rockne. Later, Marigold went to Republic Pictures, where he is recorded as working from 1948 to 1950.

Scotty Welbourne, a ten-year veteran of the studio, took the top job at Warner's in 1940 and stayed for five years. He specialised in the tough-guy realism that made huge stars out of Humphrey Bogart and James Cagney. Bert Six took Welbourne's post in 1945. He had been at Warner's for most of his career, taking stills, and was a favourite of Bette Davis. Floyd McCarty worked on the set of Warner's 1950s classics, *A Star Is Born* (1954) and *Some Like It Hot* (1959), as well as the three films that define James Dean's career and mythology, *East Of Eden* (1955), *Rebel Without A Cause* (1955) and *Giant* (1956).

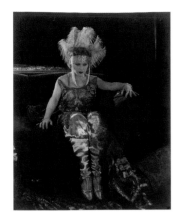

Mae Murray for *Gilded Lilly*, Paramount Pictures. ERNEST BACHRACH, 1921

Katharine Hepburn, RKO. ERNEST BACHRACH, 1935

King Kong, RKO. ROBERT COBURN, 1933

RKO

Only Ernest Bachrach at Radio Keith Orpheum had a career at one studio that rivalled Clarence Bull's tenure at MGM. He joined RKO at its inception in 1929 and stayed until Desilu purchased the studio in 1958. Before coming to RKO, Bachrach worked in New York for Famous Players—Lasky. In the mid-1920s Famous Players—Lasky was consolidated with parent Paramount Pictures and production was moved to Los Angeles. Bachrach worked independently for a short period and photographed many of the silent beauties, including Mae Murray and Gloria Swanson. According to Bob Coburn who, during the 1930s, assisted Bachrach in the RKO portrait studio, 'Gloria [Swanson] thought he was the only photographer in the world and when she came back out here to work, he came with her.'[14] His portraits of Swanson testify to her feelings about the quality of his work. 'Bachrach was an all-around man,' Coburn told Kobal. "He could do anything photographic."[15]

Katharine Hepburn was signed by RKO in 1932 and made fourteen films including *Bringing Up Baby* (1938) before she was dropped as 'box office poison' six years later. Bachrach made nearly all of Hepburn's portraits during this period and turned her angular, slightly androgynous and freckled face into an archetype of 1930s glamour. Bachrach's transformation of Hepburn's face, and the subtlety with which he photographed her through films as different as *Christopher Strong* (1933) and *Spitfire* (1934), are rivaled by the range of Hurrell's work with Joan Crawford. 'I used to pose a lot for Bachrach,' Hepburn told Kobal. 'I enjoyed it. The results amused me. He liked me, he liked to photograph me, and I enjoyed it. He was an awfully good photographer although I don't think the studio thought anything about it.'[16]

Beauties such as Carole Lombard, Michele Morgan, Ingrid Bergman and Betty Grable were also well served by Bachrach's camera when they worked at RKO. Lombard was under contract to Paramount during most of the 1930s before coming to RKO in 1939, where she made four films over two years. Coburn remembered that working with Lombard at RKO was 'fun and games. And she really knew what to do, she knew the techniques, where the lights went. She knew nothing would be wrong if I shot her. And they all knew you wouldn't let their bad points show. They trusted you.'[17]

Lombard had worked at Pathé Exchange before it merged with RKO in 1931 under the leadership of Joseph P. Kennedy. In the late twenties she was photographed extensively by William E. Thomas, who may have been employed by Pathé but more probably did contract work for the studio. Thomas served as a freelance photographer with many of the top studios during the 1950s.

Like Clarence Bull, Bachrach worked through the 1950s, giving him the chance to photograph a new generation of stars such as Marilyn Monroe and Clint Eastwood. With Monroe he managed to make an artfully contrived photograph seem as spontaneous as a snapshot. Eastwood, photographed in 1956 before he had been noticed by the public, preens before Bachrach's camera, revealing a side to the actor which is startlingly at odds with his later persona.

John Miehle was RKO's principal stills photographer and was responsible for almost every image of Astaire and Rogers dancing during their nine films at the studio. Alex Kahle and Gaston Longet also took stills and occasionally made portraits. Kahle is best known today for his photographs on the set of Orson Welles's *Citizen Kane* (1941) and *The Magnificent Ambersons* (1942), and he shot stills for many of Katharine Hepburn's RKO films. Along with assisting Bachrach, Bob Coburn occasionally shot stills at RKO, most memorably for *King Kong* (1933).

Marilyn Monroe being photographed by Frank Powolny, 20th Century Fox. UNIDENTIFIED FOX PHOTOGRAPHER, 1953

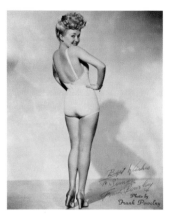

Betty Grable, 20th Century Fox. FRANK POWOLNY, 1943

Boris Karloff for *Frankenstein*, 20th Century Fox. ROMAN FREULICH, 1931

20th Century Fox

The Fox Film Corporation merged with 20th Century Productions in 1935, creating 20th Century Fox. Although Fox had been an on-going and successful business since 1914, it was the executives at 20th Century who took control of the new studio and kept their studio's logo, while adding the Fox name to the brand. The studio nourished a small group of stars that achieved great fame, including Alice Faye, Rita Hayworth and Marilyn Monroe.

Max Munn Autrey was Fox's first portrait photographer, joining in 1925 and remaining until 1933. He depicted Fox's early leading ladies in a particularly romantic guise. When he left Fox he worked independently, including as stills photographer for Charlie Chaplin's *Modern Times* (1936). Concurrent with Autrey's departure, Fox hired two new photographers, Otto Dyar and Gene Kornman. Dyar came from Paramount where he had been photographing ingénues, and Kornman previously worked on most of Harold Lloyd's now classic comedies from the 1920s. Kornman stayed at Fox until the mid-1950s, photographing the studio's wide range of talent, from Shirley Temple to Rita Hayworth, and in the 1950s he still showed fire behind the lens in his portraits of Marilyn Monroe.

Frank Powolny worked at Fox beginning in 1923 and continued until 1966, eventually serving as head portrait and still photographer. 'They used to say that still men were disappointed cameramen, but I don't think so.' Powolny was recounting with Kobal the pecking order among studio photographers with the exalted cinematographers occupying the top rung. 'I've known too many good still men who were just as good with a movie camera and who, like me, preferred still work. In my case, I suppose, it had a lot to do with my early training in painting and sculpture; there is the same problem – suggesting motion and story telling in a fixed pattern of light and shade.'[18]

Most of the top portrait photographers had a favourite subject or one whose images are closely identified with their work. In the case of Powolny the actress is Loretta Young, who was one of Fox's biggest stars of the 1930s. Young takes credit for Powolny's jump from still to portrait photographer. 'Powolny is the only one that I am conscious of spending any time with. I took him out of that candid stuff on the set and put him into the portrait gallery.' Although she liked him and he made some of her very best portraits, the name of another photographer lingered in the background. 'Just take a look at all those Hurrell things', Young told Powolny; '…that's what I like to look like.'[19]

Powolny is responsible for the most famous of all Hollywood portraits, at least the one most reproduced: Betty Grable's iconic image from 1942. Wearing a bathing suit, Grable was shot full length from the rear with her head coyly turned to the spectator. Powolny's photograph was circulated in the millions to soldiers during World War Two and made the actress the twentieth century's number one pin-up girl.

Universal

Unlike most other Hollywood studios in the 1930s that competed for audiences with sophisticated dramas and comedies, Universal became known for horror films. Two of the scariest horror films of the silent period were made at Universal, *The Hunchback of Notre Dame* (1923) and *The Phantom of the Opera* (1925), both starring Lon Chaney. It was in 1931, however, with the release of *Dracula* (1931) and *Frankenstein* (1931), that the name Universal became synonymous with this ghoulish genre. They were followed by *The Mummy* (1932) and *The Invisible Man* (1933), and sequels that played on into the 1940s.

Jack Freulich had been Universal's portrait photographer since the silent days, and had photographed Lon Chaney, as well as a young Bette Davis when she made her first three

Burt Lancaster and Ava Gardner for *The Killers*, 20th Century Fox. RAY JONES, 1946

Director Frank Borzage for *Men Of Tomorrow*, Columbia Pictures. A.L. 'WHITEY' SCHAEFER, 1934

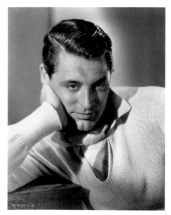

Cary Grant, RKO. ROBERT COBURN, 1935

pictures at Universal. The studio's apparent lack of interest in cultivating brand-name stars, however, meant that although Freulich was a skilful and elegant photographer, he rarely had the chance to photograph the great faces such as those found at MGM and Paramount. His brother Roman Freulich was the chief still photographer and seems to have had all the fun, taking many of the most memorable images of the 1930s such as his stills and on-set photographs of actors such as Boris Karloff and Bela Lugosi, artfully made-up as Frankenstein's monster or Count Dracula. Sherman Clark assisted with stills and served as the studio's general photographer for twenty years starting in the early 1930s, aside from a short stint at Paramount in 1932.

The name Ray Jones is practically synonymous with portraiture at Universal Studios. In 1935, the year after Jack Freulich's death, he took over the portrait studio and stayed until Universal closed the portrait gallery in 1958.[20] It was during Jones's tenure that Universal changed its policy and started putting stars under long-term contract. Marlene Dietrich and W.C. Fields were two Universal headliners during the early 1940s. Yvonne de Carlo and Burt Lancaster came later in the decade. Smouldering sex was never Ray Jones's stock in trade, but his portraits of Lancaster and Ava Gardner for *The Killers* (1946) sizzle.

Columbia

Like Universal, Columbia was late in gathering up stars. When the studio began hiring in earnest in the mid-1930s, Columbia succeeded admirably, adding Cary Grant, Irene Dunne, Loretta Young, William Holden and most notably Rita Hayworth. A.L. 'Whitey' Schafer photographed them all before leaving Columbia in 1941 to take the top job at Paramount. William Fraker, Jr. was Columbia's first portrait photographer beginning in the late twenties and remaining until his death in 1934, and was the uncle of Bud Fraker who shot stills at Paramount.

The photographer most closely identified with Columbia is Bob Coburn, who came to the studio from RKO in 1941 having also worked for two years (1935–36) for Samuel Goldwyn, and stayed until the 1950s. 'Bachrach taught me … to never take a straight shot. We always cocked the cameras. We'd either sit on our butts and shoot up or something, or turn the camera. We'd go for the composition of the picture and make something interesting out of it rather than what we call "the company front".'[21] Kobal's interview with Coburn was one of the most interesting and illuminating interviews among the many photographers he visited. Coburn was described by Kobal as resistant to talking about the past, but when he opened up he brought to life something of what really happened during portrait sessions. Describing his work with Merle Oberon, Coburn recalled, 'She'd sit there with very little makeup on, and I'd start painting her face with light.'[22] He also discussed the long hours necessary to come up with the one essential photograph: '… you had to shoot a lot of film to get a good one; you can't just depend on that *one shot* to be good to get that expression on a Hayworth or an Oberon that would get everybody excited about them.'[23]

Gilda ranks as one of the finest film noir classics, and its place in film history depends largely upon Rita Hayworth's portrayal of the title character. Hayworth's beauty and her dancing ability made her Columbia's top star for a decade. While working with Fred Astaire on *You'll Never Get Rich*, *Life* photographer Bob Landry photographed Hayworth at the studio, at the beach and in her apartment. So good were the photographs that Hayworth got the magazine's cover for the week of 11 August 1941, and one of the images reproduced shows the actress kneeling provocatively on her bed wearing a silk and lace slip. Like Powolny's portrait of Grable, this photograph caught the attention of American GIs and became the second-most reproduced pin-up of the war years (and perhaps of the century).

Rita Hayworth, Columbia Pictures.
BOB LANDRY, 1946

Clara Bow. NICKOLAS MURAY, circa
1925

Lillian Gish. JAMES ABBE, 1925

When Hayworth started to show troubling signs of middle age, Columbia chief Harry Cohn decided that Kim Novak would became his studio's new sex goddess. She had neither the talent nor the beauty of Hayworth, but she managed over a dozen years beginning in 1955 to become a popular leading lady, if not quite a major star.

There are many Hollywood photographs, even those reproduced time and again, where the name of the maker has been lost. The most famous of these mysteries concern stills made for two Columbia films. Few images conjure better the rebellious youth of the 1950s than the photograph of Marlon Brando seated confidently astride a motorcycle that was taken as publicity for *The Wild One* (1953). Irving Lippman served as still photographer on the film and Robert Coburn shot portraits, but it is impossible to credit either man with assurance. Even more of a mystery is the sensational series of portraits taken of Elizabeth Taylor on the beach in a white bathing suit for *Suddenly Last Summer* (1959).

As Kobal learned from his many conversations with the surviving stillsmen, in the end it was a special relationship between photographer and subject that engendered the best results. 'There are things it's hard to explain, John,' Coburn recounted, 'how you get people to do things, to respond. You work with them a lot; they became like your second nature sometimes. I'd be talking and telling them things and be focused all the time, having everything ready to shoot, so that when I got what I wanted, I shot like a madman. Film was cheap.'[24]

Independent Photographers – New York

For many stars or would-be stars the journey to Hollywood began in New York City. Brooklyn-born Clara Bow won a beauty contest sponsored by *Motion Picture* magazine that promised the winner a role in a movie. Several film parts followed, all shot in New York, and during that time she started seeking out the finest portrait photographers, including Nickolas Muray. Her career took off when she was offered a contract with Preferred Pictures (later Paramount) which necessitated a move to Los Angeles.

Charles Albin was a New York society photographer, and his superb portraits of Mary Astor made when she was sixteen are rumoured to have been her ticket to movie stardom.

Likewise, Arnold Genthe's masterful portraits of Garbo made in New York during the summer of 1925 are often credited as awakening MGM to the young actress's potential. It is an attractive myth, but Garbo was already cast in her first MGM film before she even met Genthe. Mary Pickford was among the Hollywood stars to patronise Adolph de Meyer during the decade (1912–22) when he worked primarily in New York.

New York's bustling theatre and nascent movie industries supported a thriving coterie of portrait photographers. Irving Chidnoff and Herbert Mitchell were two of the most successful. Marlene Dietrich was among the hundreds of hopefuls who passed through New York on their way to Hollywood and took time to have Chidnoff make portraits. Among New York photographers, James Abbe worked more closely with the movie industry than did his colleagues and he was always ready to follow his clientele, working, as the need arose, in California or Europe.

British photographer Cecil Beaton was enthralled by the Hollywood life and took his first trip to southern California in the early 1930s to make portraits for *Screenland* magazine. As she had been for many photographers, Garbo was his goal. He would have to wait until 1946 before finally being allowed to photograph the great face. Away from the movies for five years and living quietly in New York, Garbo was considering returning to film work. Making his first post-war visit to New York, Beaton had been lured by a lucrative contract from *Vogue* to shoot fashion photographs. Hearing he was in New York, Garbo asked the eager Beaton to

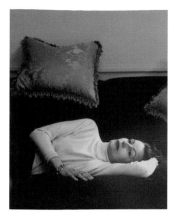

Greta Garbo. CECIL BEATON, 1946

William S. Hart. NELSON EVANS, 1920

The Ten Commandments, Paramount Pictures. EDWARD SHERIFF CURTIS, 1923

take her passport photograph – and, as it turned out, dozens more – and the results of an afternoon's work revealed that Garbo's thrilling beauty was hardly diminished.

George Hoyningen-Heune was, like Beaton, a well known fashion photographer. He was based in New York but occasionally worked in Hollywood, particularly when called on by director George Cukor throughout the 1950s and early 1960s. In Hollywood he photographed Ava Gardner during the filming of *Bhowani Junction* (1956) and Marilyn Monroe shooting *Let's Make Love* (1962).

Independent Photographers – Los Angeles

The *Film Daily 1928 Yearbook* lists more than three dozen independent photographers working in Los Angeles and supporting the rapidly growing film industry. One name that does not appear on the list is Nelson Evans, who was among Hollywood's first photographers. Kobal examined Evans's career in detail in his book *Hollywood: The Years of Innocence*. Recorded working by 1915, within a decade Evans had vanished; Kobal did not speculate on the reason but merely asked, 'Who was he? What happened to him?'[25] Evans left an extraordinary photographic legacy, recording Hollywood at work and at play, making portraits as well as photographing the ever-changing city of Los Angeles. Pickford and Swanson were among his subjects, as were the first cowboy stars Tom Mix and William S. Hart. Little, too, is known about Arthur Rice, who photographed Valentino in 1921 and 1922 and Keaton during the same period.

Among that list of independents were a select few favoured by the stars of the burgeoning movie industry. Albert Witzel's work with Theda Bara in 1917 might well establish that he was Hollywood's first proper glamour photographer. Working at the same time was Walter Frederick Seely. Like Witzel he enjoyed a decade of popularity with the stars, before publicity was moved within the studio's walls where it could be tightly controlled. Melbourne Spurr lasted a bit longer than the others, in part because he was a well liked ladies man. His work also kept pace with the changes emanating from the studio's galleries, and into the 1930s Spurr could be counted on to provide top-notch work for actors who were outside the protection of a studio.

Mary Pickford, who served as producer on many of her films, hired Knute Olaf Rahmn to make her portraits and to shoot scene-stills. So completely did she monopolise Rahmn that his credit has only been found on publicity for Pickford's films. Portraits and stills for Charlie Chaplin's early shorts and features, on the other hand, are rarely credited, so we lack the name of the photographer for some of the most enduring images of early Hollywood.

A few photographers had tight professional relationships with directors, such as George Cannons who worked primarily for Mack Sennett. Harry Lachman, a successful painter living in Paris, was hired by MGM director Rex Ingram to assist with *Mare Nostrum*. Ingram brought Lachman to Hollywood where he worked sporadically as a photographer, including a stint on the set of MGM's first great hit, *Ben-Hur* (1925).

It is hard to imagine that Edward Sheriff Curtis, the first authority on and famous chronicler of the American Indian, with J. Pierpont Morgan as a onetime patron, would arrive in Hollywood virtually penniless. To pay off the debts from a crippling divorce, Curtis worked as a cameraman and stills photographer for Cecil B. De Mille on *The Ten Commandments* (1923) and other films. After five years, Curtis left Hollywood in 1927 to resume his earlier work. William Mortensen, who went on to write many important books about photography, also worked for De Mille shooting artistic stills and portraits for *King of Kings* (1927).

Thomas Meighan for *Male & Female*, Paramount Pictures. ARTHUR KALES, 1919

Farley Granger for *The North Star*, Samuel Goldwyn Company. MARGARET BOURKE-WHITE, 1943

Charlton Heston. YOUSEF KARSH, 1957

Two more photographers who worked with De Mille would go on to achieve great fame: Karl Struss in Hollywood as an Academy Award winning cinematographer for *Sunrise* (1929), and Arthur F. Kales as a leader in the photography movement known as California Pictorialism. Struss and Kales were both hired by De Mille when he was shooting *Male and Female* (1919), starring Gloria Swanson. The extravagant budgets accorded early De Mille productions, especially when working with stars in the order of Swanson, allowed equally excessive publicity. Struss and Kales each rendered their subjects with an atmospheric sensuality that must have seemed radical in pre-roaring-twenties Hollywood portraiture.

Producer Samuel Goldwyn, who remained independent of Hollywood's studio system, nevertheless was in need of portrait and stills photographers. Kenneth Alexander worked on most Goldwyn projects from about 1925 to 1935 and occasionally he would take on contract work with one of the major studios. More recently, Margaret Bourke White, well known photographer for Life and the first woman to work as a war photographer, took a break in 1943 to take portraits and set shots for Goldwyn's *The North Star* (1943), which, given the day's politics, provided something of an idealised view of Soviet life.

After the onset of the studio system, which by 1930 brought nearly all stills and portrait photography under the watchful eyes of the moguls and their publicity chiefs, there remained a small group of independent photographers who worked contractually or on special projects. Russell Ball preferred freelance working at various times in New York City and Hollywood. In the mid-1920s Ball had a studio on West 49th Street in New York, where he made Garbo's (practically unrecognisable) first American portraits. These photographs, which rarely have a credit stamp, are usually attributed to Ruth Harriet Louise. Ball moved to Hollywood in 1927, where he worked for a short time at MGM. This gave him a second opportunity to photograph Garbo. Once again, his photographs are generally attributed to Louise. Examples from both sessions were published by Kobal with credit to Louise.[26] After leaving MGM, Ball became a popular photographer with performers who were working in independent productions such as films distributed through United Artists.

Henry Waxman was a favourite of early stars such as Mae Murray and Lillian Gish, and was hired by both to shoot portraits when they worked at MGM, breaking the rule that largely excluded outside photographers. Lansing Brown also made a good living independently of the studios, although the death of singer Russ Columbo from a shot fired from an antique pistol at Brown's house somewhat curtailed his activities within the tight-knit world of Hollywood. Details of the shooting were never fully described, but Brown was exonerated.

British-born Davis Boulton was among the first transatlantic photographers, dividing his time over three decades between London and Hollywood. In the 1950s Leo Fuchs, who was born in Vienna, worked on many American projects filming in Europe, before being brought to the United States by Rock Hudson in 1960.

It is surprising, given his extraordinary corpus of portraits of major twentieth century figures, that Yousef Karsh photographed so few film stars. Ottawa-based, Karsh frequently travelled to the United States. While in Los Angeles in 1956, he photographed Charlton Heston, out of costume, during the filming of *The Ten Commandments* (1956).

Alongside the official Hollywood portrait machine was a smaller industry specialising in risqué photographs, generally of young women with dreams of silverdust. Edwin Bower Hesser, who had a good business making traditional portraits of his subjects, also made intimate and revealing drape-shots. In order to ensure that his work was seen as artistic and not prurient, he published a magazine boldly titled *Edwin Bower Hesser's Arts Monthly Pictorial*. Before she became a great MGM star, Jean Harlow was one of his subjects, and they had a memorable session together in 1929 at Los Angeles's Griffith Park. Harlow can be seen variously seated on rocks, wading in a shallow pool or standing arms outstretched. Men

Jean Harlow, Los Angeles. EDWIN BOWER HESSER, 1929

Marilyn Monroe, Los Angeles. TOM KELLEY, 1949

escaped this sort of exposure for, with rare exceptions, it was unusual for male subjects to be photographed with as much as a shirt unbuttoned. Ramon Novarro was the single exception in twenties Hollywood, and in long portions of *Ben-Hur* (1925) and nearly all of *The Pagan* (1928) he sports a loin-cloth. When in Italy to shoot *Ben-Hur* he was persuaded by the Rome-based avant-garde photographer Anton Giulio Bragaglia to pose nude. Other such works, if made by American photographers, remain discreetly hidden.

Little had changed for the girls when Marilyn Monroe agreed, twenty years later in 1949, to pose for Tom Kelly, who specialised in calendar art. Like Harlow, she was working in bit parts when her photographs were taken. Unlike Harlow, who was married to a wealthy man, she was broke and needed the day's pay. Monroe's financial situation would begin to change the next year, when she was cast for *The Asphalt Jungle* (1950) in a small but significant role that helped ignite her career.

Marilyn Monroe was not a subject that Kobal collected with much enthusiasm. Harlow, on the other hand, counted for scores of original prints and negatives. Each was a blonde, beautiful and talented actress who embodied her era's ideal of female sensuality. Harlow epitomised glamour and her photographs radiate an otherworldly glow. Monroe too projected glamour, but it was a thin coating that quickly melted under the force of her personality. It would be a waste of our time to search the glittering surfaces of Harlow's portraits for melancholy or a premonition of the illness that took her life at the age of twenty-six. Monroe, on the other hand, was transparent before the camera, and the products of her portrait sessions continue to be scrutinised for signs of the trouble that led to her untimely death. Glamour protected the screen goddesses of an earlier era, enabling Garbo, Dietrich, Swanson and Harlow, behind an impenetrable veneer, to live largely private lives. Once upon a time moviegoers wanted actors and actresses to be bright and shining yet remote and distant – that is why they were called stars. Later, audiences changed, and the stars followed suit. Kobal showed us this earlier world, that had lasted nearly half a century, in dozens of his books and exhibitions. For Kobal the silent era produced the 'titans' and in the 1930s they were followed by the 'gods'.

1 For a discussion of the Bull-Garbo sessions see: Pepper and Kobal, *The Man Who Shot Garbo*,
 London: Simon and Schuster, 1989, pp.21–25.
2 Kobal, *Art*, p.95
3 Ibid, p.94
4 Kobal, *Gable*, p.103
5 Kobal, *People*, p.378
6 Ibid
7 Ibid, p.379
8 Kobal, *Gable*, p.103
9 Kobal, *Art*, pp.55–56
10 John Kobal, *Hollywood Glamour Portraits: 145 Photos of Stars 1926-1949*, p.xi
11 Kobal, *People*, p.347
12 John Engstead, *Star Shots*, New York: E.P. Dutton, 1978, p.27
13 Kobal, *Art*, p.63
14 Kobal, *People*, p.345
15 Ibid, p.342
16 Ibid, p.330
17 Ibid, p.349
18 Kobal, *Art*, p.78
19 Kobal, *People*, p.400
20 Tom Zimmerman, *Light and Illusion: The Hollywood Portraits of Ray Jones*, Glendale: Balcony Press, 1998, p.41
21 Kobal, *People*, p.346
22 Kobal, *Art*, p.120
23 Kobal, *People*, p.349
24 Ibid
25 John Kobal, *Hollywood: The Years of Innocence*, London: Thames and Hudson, 1985, p.190
26 For example see Kobal, *Art*, pp.143 and 145

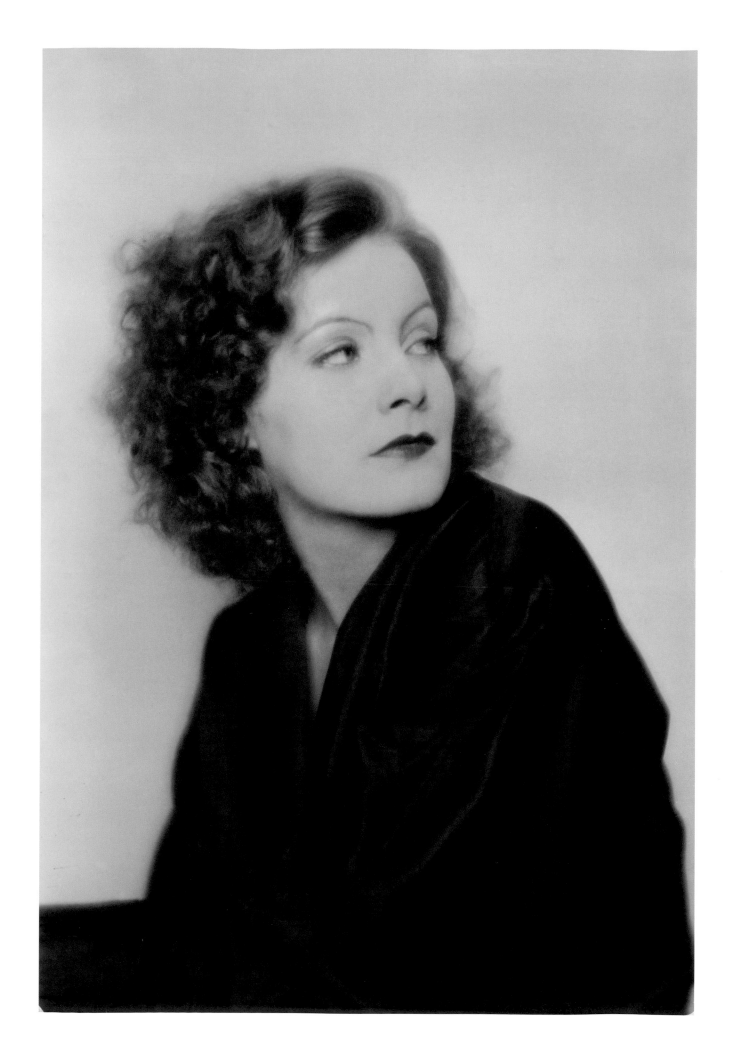

Greta Garbo for *Love*, MGM. RUSSELL BALL, 1927

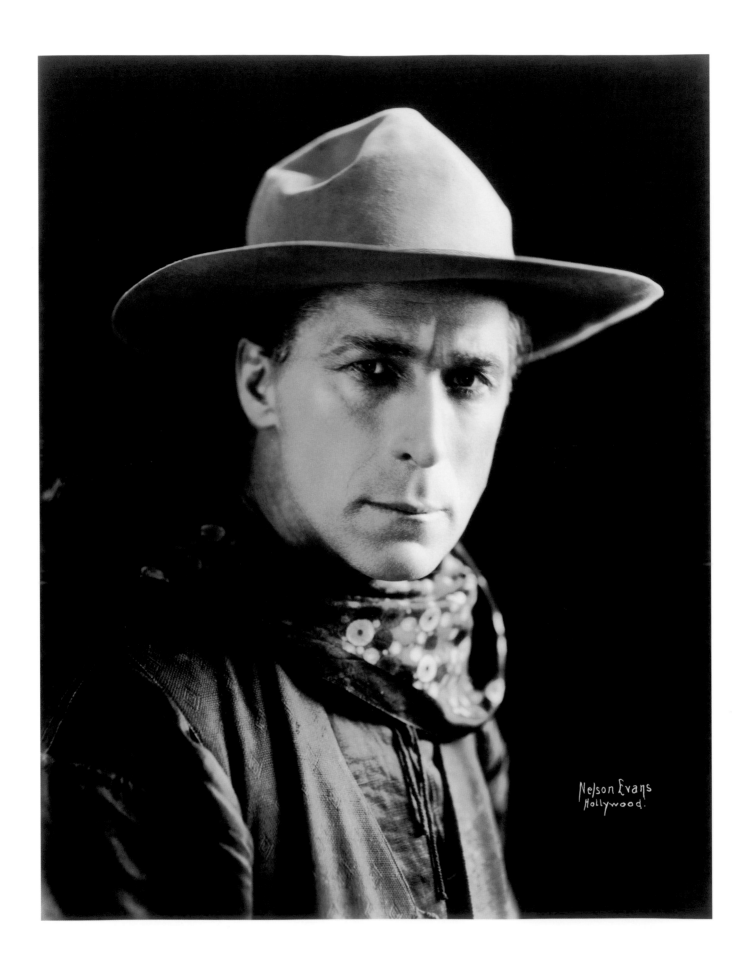

William S. Hart. Nelson Evans, 1920

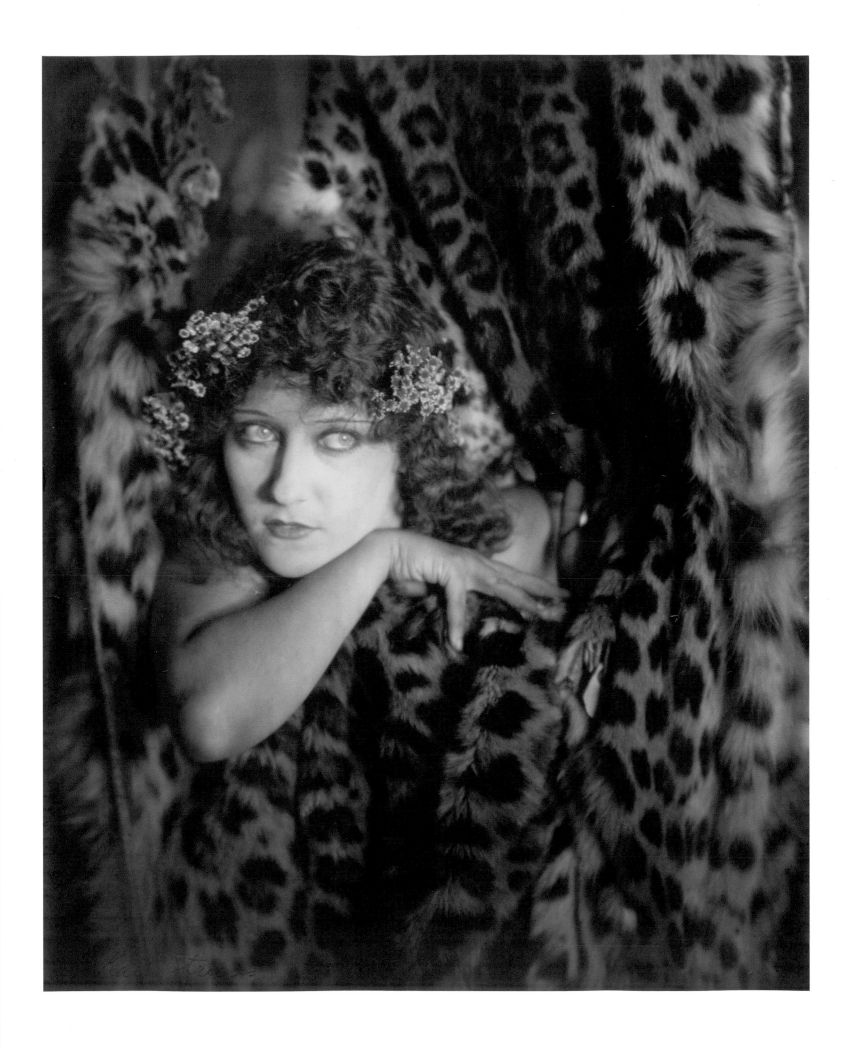

Gloria Swanson for *Male and Female*, Paramount Pictures. KARL STRUSS, 1919

Mary Astor. CHARLES ALBIN, circa 1920

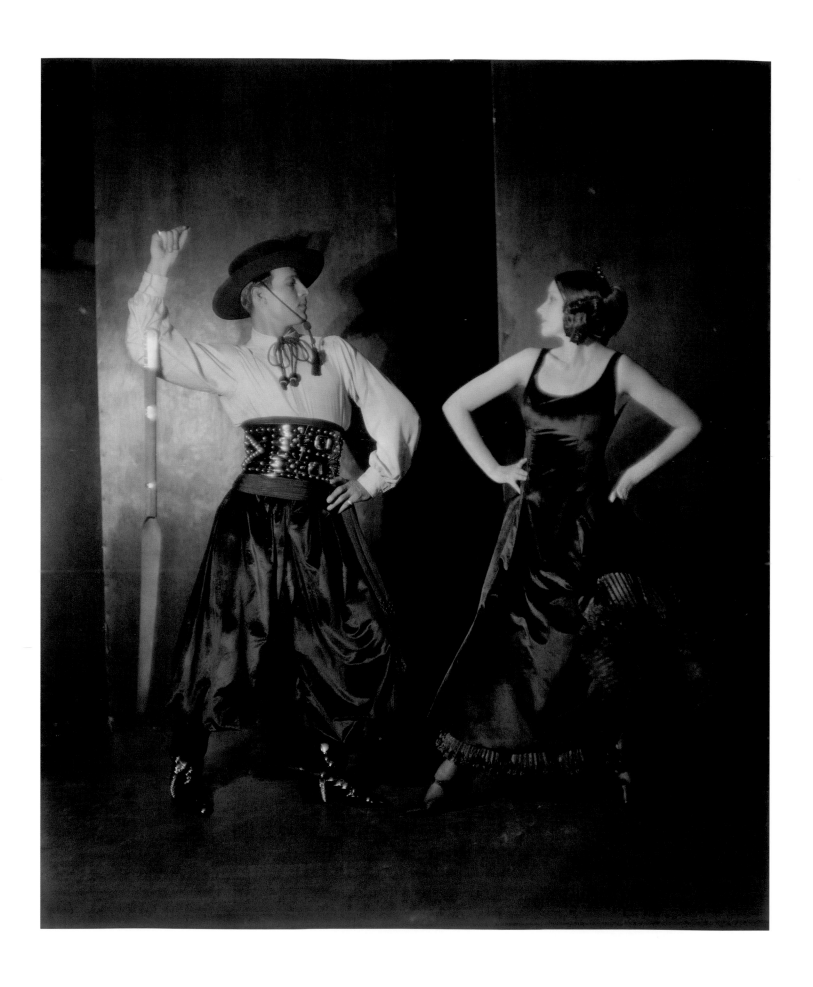

Rudolph Valentino and Natasha Rambova for *The Four Horsemen of the Apocalypse*, Metro. ABBE, 1921.

43 Charlie Chaplin and Jackie Coogan for *The Kid*, Charles Chaplin Productions. UNIDENTIFIED PHOTOGRAPHER, 1921

Mae Murray for *Gilded Lilly*, Paramount Pictures. ERNEST BACHRACH, 1921

44

Norma Talmadge for *The External Flame*, First National. ABBE, 1922

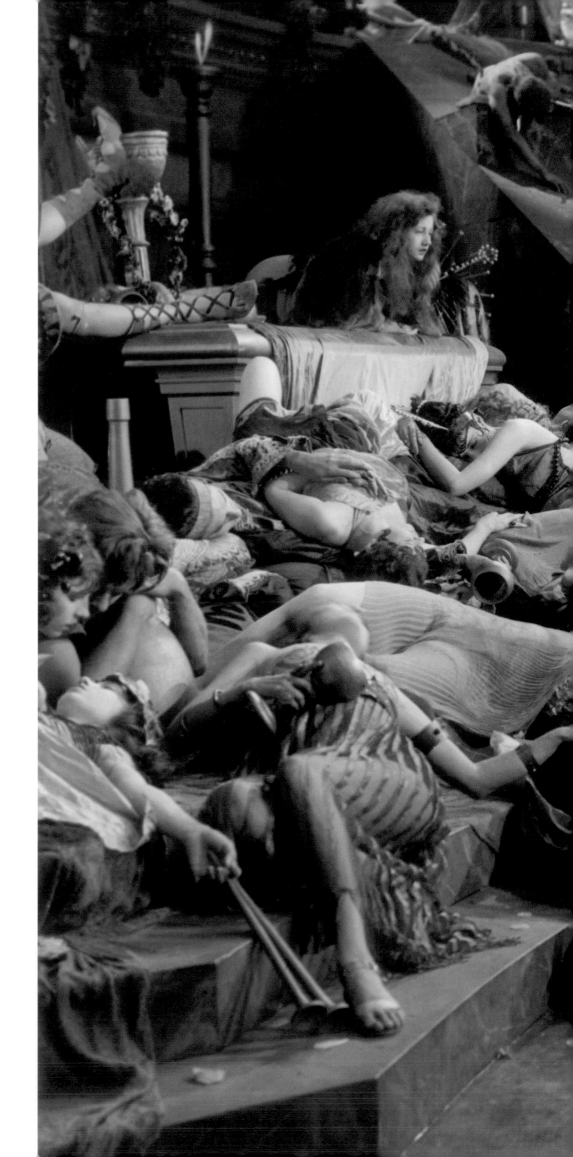

Manslaugher, Paramount Pictures.
DONALD BIDDLE KEYS, 1922

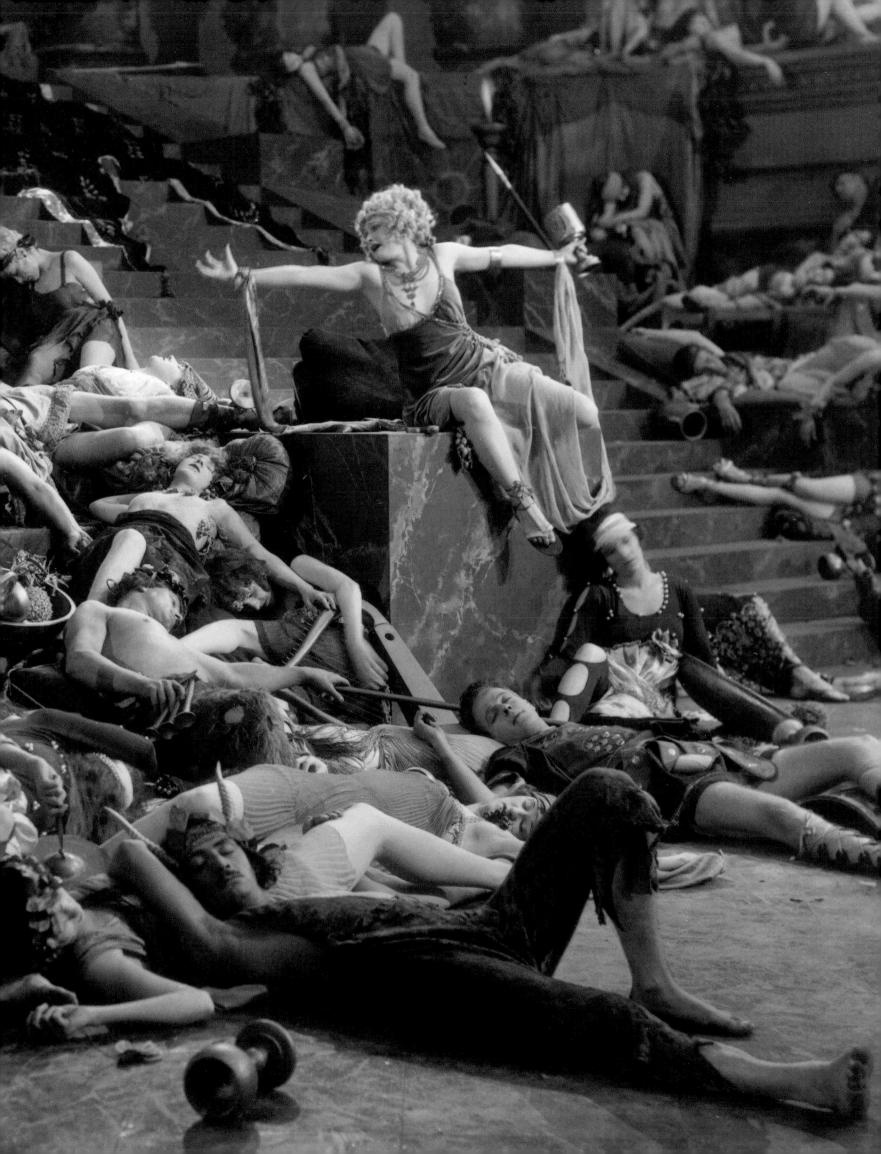

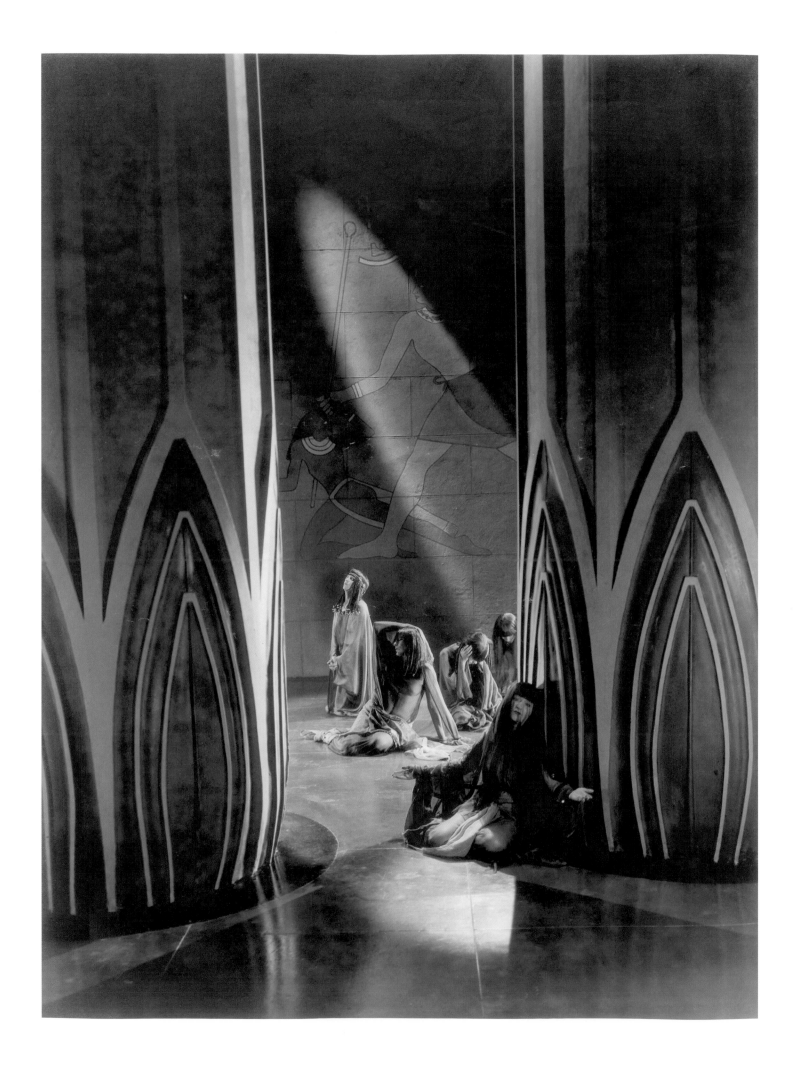

The Ten Commandments, Paramount Pictures. EDWARD SHERIFF CURTIS, 1923

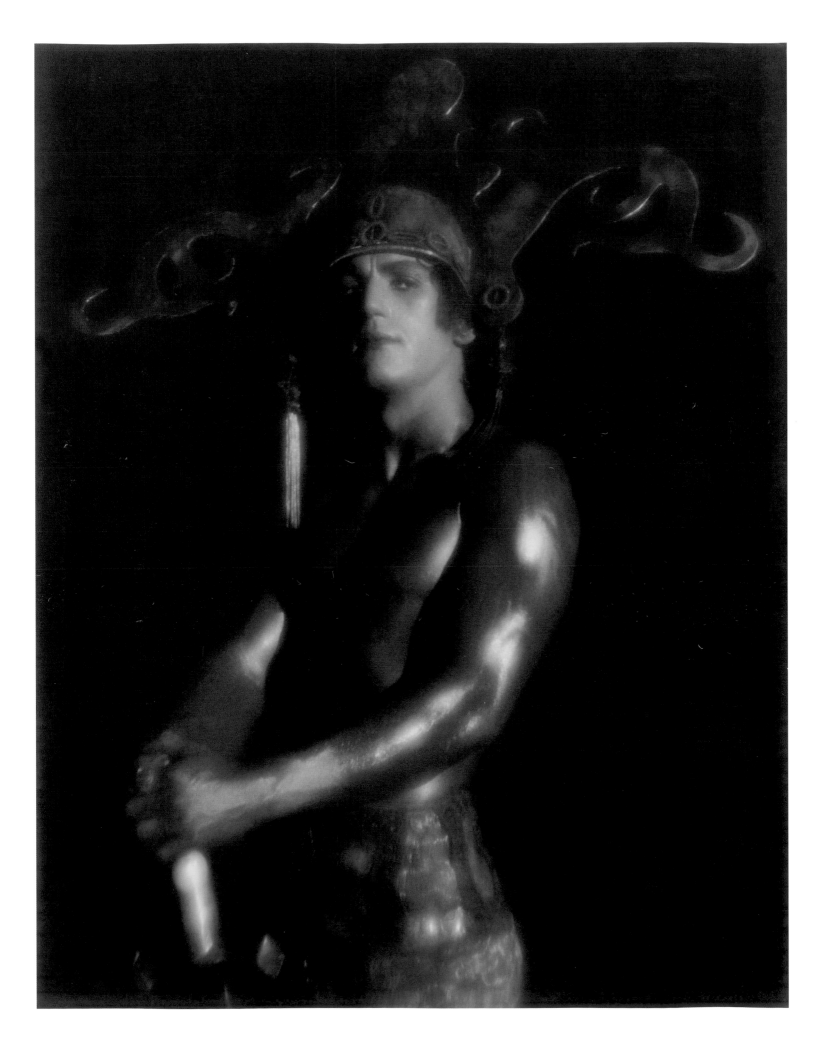

Thomas Meighan for *Male & Female*, Paramount Pictures. ARTHUR KALES, 1919

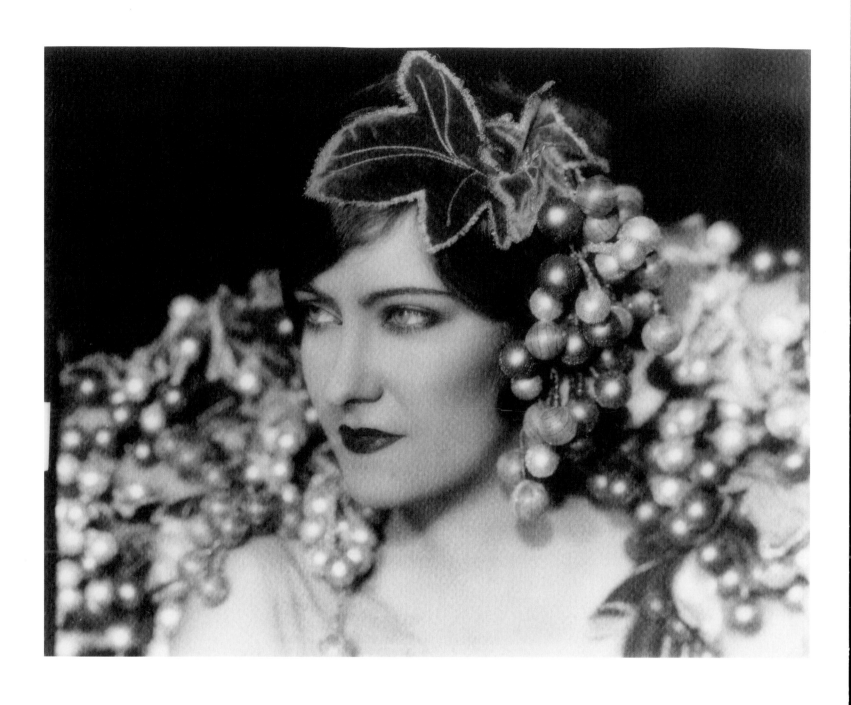

Gloria Swanson for *The Humming Bird*, Paramount Pictures. ERNEST A. BACHRACH, 1924

Leatrice Joy. MELBOURNE SPURR, 1923

Anna May Wong. EUGENE ROBERT RICHEE, circa 1924

Greta Garbo, MGM. Russell Ball, 1925

MPGP-7408

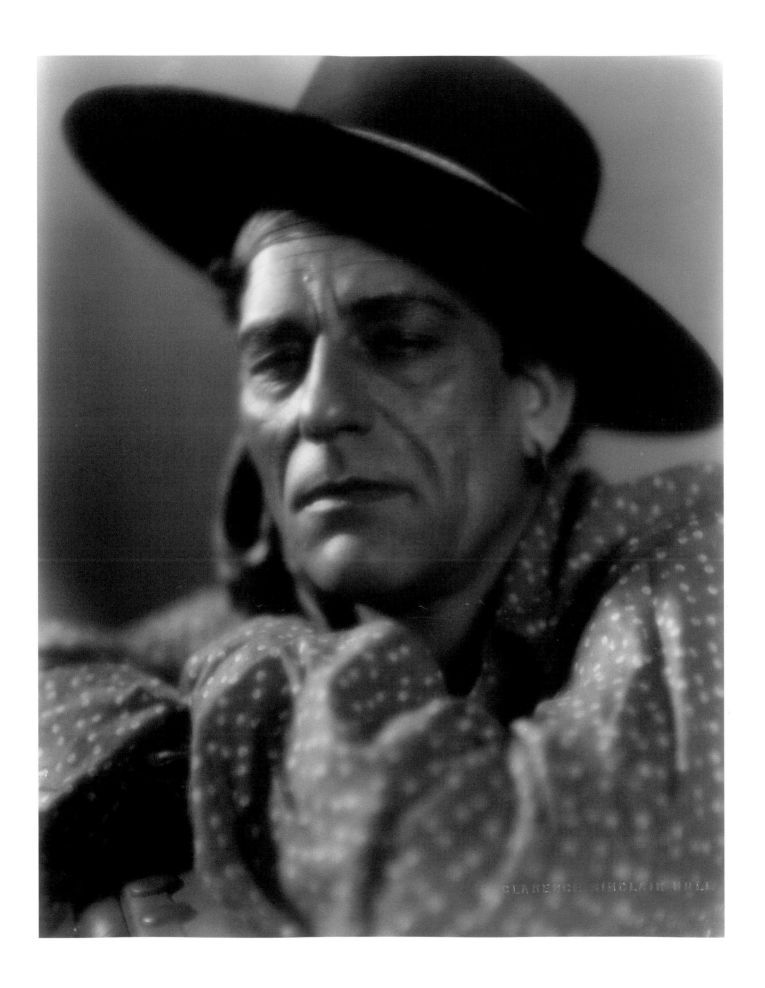

Lon Chaney for *The Unknown*, MGM. Clarence Sinclair Bull, 1927

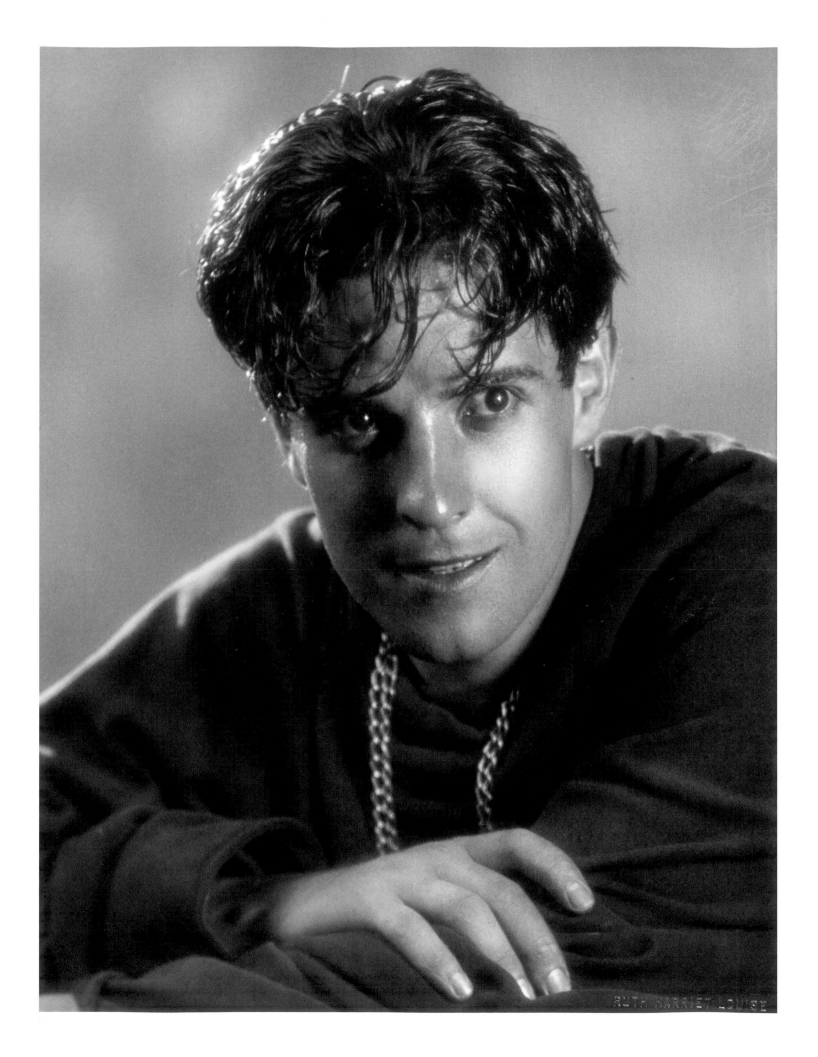

Ramon Novarro for *Ben-Hur*, MGM. RUTH HARRIET LOUISE, 1925

PUB 161

Rice

Buster Keaton. ARTHUR RICE, 1925

Harry Langdon, Mack Sennett Studio. MELBOURNE SPURR, 1925

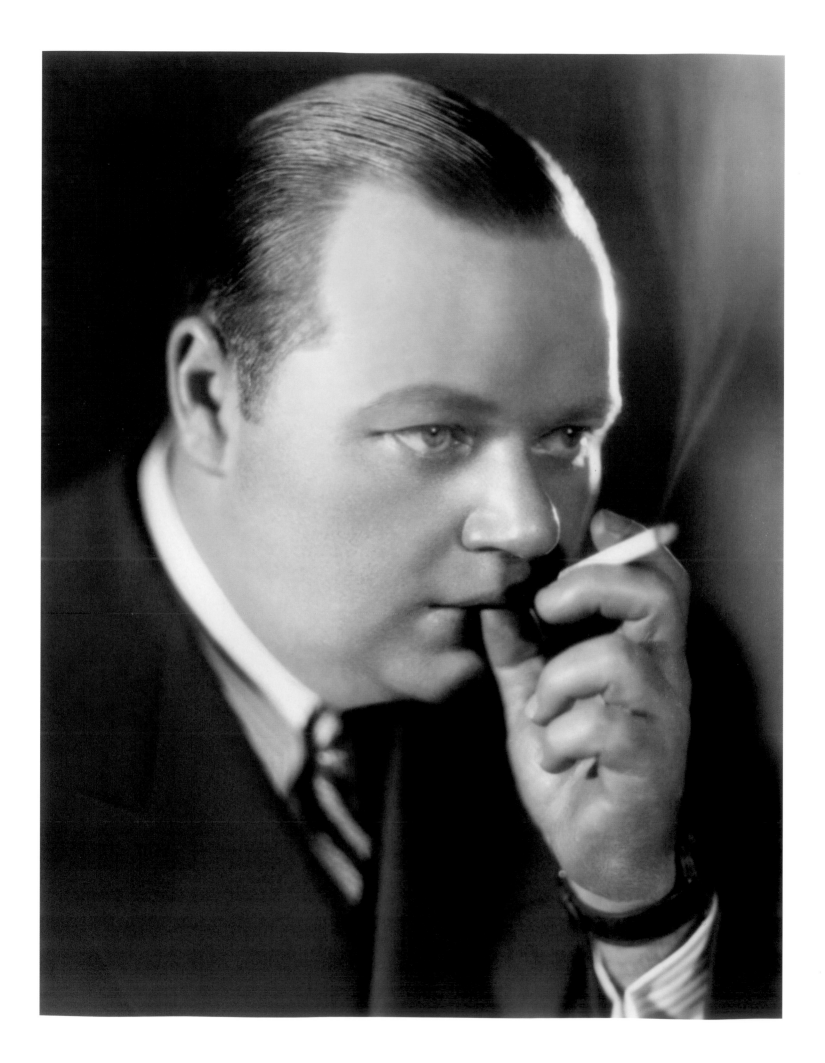

Fatty Arbuckle. HERBERT MITCHELL, 1925

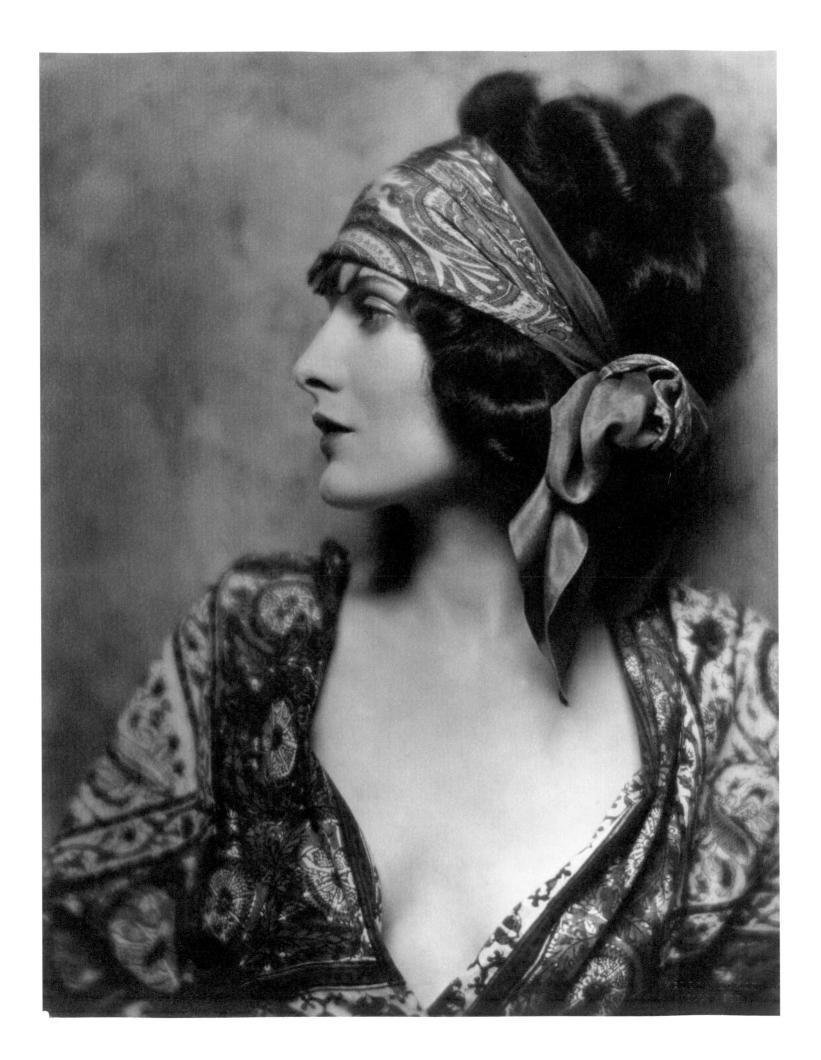

Evelyn Brent. Henry Waxman, circa 1925

To John—
Good luck—good health
and "God bless".
Sincerely
May McAvoy

May McAvoy. RUSSELL BALL, 1925

Lillian Gish. JAMES ABBE, 1925

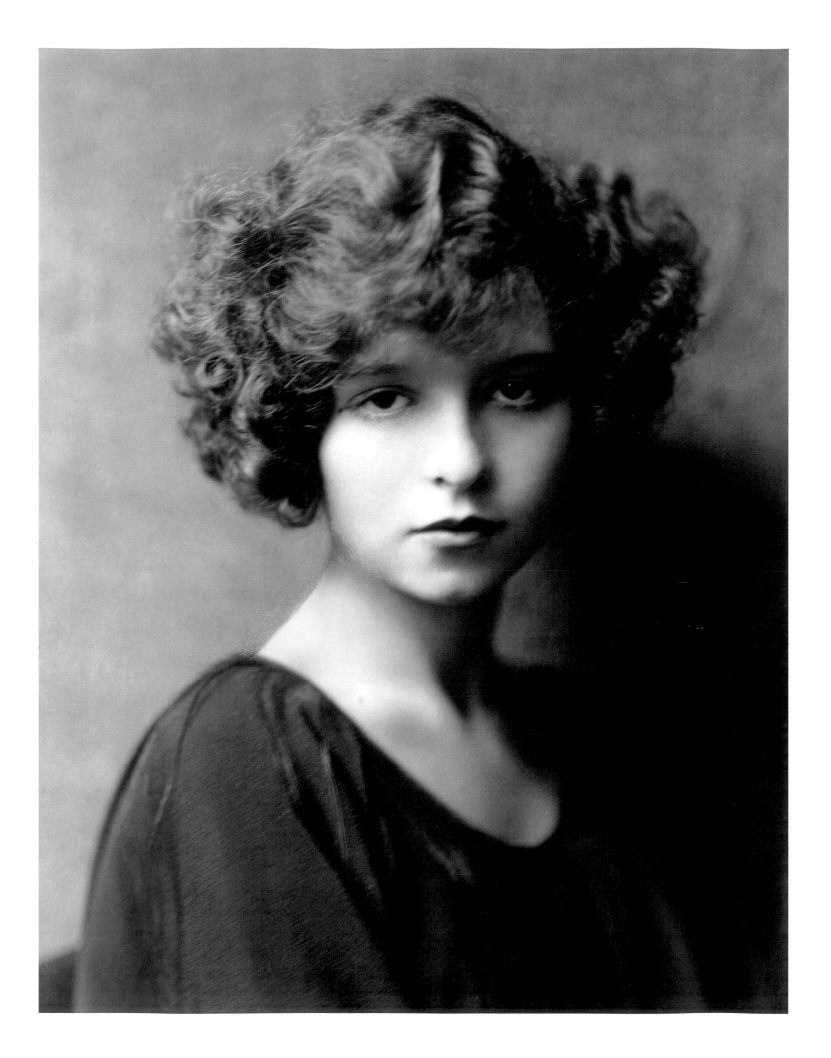

Clara Bow. Nickolas Muray, circa 1925

Ramon Novarro for *Ben-Hur*, MGM. Harry Lachman, 1925

810·284·S

2-284·S

Nita Naldi for *Cobra*, Paramount Pictures. Unidentified photographer, 1925

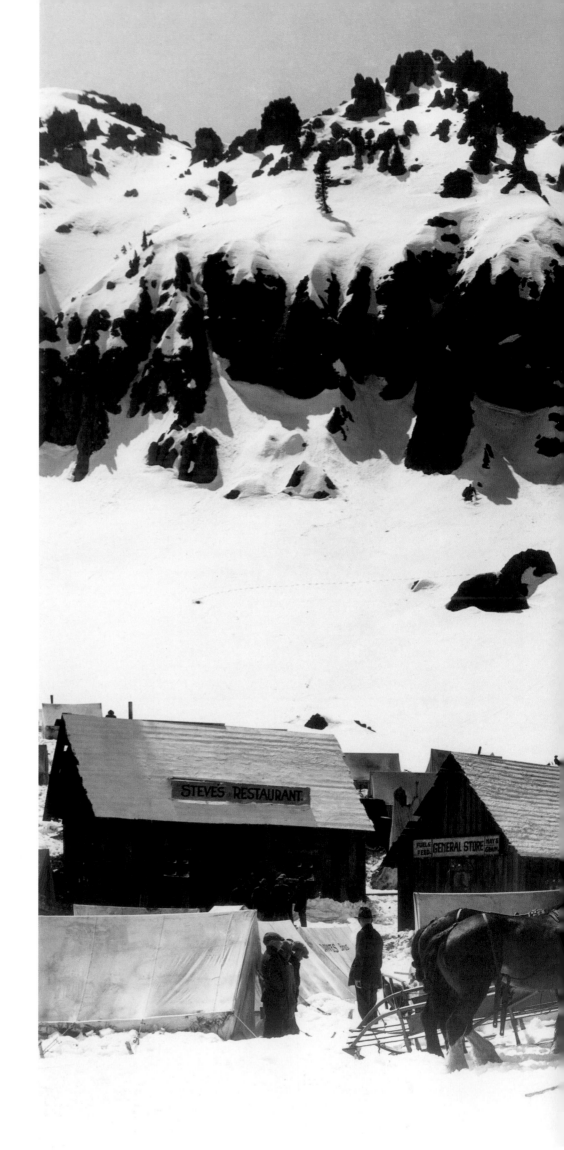

The Gold Rush, United Artists.
UNIDENTIFIED PHOTOGRAPHER, 1925

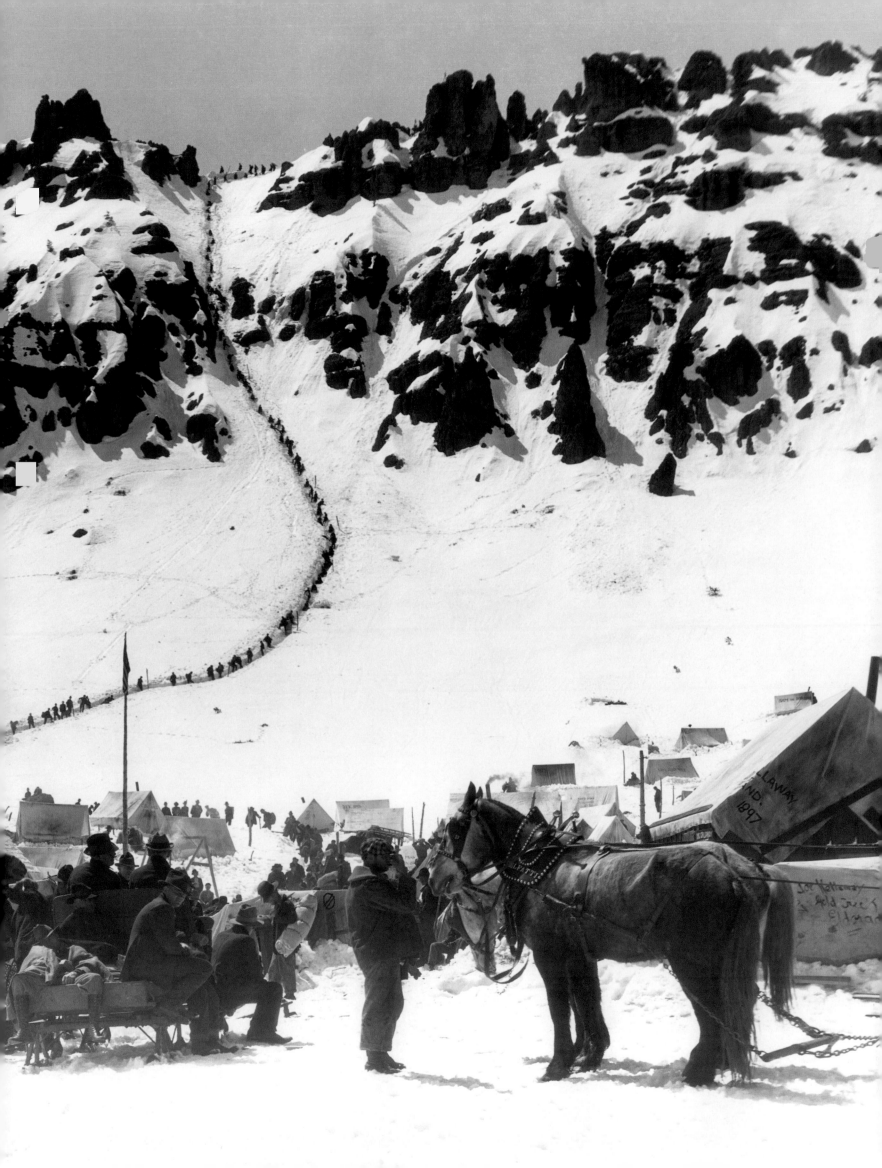

Ramon Novarro for *Ben-Hur*, MGM. ANTON GIULIO BRAGAGLIA, 1925

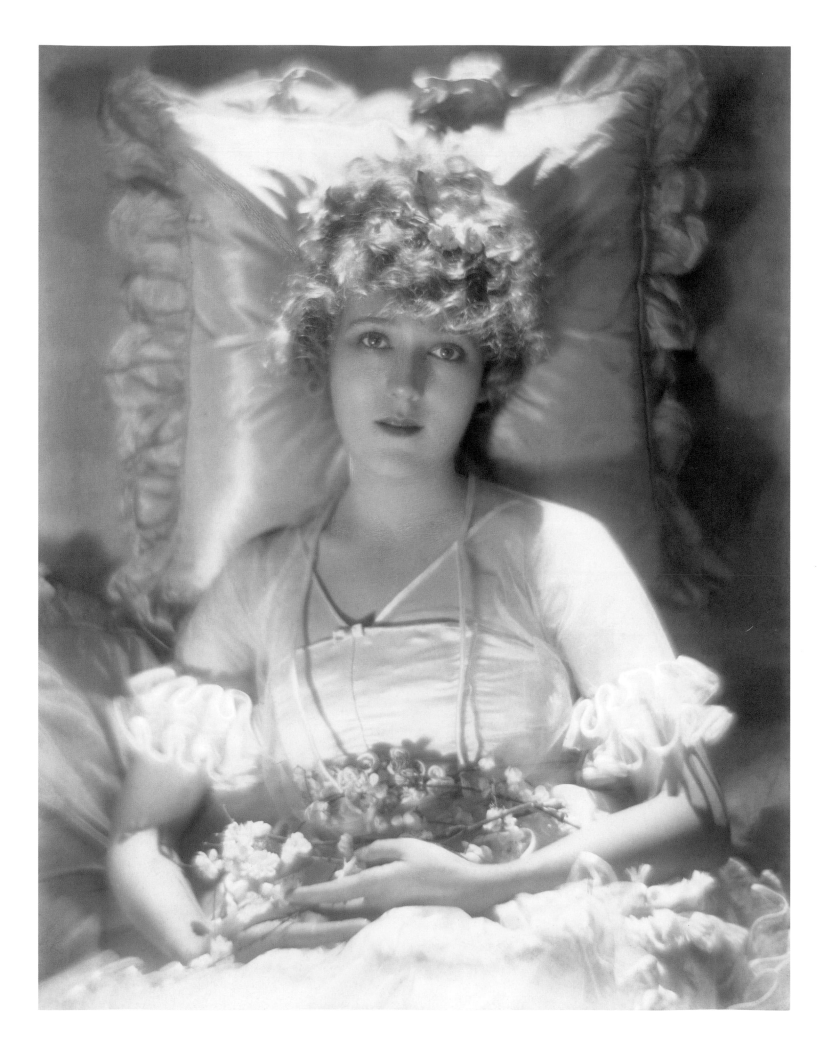

Mary Pickford. Adolph de Meyer, 1925

200-691

Ben-Hur, MGM.
UNIDENTIFIED MGM PHOTOGRAPHER, 1925

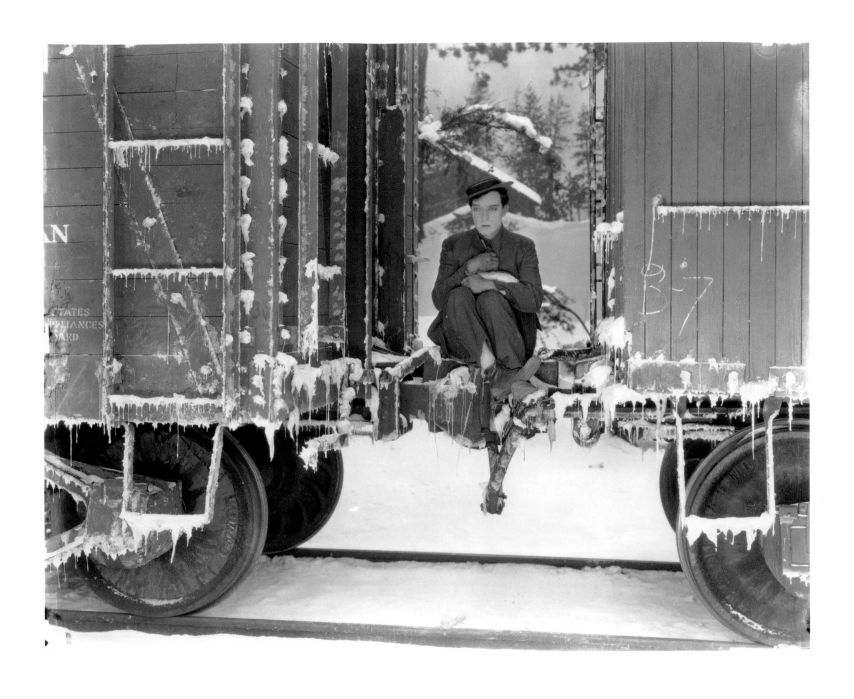

Buster Keaton for *Go West*, MGM. ATTRIBUTED TO JAMES MANATT, 1925

Stan Laurel and Oliver Hardy. Lansing Brown, 1925

Greta Garbo. ARNOLD GENTHE, 1925

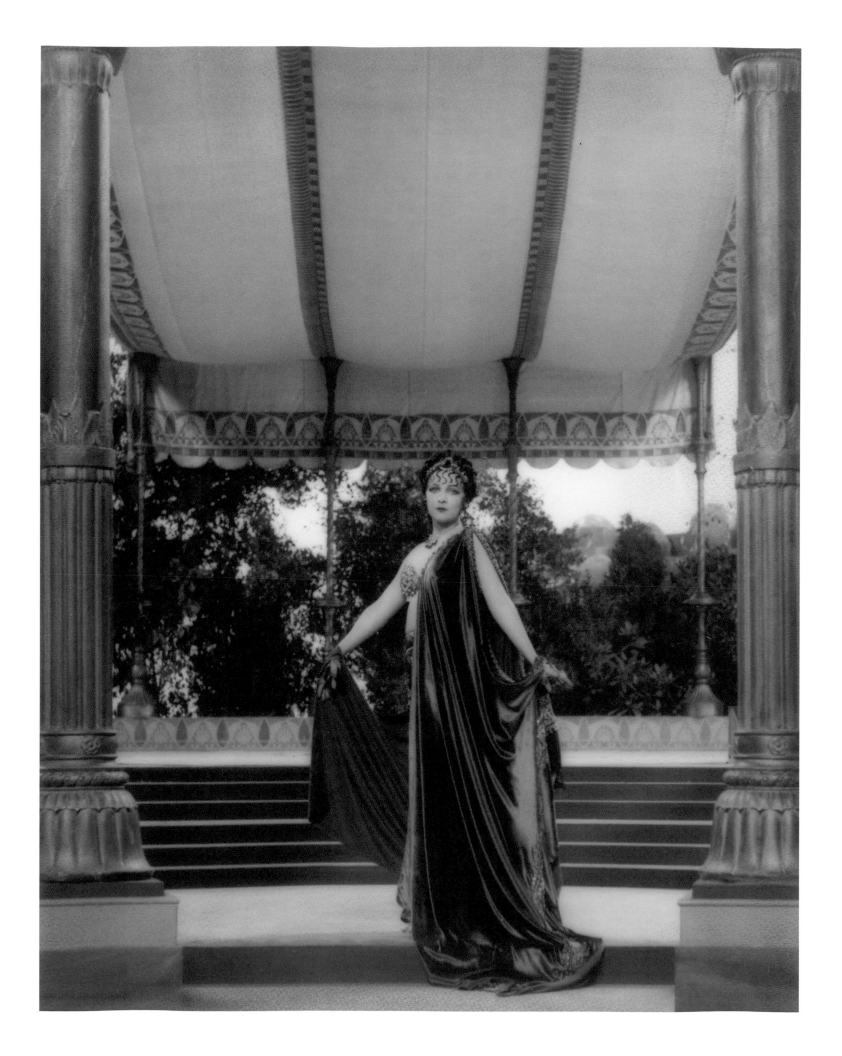

Jacqueline Logan for *King of Kings*, DeMille Pictures. WILLIAM MORTENSEN, 1927

Ronald Colman and Vilma Banky for *The Magic Flame*, Samuel Goldwyn Company. KENNETH ALEXANDER, 1927

Ronald Colman and Vilma Banky for *The Magic Flame*, Samuel Goldwyn Company. KENNETH ALEXANDER, 1927

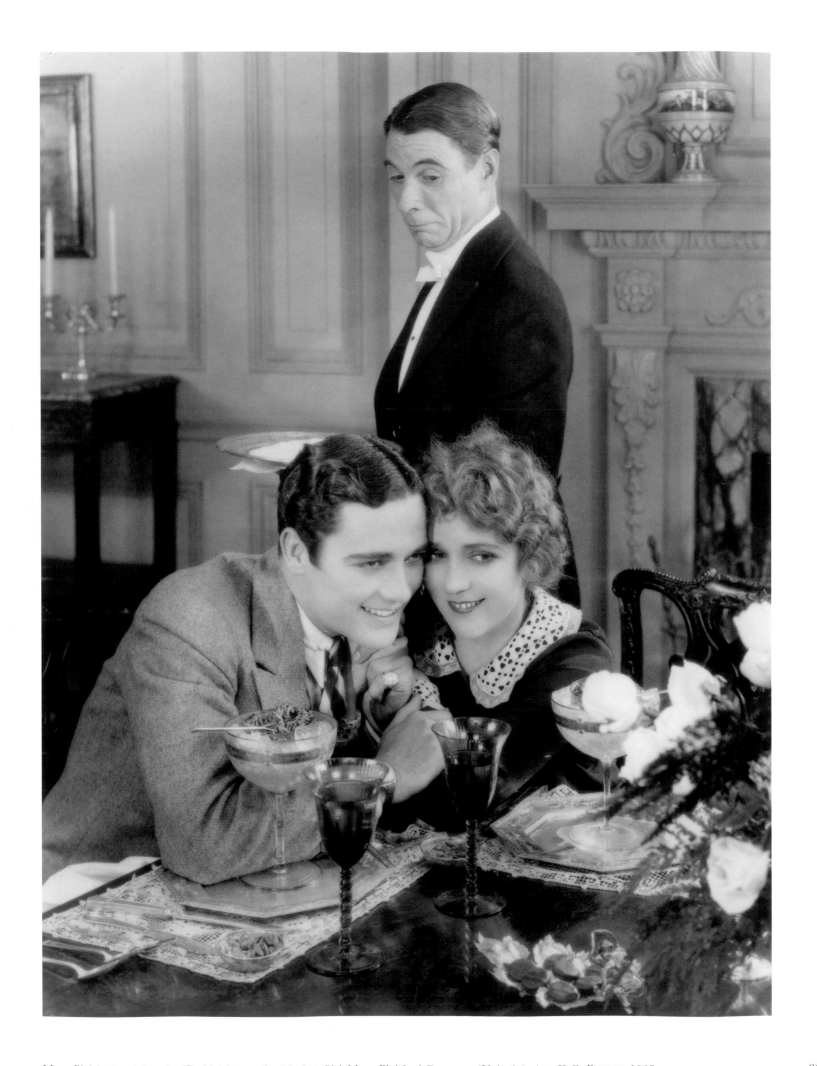

Mary Pickford and Charles 'Buddy' Rogers for *My Best Girl*, Mary Pickford Company/United Artists. K.O. RAHMN, 1927

Greta Garbo and John Gilbert for *Flesh & The Devil*, MGM. Bertram 'Buddy' Longworth, 1926

Lillian Gish for *The Wind*, MGM.
ATTRIBUTED TO MILTON BROWN, 1927

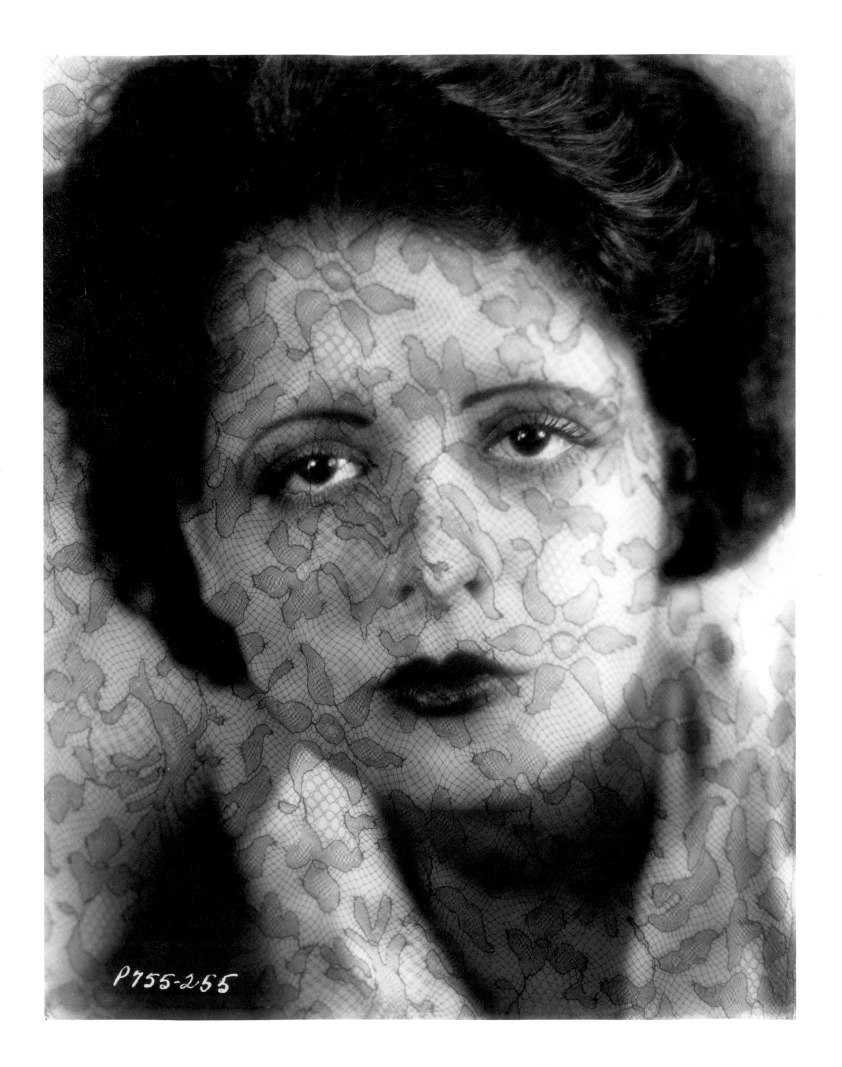

P755-255

Clara Bow, Paramount Pictures. EUGENE ROBERT RICHEE, 1927

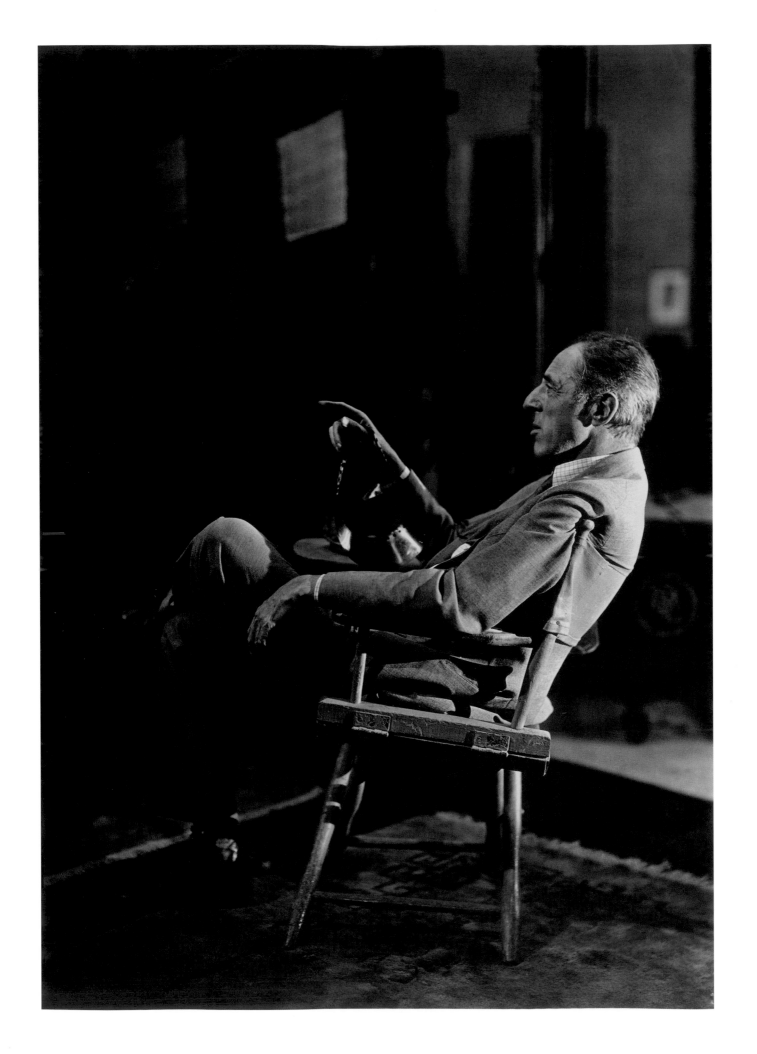

D.W. Griffith. Abbe, 1915

Dolores del Rio for *The Trail of 98*, MGM. Russell Ball, 1928

MGMP.5136

Joan Crawford with photographer Ruth Harriet Louise, MGM. CLARENCE SINCLAIR BULL, 1928

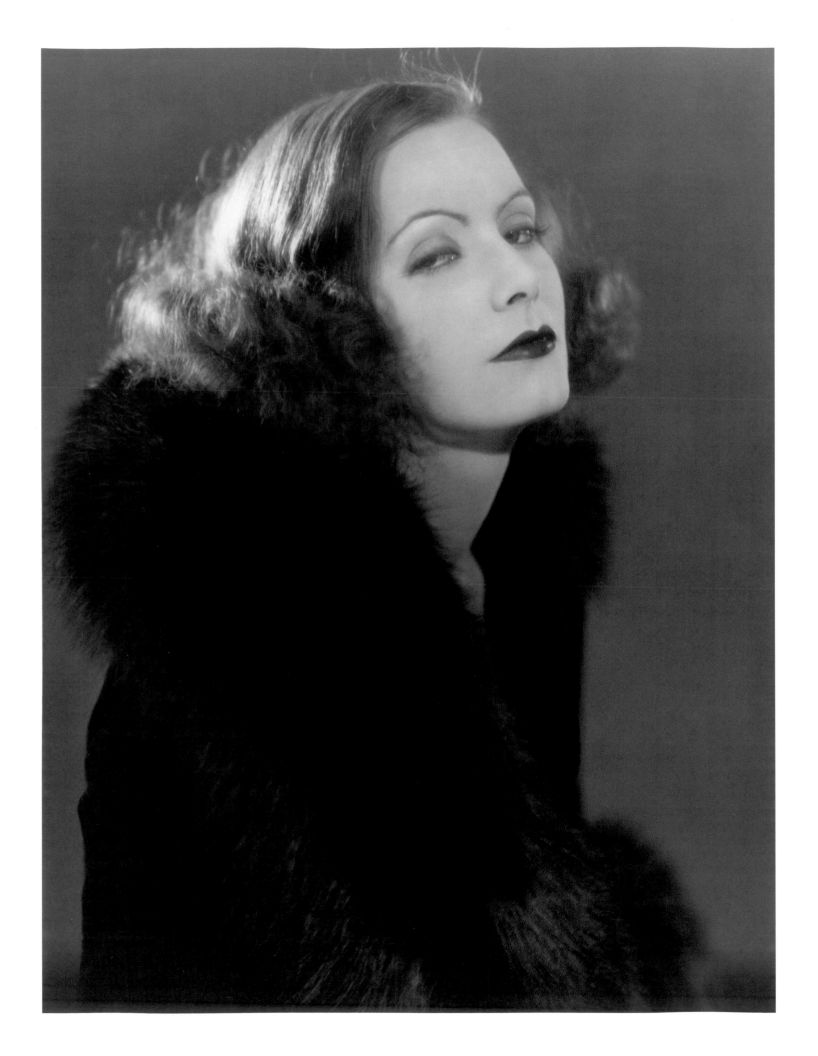

Greta Garbo, MGM. Ruth Harriet Louise, 1928

MGM lion being filmed and recorded for MGM screen credits, MGM. Unidentified MGM photographer, 1928

Ronald Colman and Vilma Banky for *Two Lovers*, Samuel Goldwyn. KENNETH ALEXANDER, 1928

Buster Keaton, MGM. RUTH HARRIET LOUISE, 1929

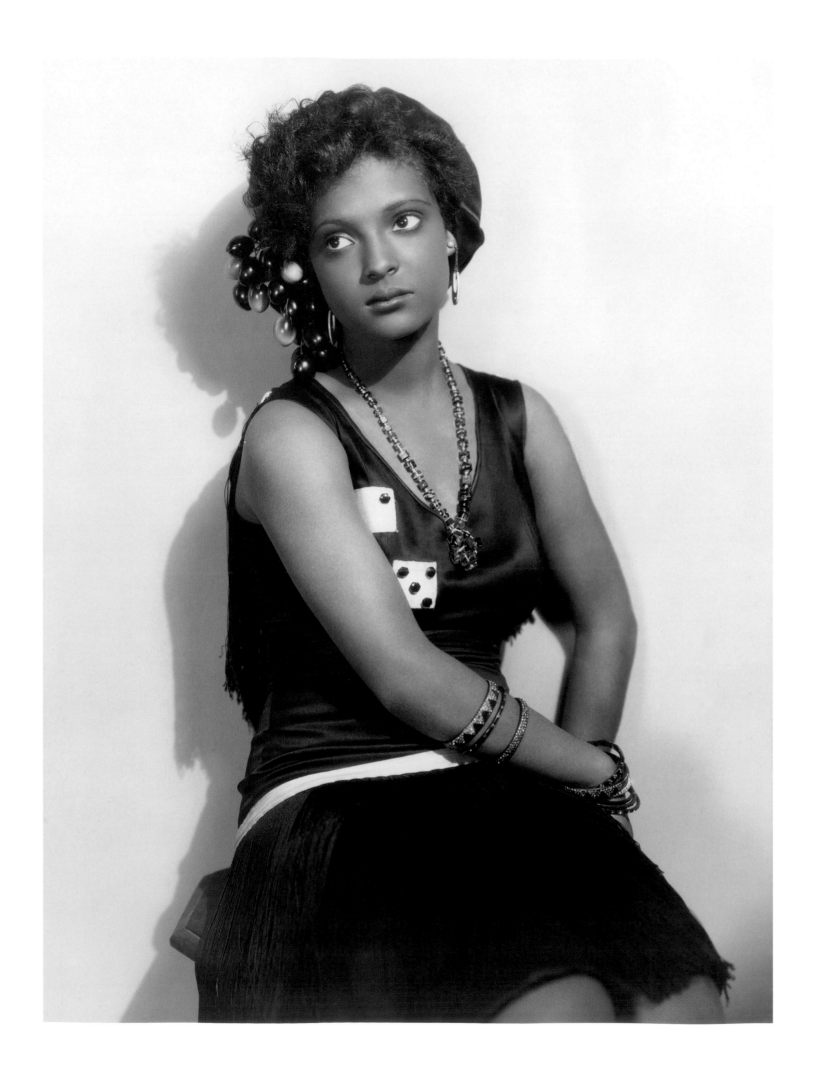

Nina Mae McKinny for *Hallelujah*, MGM. Ruth Harriet Louise, 1929

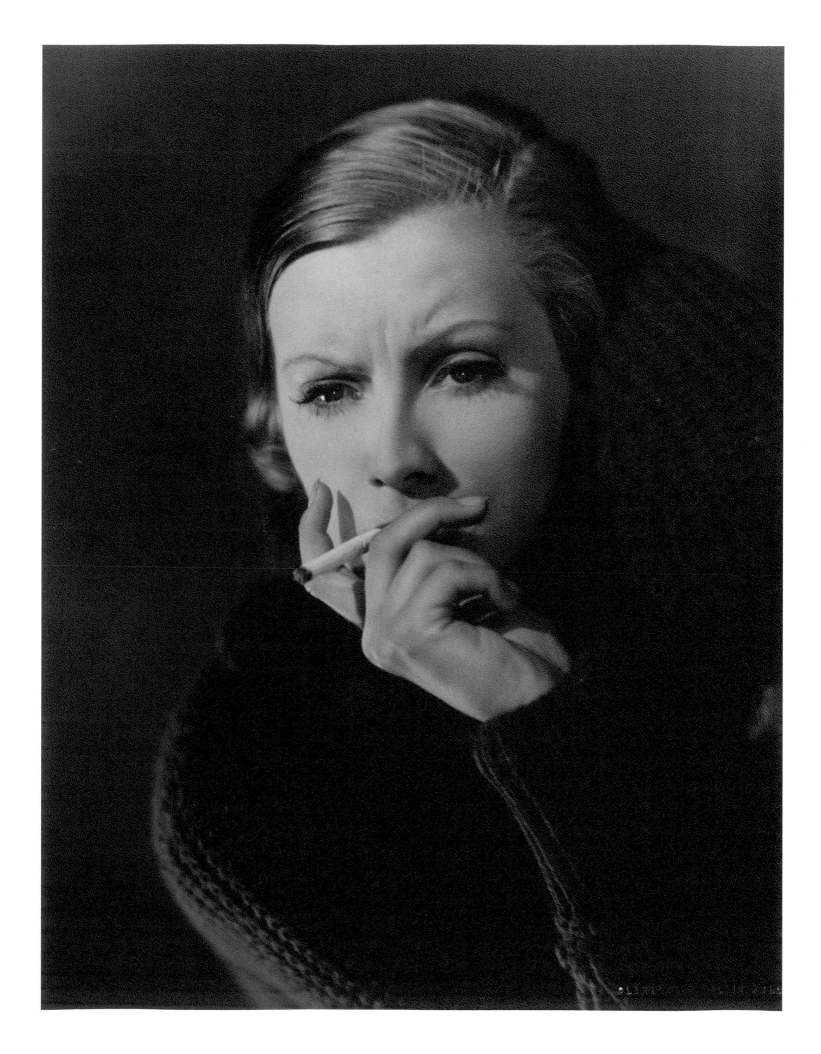

Greta Garbo for *Anna Christie*, MGM. CLARENCE SINCLAIR BULL, 1929

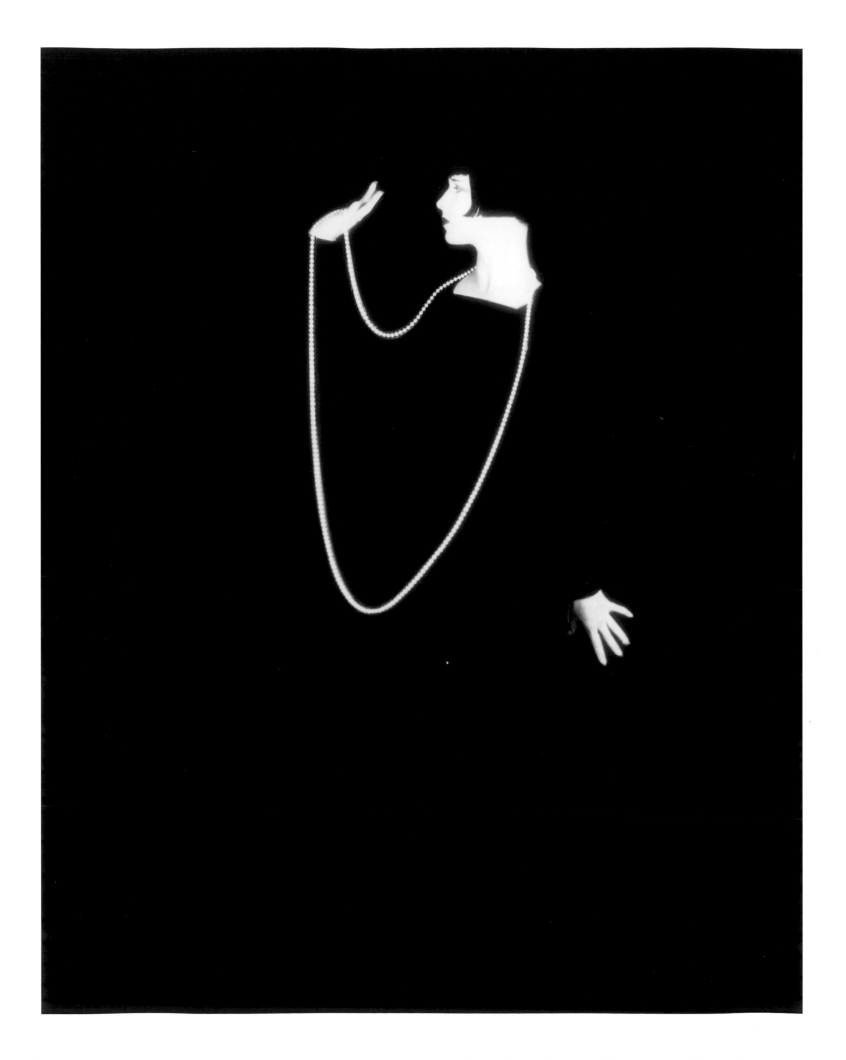

Louise Brooks, Paramount Pictures. Eugene Robert Richee, 1929

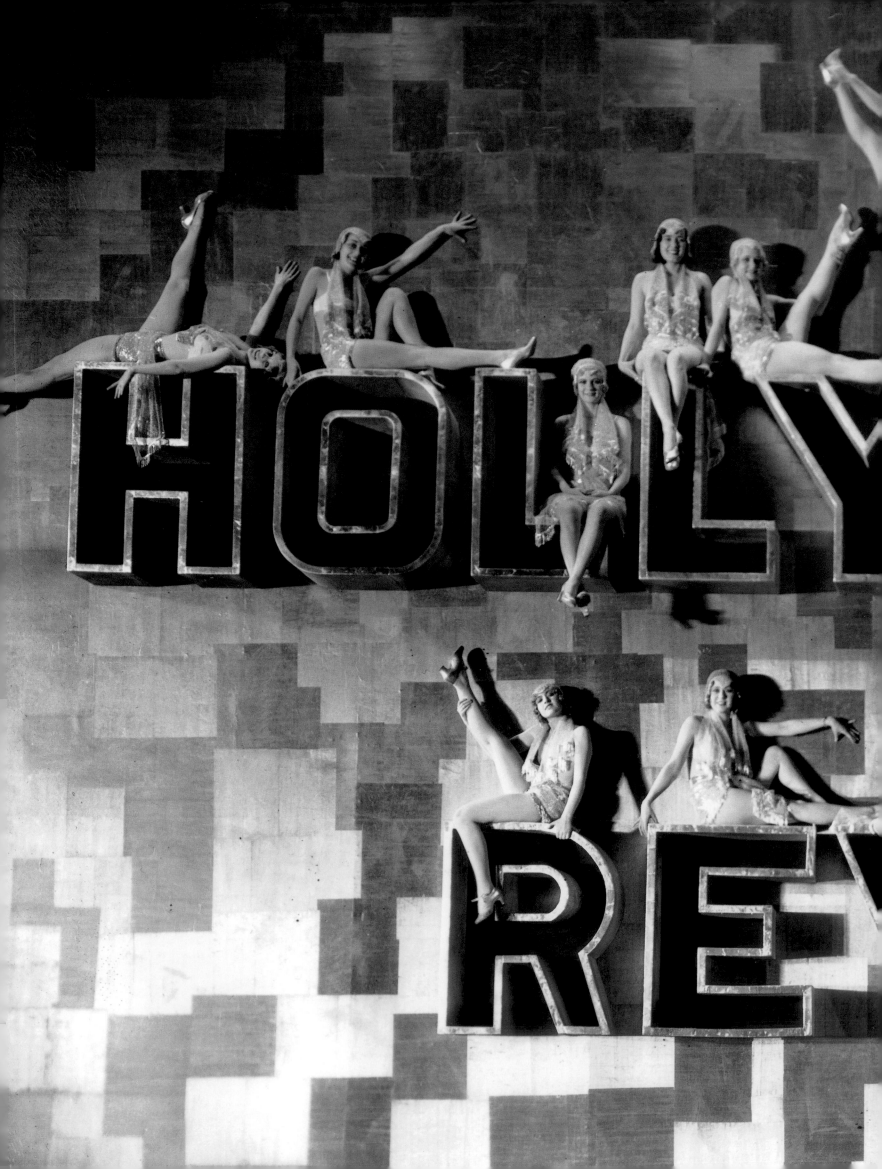

Previous page: Chorus girls for *Hollywood Revue*, MGM. Unidentified MGM photographer, 1929

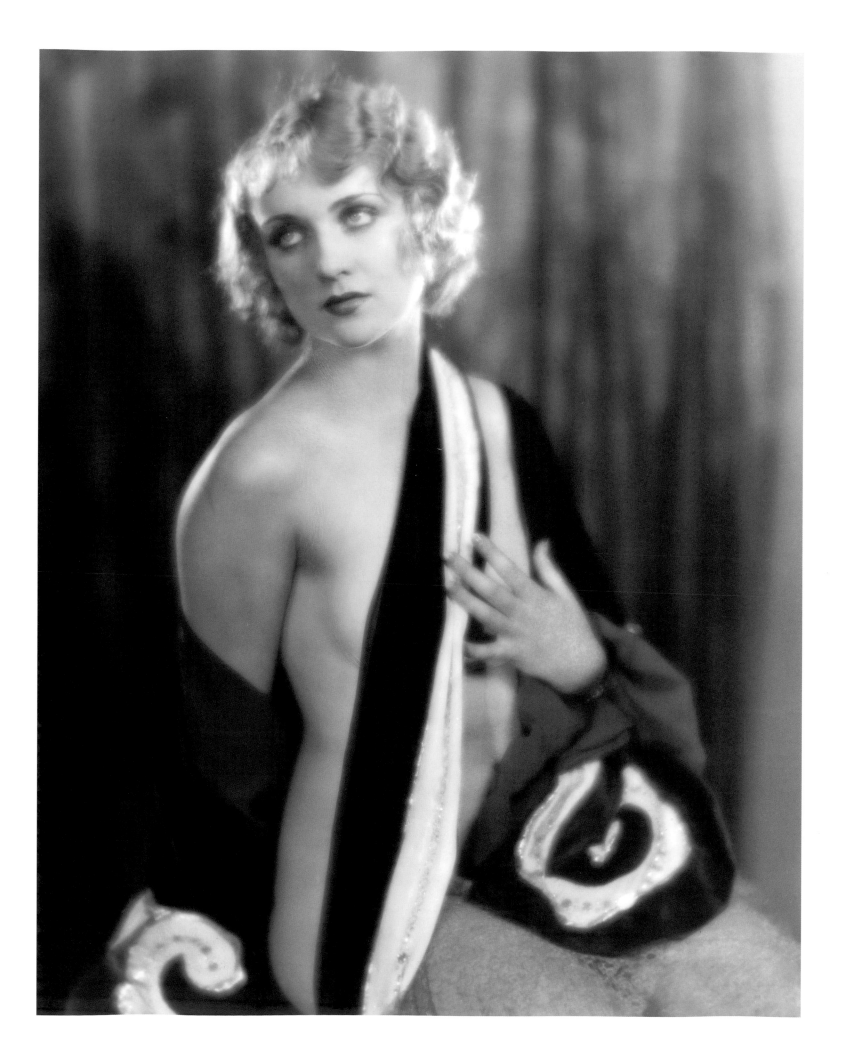

Carole Lombard, Pathé. WILLIAM THOMAS, 1929

Chorus girls for *Hollywood Revue*, MGM. UNIDENTIFIED MGM PHOTOGRAPHER, 1929

103 Nina Mae McKinney and Daniel Haynes for *Hallelujah*, MGM. Ruth Harriet Louise, 1929

Hallelujah, MGM. Ruth Harriet Louise, 1929

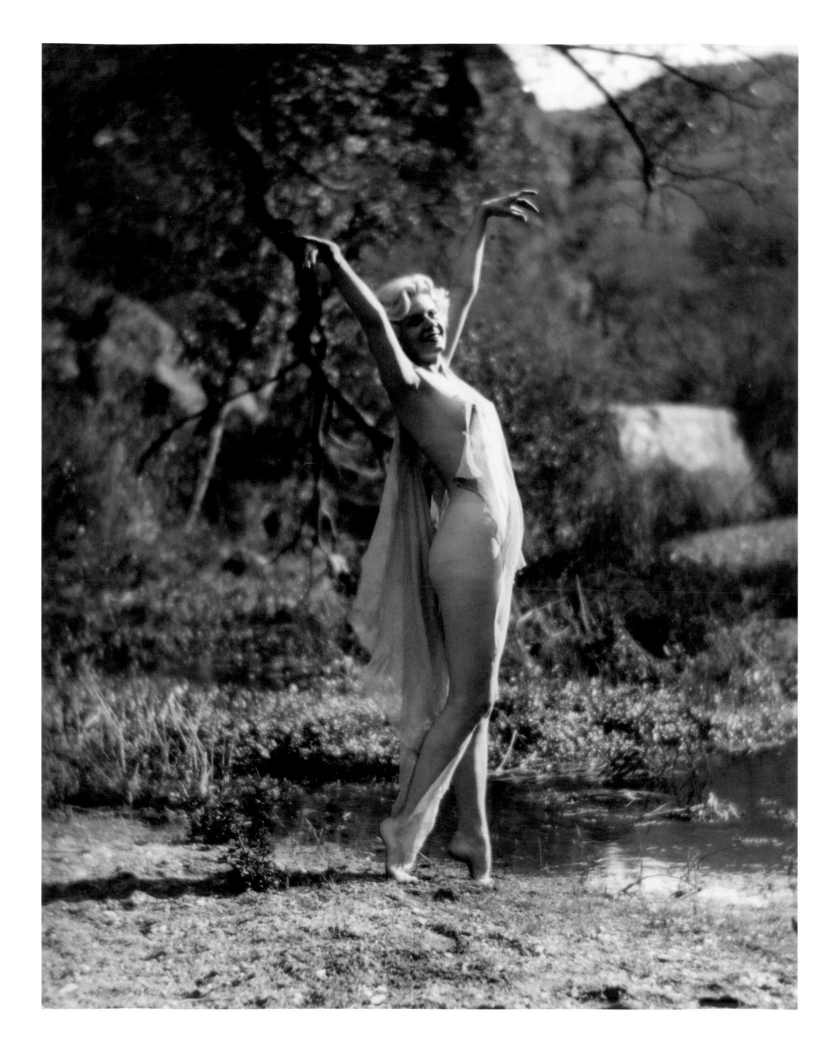

Jean Harlow, Griffiths Park, Los Angeles. Edwin Bower Hesser, 1929

Greta Garbo for *The Kiss*, MGM. CLARENCE SINCLAIR BULL, 1929

Renee Adoree and wardrobe assistant, MGM. CLARENCE SINCLAIR BULL, 1929

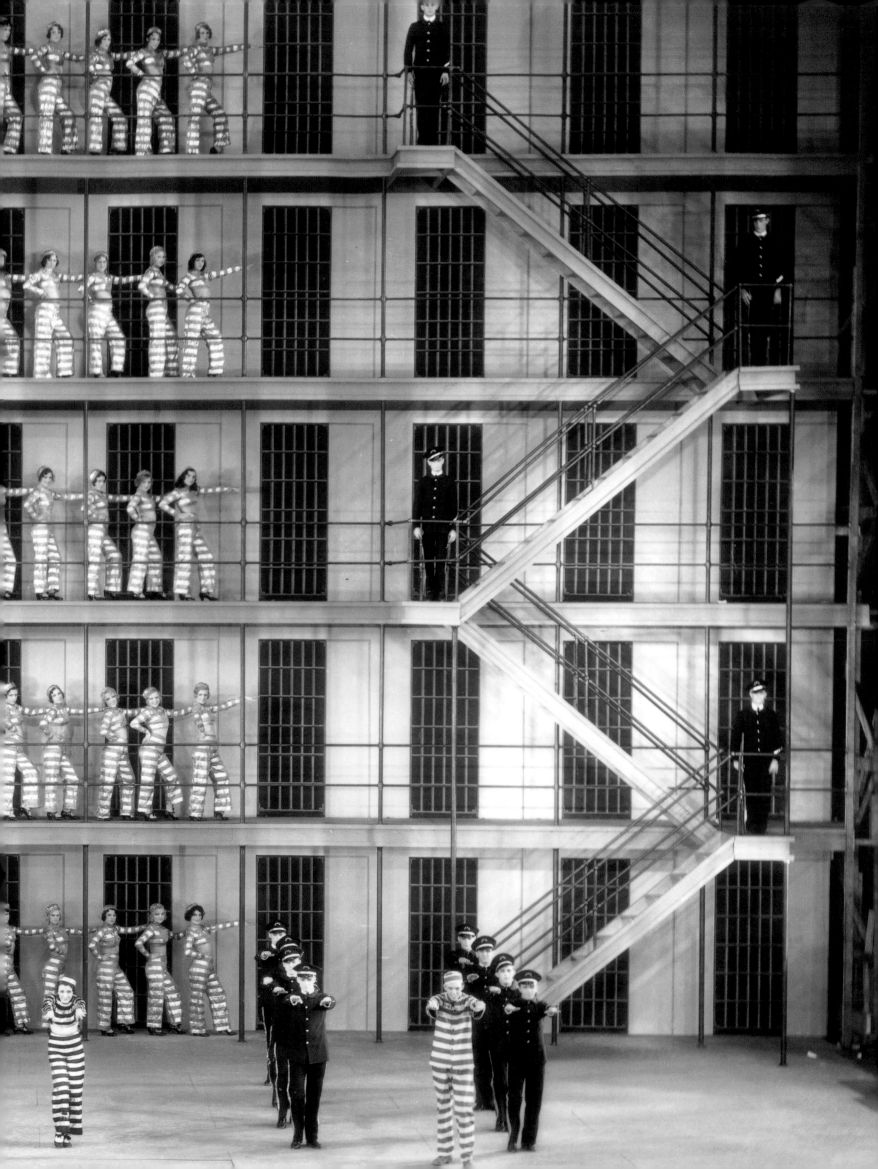

P684-162

Harold Lloyd for *Feet First*, Paramount Pictures. Gene Kornman, 1930

Previous page: Chorus girls and boys rehearsing for *The March of Time*, MGM. Unidentified MGM photographer, 1930

111 Kay Johnson for *Madam Satan*, MGM. James Manatt, 1930

Marlene Dietrich. IRVING CHIDNOFF, 1930

Robert Montgomery and Chester Morris for *The Big House*, MGM. GEORGE HURRELL, 1930

Alice White for *Show Girl in Hollywood*, Warner Brothers. BERTRAM 'BUDDY' LONGWORTH, 1930

Clara Bow, Paramount Pictures. Otto Dyar, 1930

Joan Crawford, MGM. GEORGE HURRELL, 1930

John Barrymore for *Svengali*, Warner Brothers. BERTRAM 'BUDDY' LONGWORTH, 1931

Pola Negri, RKO Pictures. RUSSELL BALL, 1931

Joan Crawford promoting 4th July Festivities, MGM. CLARENCE SINCLAIR BULL, 1931

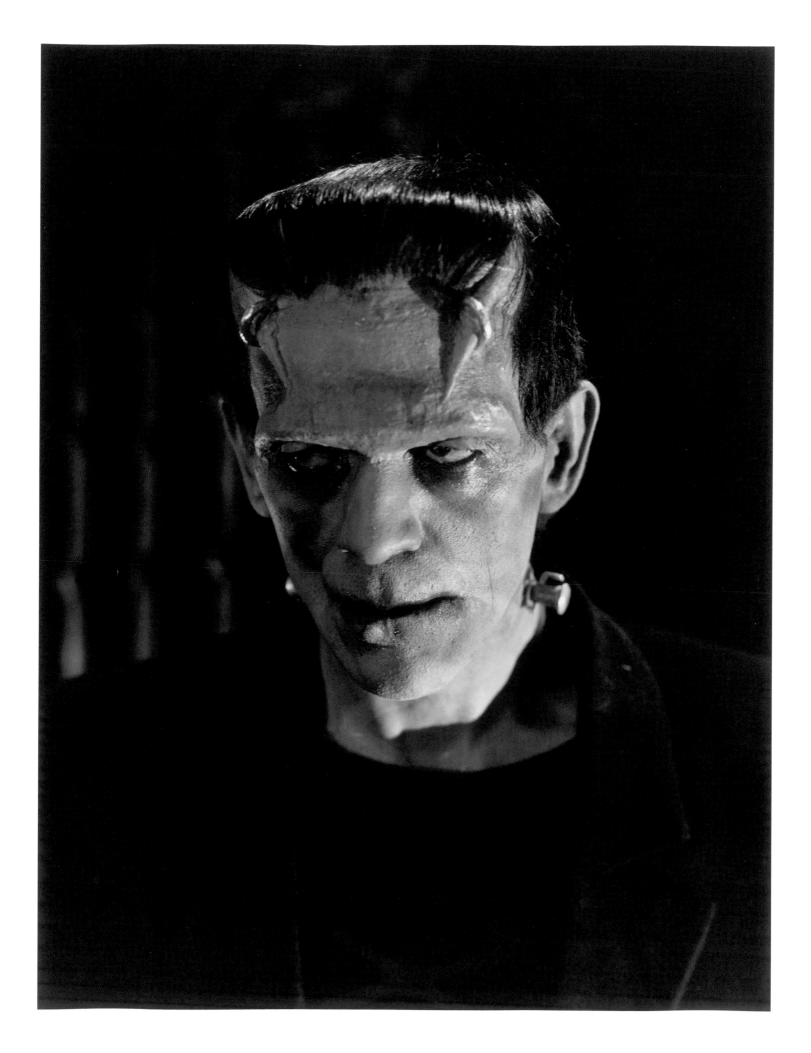

Boris Karloff for *Frankenstein*, Universal. ROMAN FREULICH, 1931

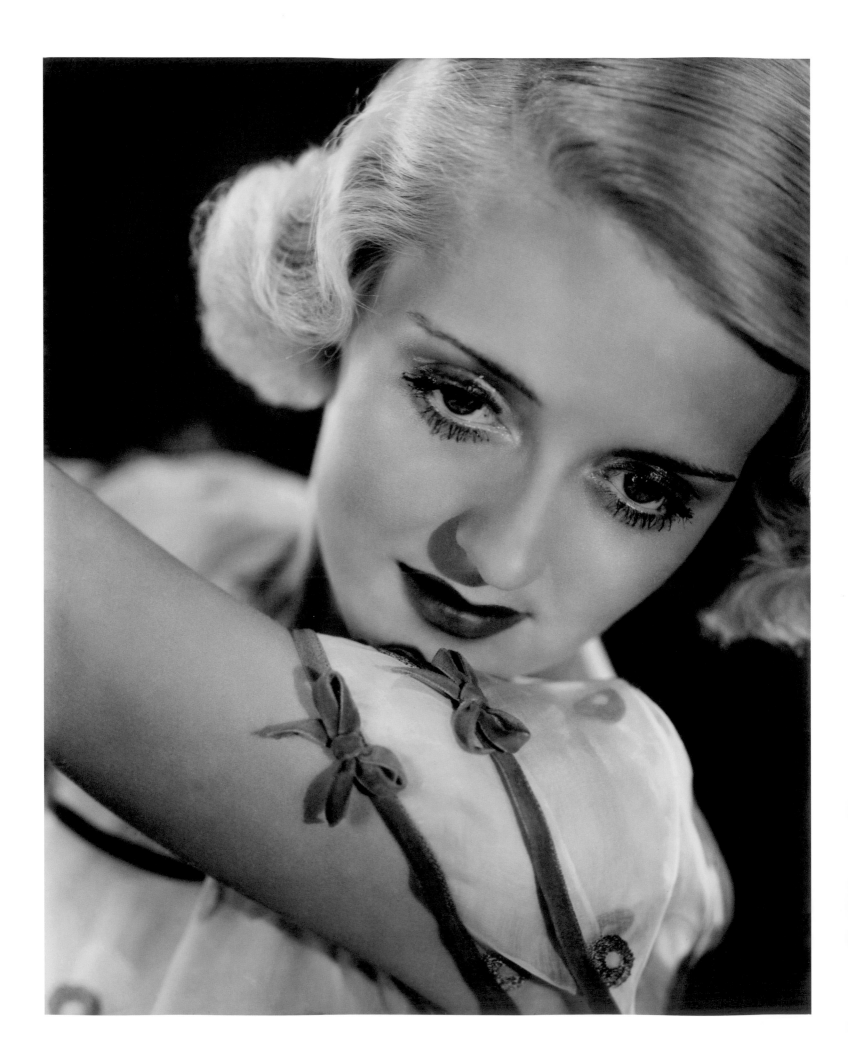

Bette Davis, Warner Brothers. ROMAN FREULICH, 1931

Jean Harlow for *Iron Man*, Universal. SHERMAN CLARK, 1931

Marie Dressler, MGM. CLARENCE SINCLAIR BULL, 1932

Boris Karloff for *The Mask of Fu Manchu*, MGM. CLARENCE SINCLAIR BULL, 1932

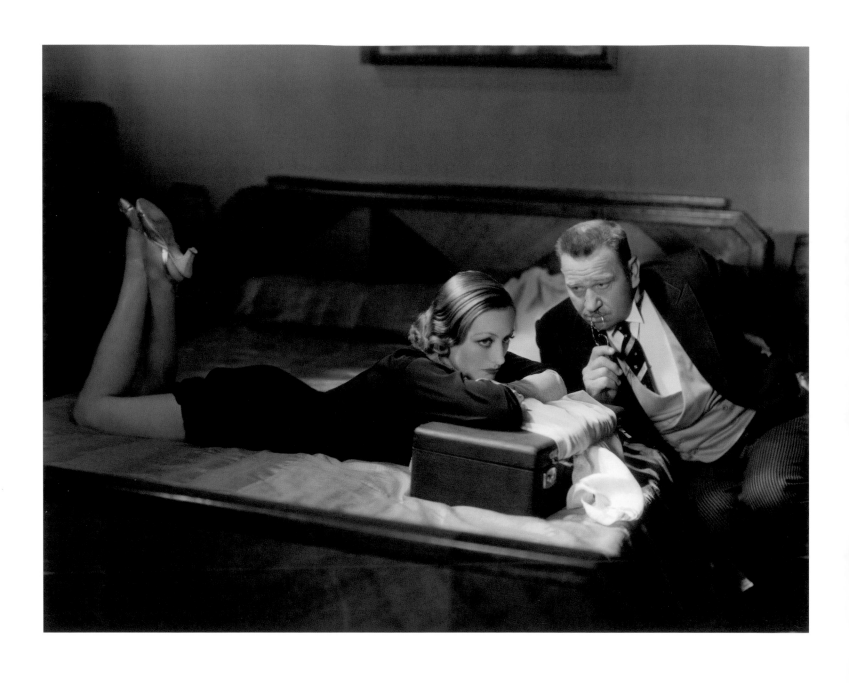

Joan Crawford and Wallace Beery for *Grand Hotel*, MGM. GEORGE HURRELL, 1932

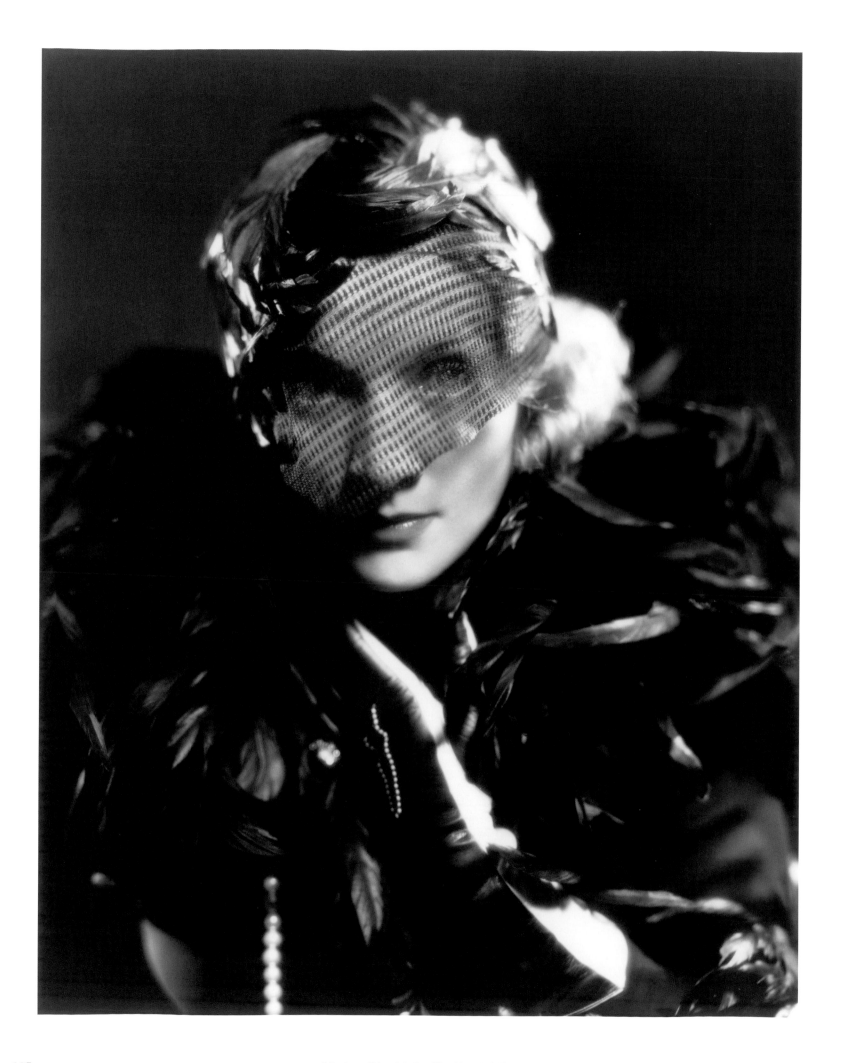

Marlene Dietrich for *The Shanghai Express*, Paramount Pictures. EUGENE ROBERT RICHEE, 1932

Photographer George Hurrell with Dorothy Jordan, MGM. Unidentified MGM photographer, 1932 128

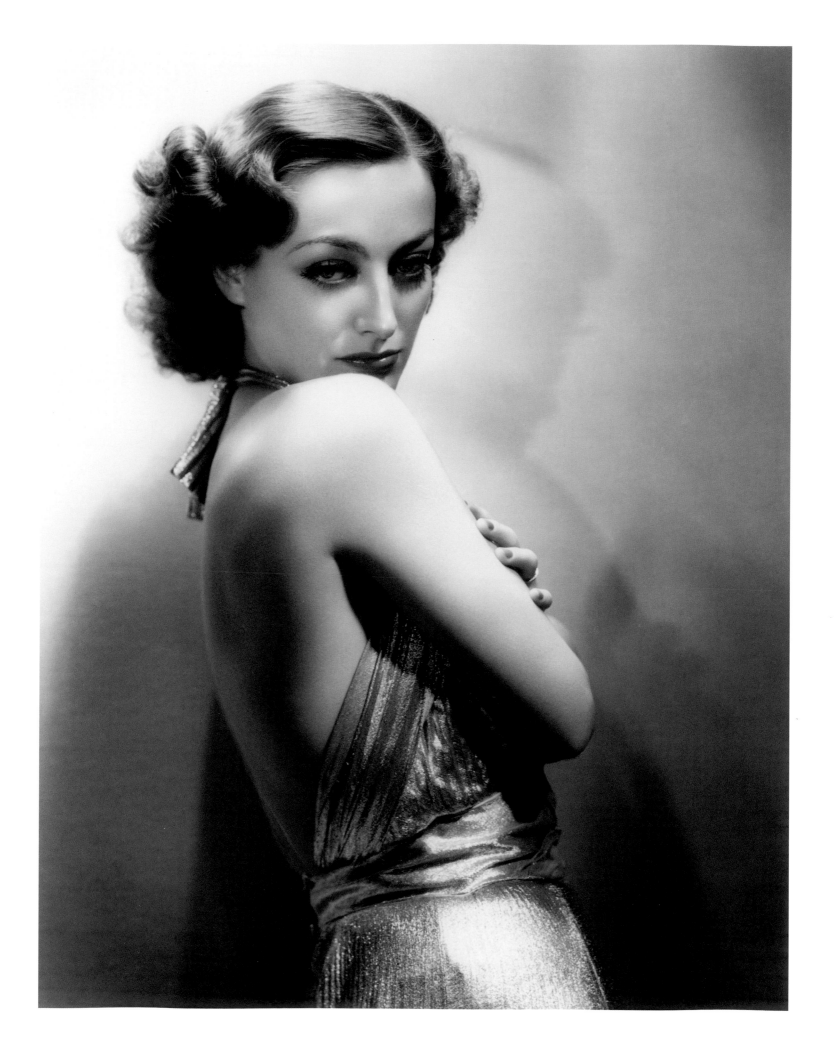

Joan Crawford, MGM. George Hurrell, 1934

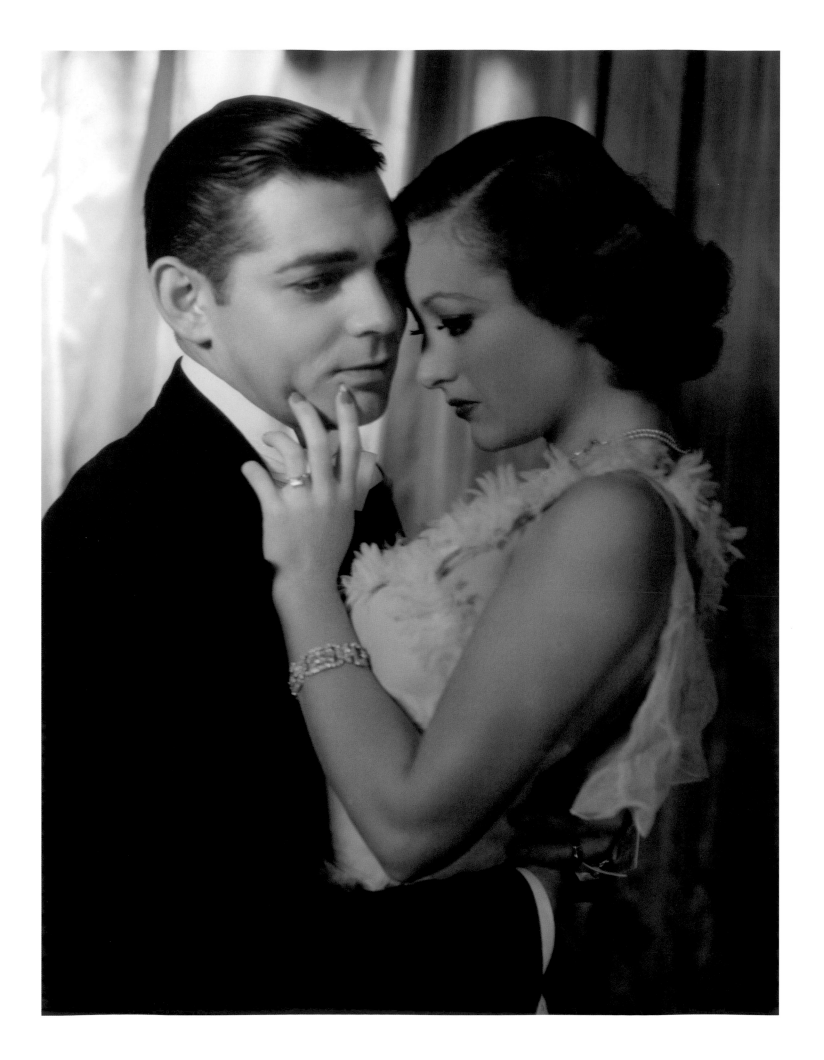

Clark Gable and Joan Crawford for *Dancing Lady*, MGM. GEORGE HURRELL, 1933

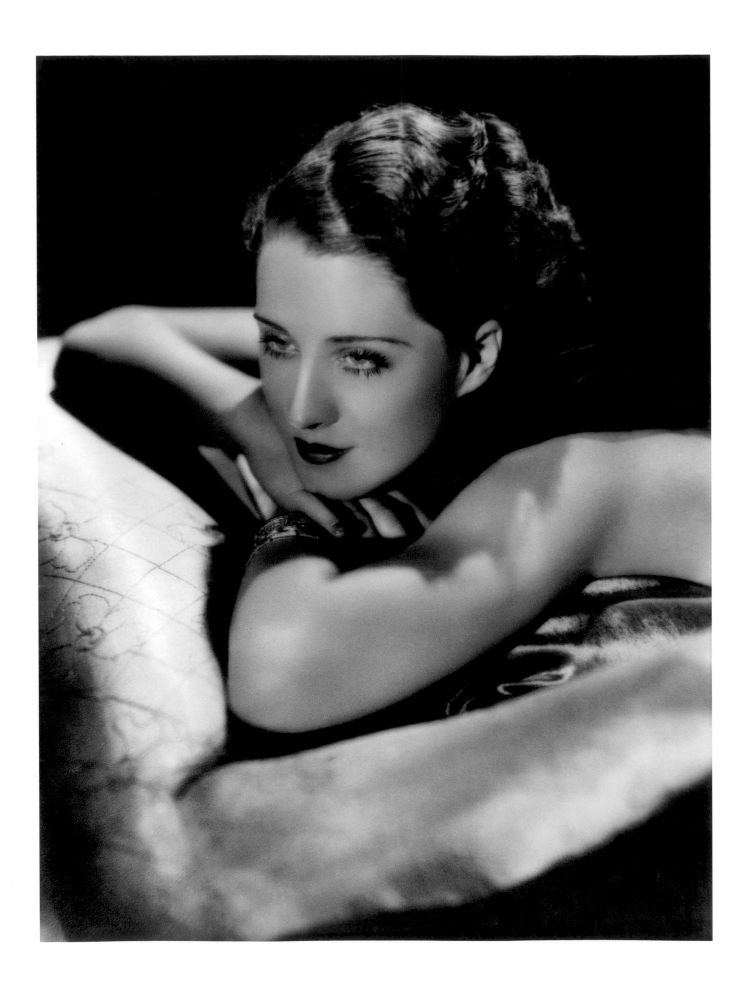

Norma Shearer, MGM. George Hurrell, 1933

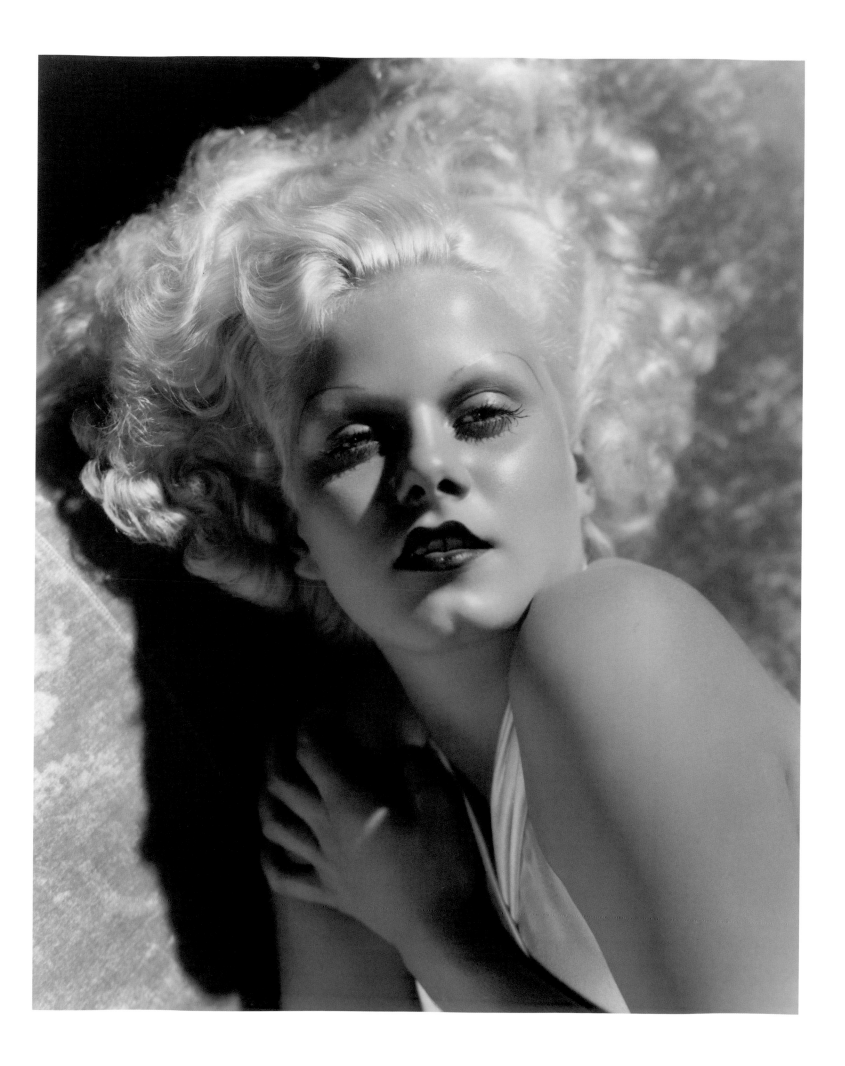

Jean Harlow, MGM. GEORGE HURRELL, 1933

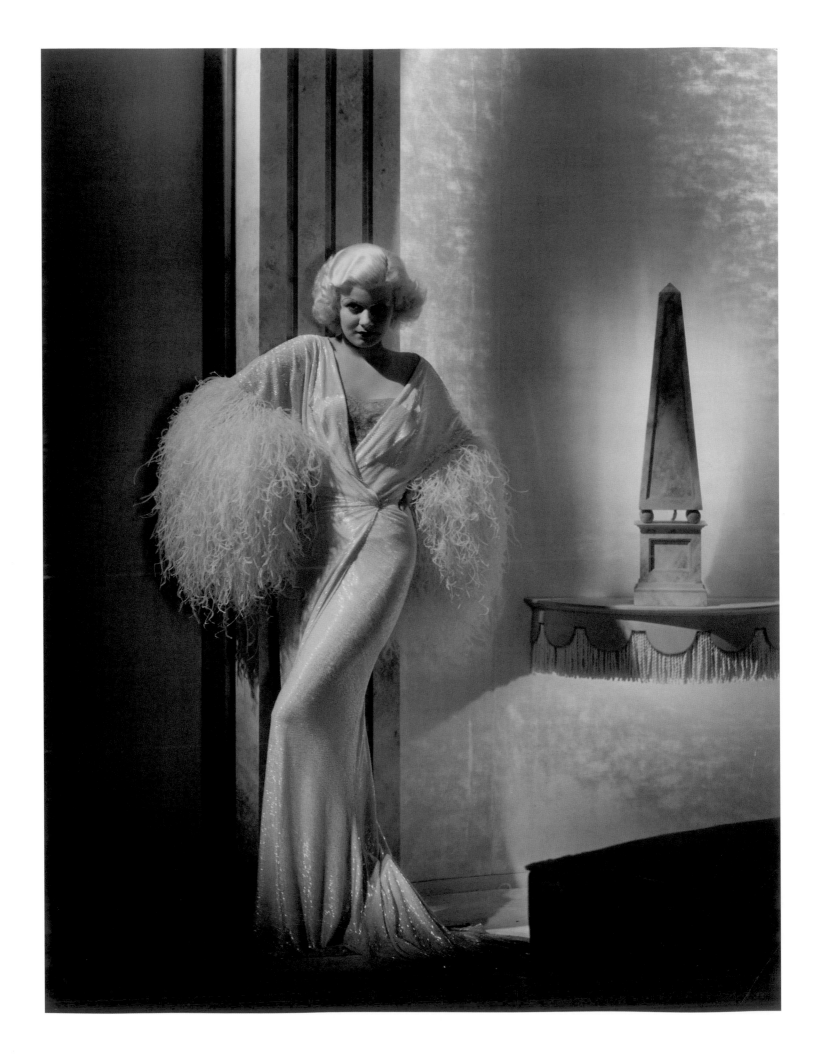

Jean Harlow for *Dinner at Eight*, MGM. HARVEY WHITE, 1933

Johnny Weissmuller for *Tarzan, the Ape Man*, MGM. CLARENCE SINCLAIR BULL, 1933

Director Lloyd Bacon with Ruby Keeler and Joan Blondell for *42nd Street*, Warner Brothers. BERTRAM 'BUDDY' LONGWORTH, 1933

Shirley Temple and Baby Leroy, Paramount Pictures. WILLIAM WALLING, 1933

King Kong, RKO.
Robert Coburn, 1933

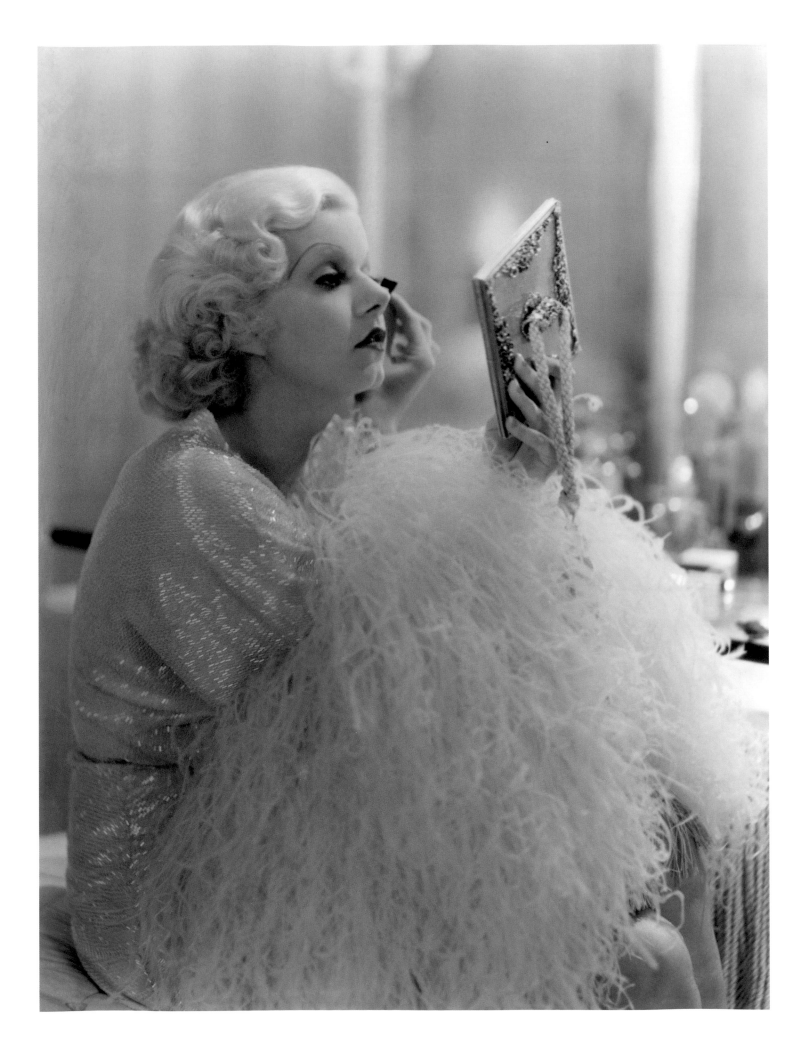

Jean Harlow for *Dinner at Eight*, MGM. HARVEY WHITE, 1933

Margaret Sullavan, Universal. JACK FREULICH, 1933

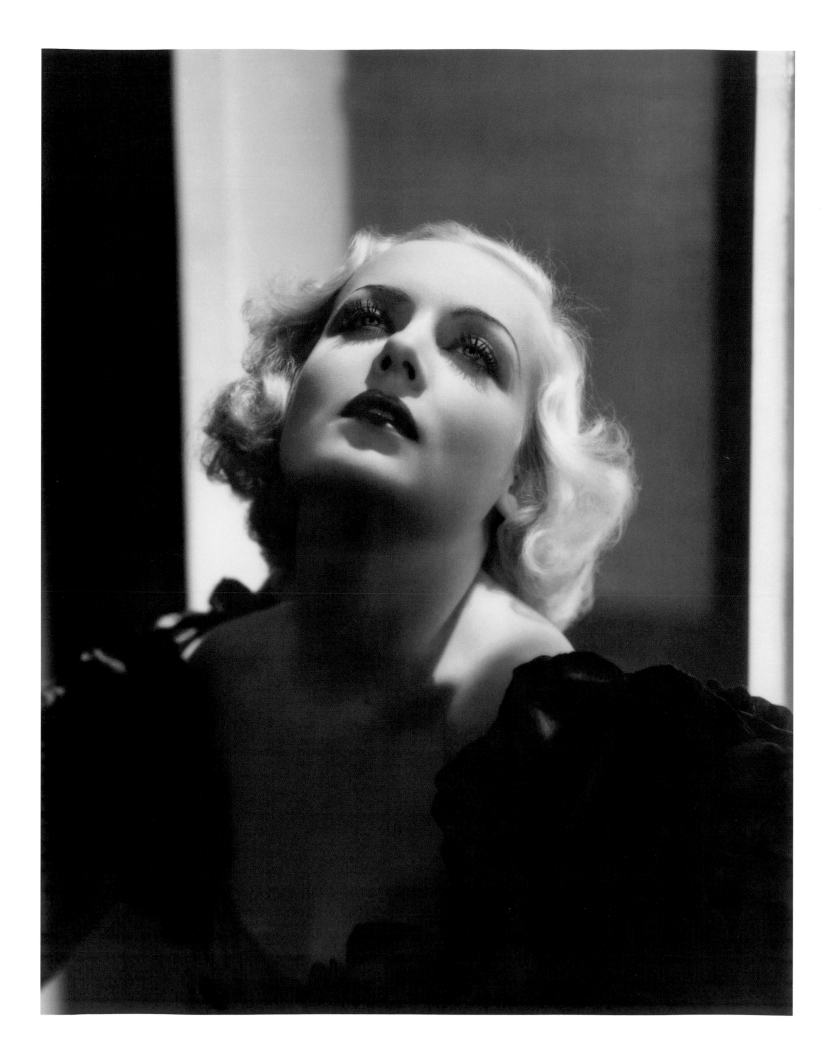

Carole Lombard, Paramount Pictures. GEORGE HURRELL, 1933

Chorus girls for *Dancing Lady*, MGM.
TED ALLAN, 1933

Pat Paterson, Fox. Otto Dyar, 1934

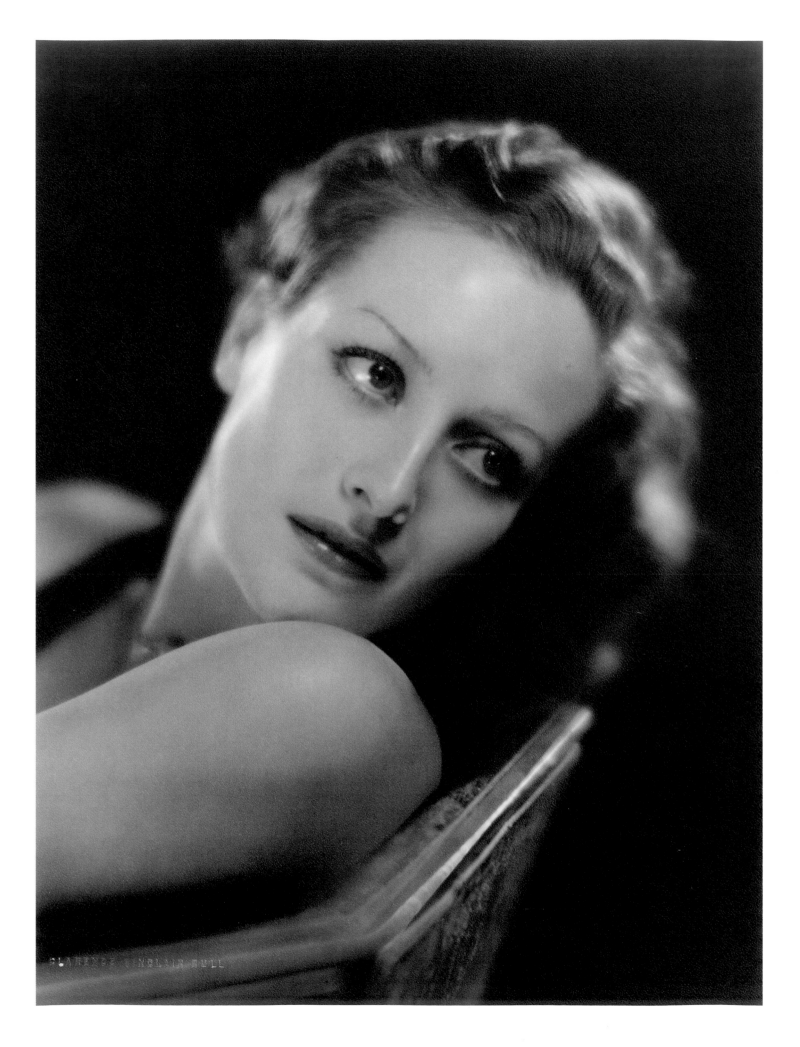

Joan Crawford, MGM. CLARENCE SINCLAIR BULL, 1933

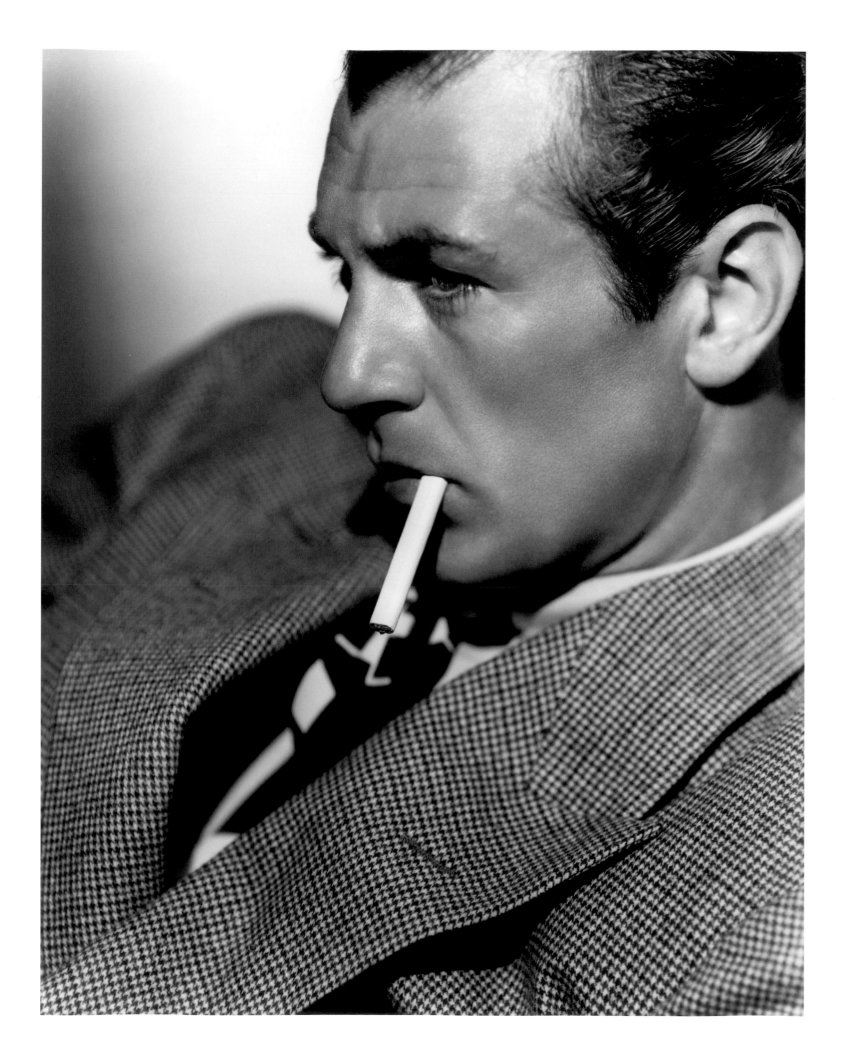

Gary Cooper, MGM. CLARENCE SINCLAIR BULL, 1934

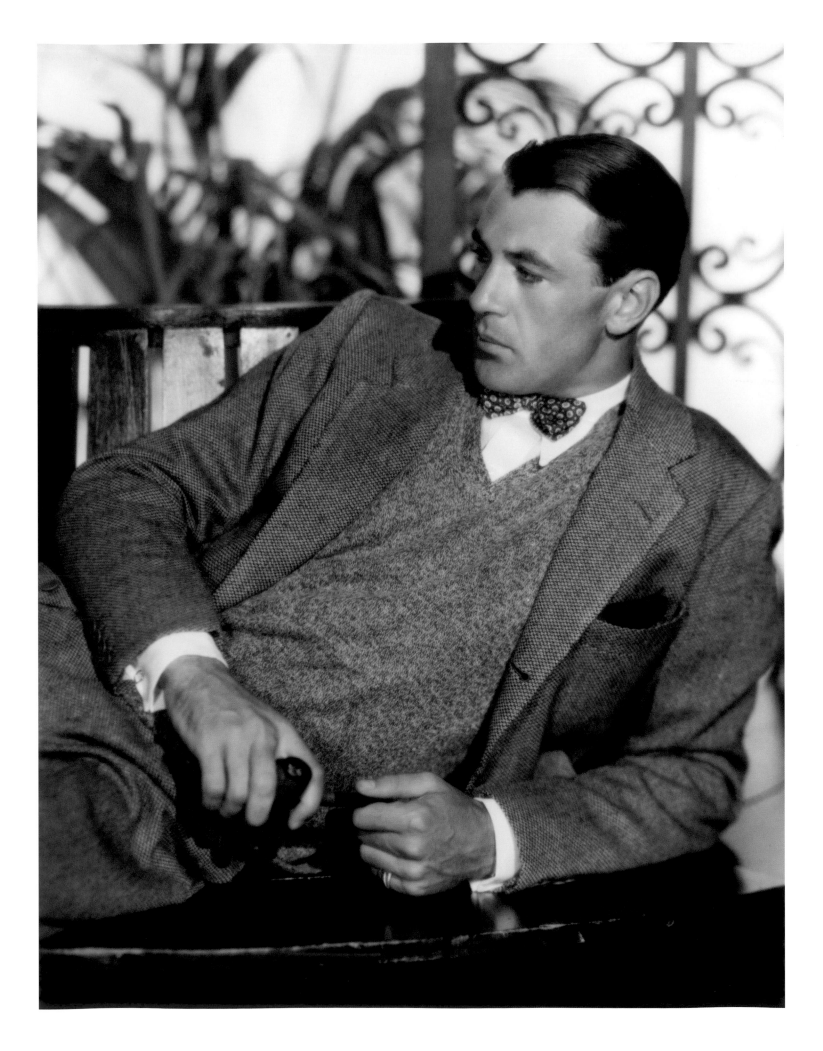

Gary Cooper, Paramount Pictures. Eugene Robert Richee, 1934

Mae West and Roger Pryor for *It Ain't No Sin*, Paramount Pictures. DON ENGLISH, 1934

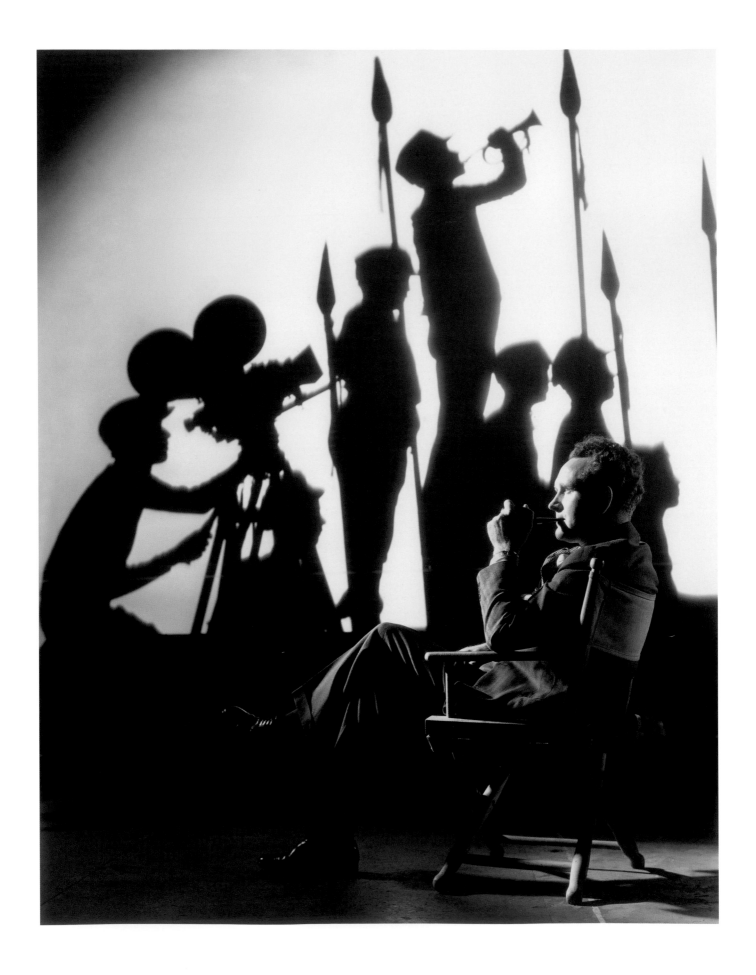

Director Frank Borzage for *Men Of Tomorrow*, Columbia Pictures. A.L. 'WHITEY' SCHAEFER, 1934

154

Spencer Tracy and Myrna Loy for *Whipsaw*, MGM. TED ALLAN, 1935

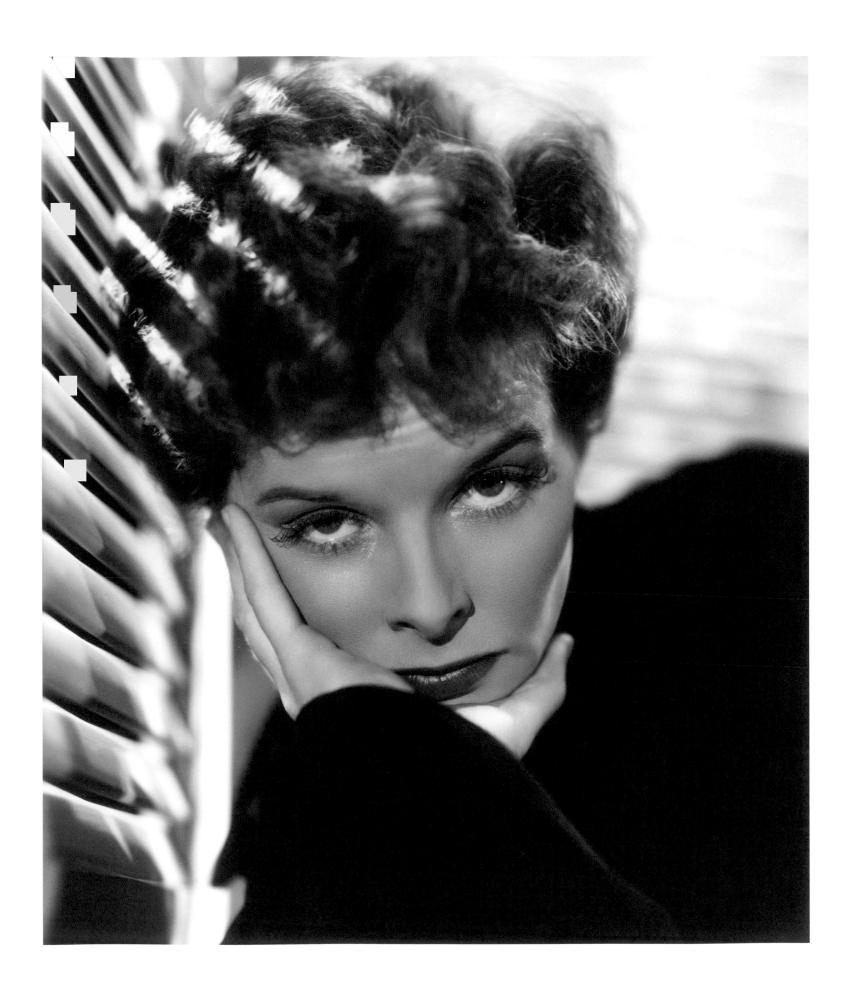

Katharine Hepburn, RKO. Ernest Bachrach, 1935

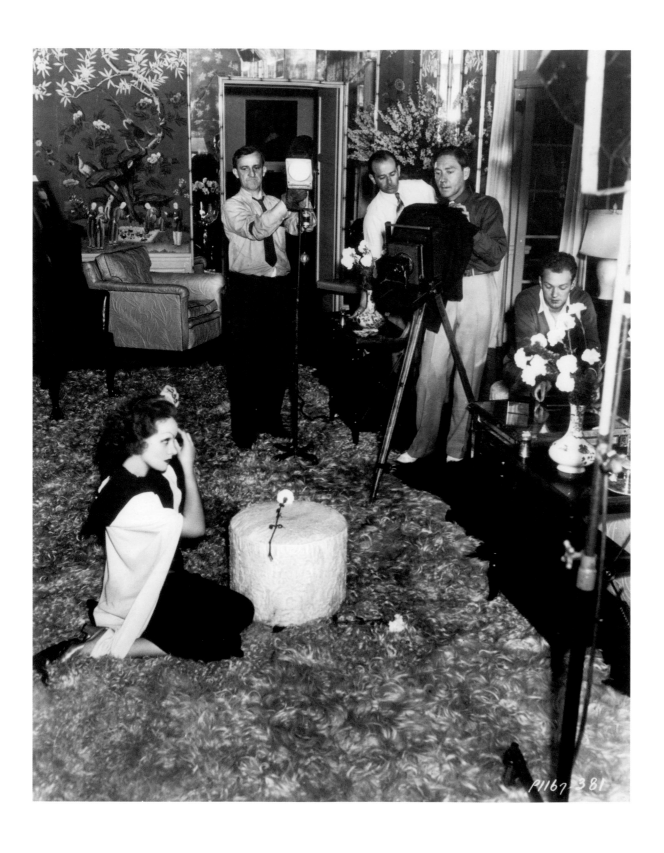

Marlene Dietrich being photographed by Eugene Robert Richee with assistant John Engstead (sitting), Paramount Pictures.
UNIDENTIFIED PARAMOUNT PHOTOGRAPHER, 1935

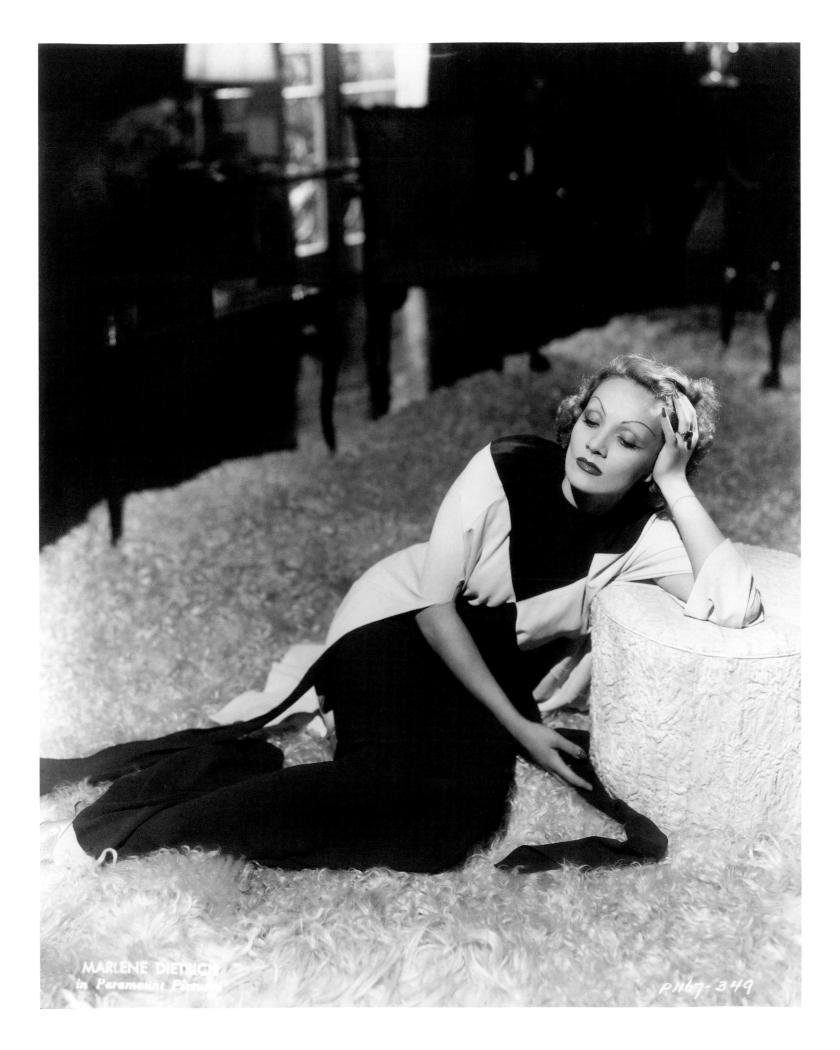

Marlene Dietrich, Paramount Pictures. Eugene Robert Richee, 1935

MG48669

Myrna Loy, MGM. Ruth Harriet Louise, 1935

NY-NC42-1-Δ

Cary Grant, RKO. ROBERT COBURN, 1935

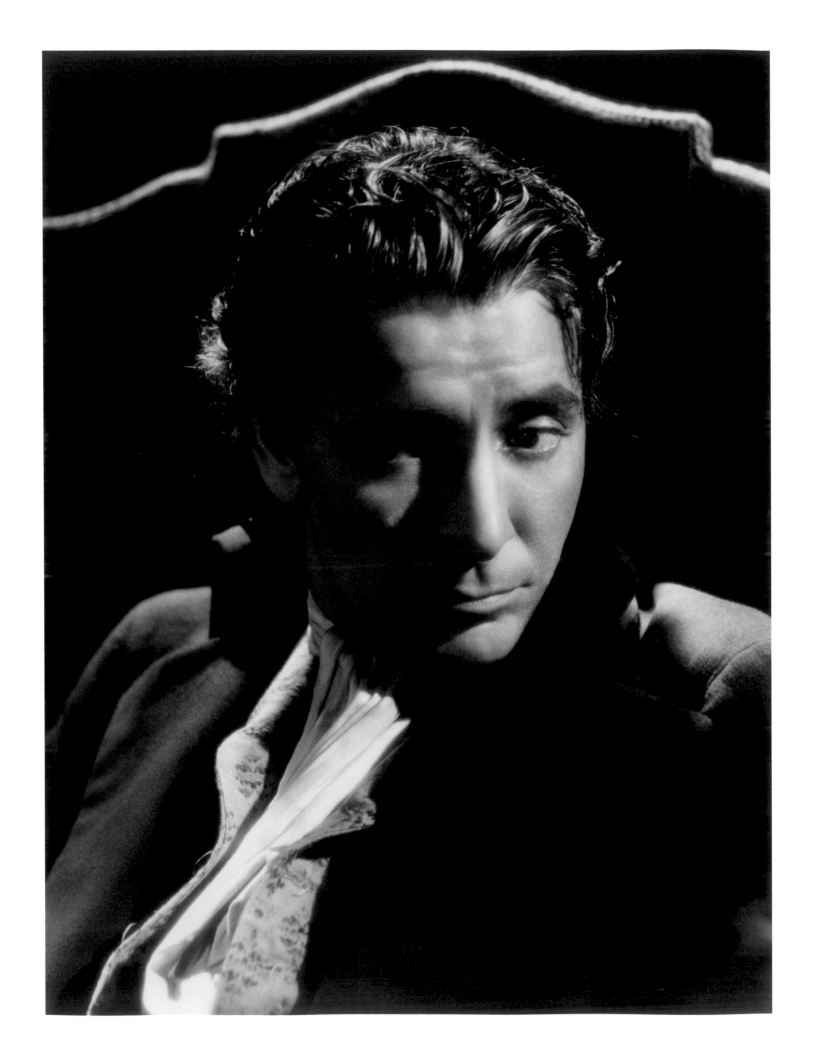

Ronald Colman for *A Tale of Two Cities*, MGM. CLARENCE SINCLAIR BULL, 1935

Charles Laughton, Paramount Pictures. WILLIAM THOMAS, 1935

Katharine Hepburn and Cary Grant with Alex Kahle on set for *Sylvia Scarlett*, RKO. ALEX KAHLE, 1935

A starlet being lined up with a 10 x 8 camera for a portrait sitting, MGM. CLARENCE SINCLAIR BULL, 1935

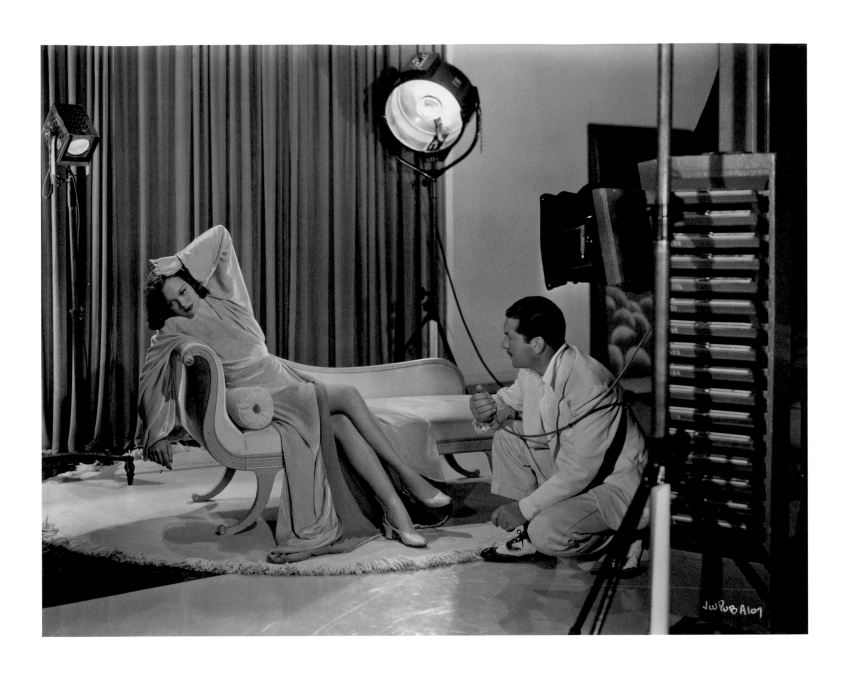

Jane Wyman with photographer Elmer Fryer, Warner Brothers. Unidentified Warner Brothers photographer, 1936

Eleanor Powell for *Born To Dance*, MGM. UNIDENTIFIED MGM PHOTOGRAPHER, 1936

Fred Astaire and Ginger Rogers for *Swing Time*, RKO. JOHN MIEHLE, 1936

Katharine Hepburn, RKO. ERNEST BACHRACH, 1936

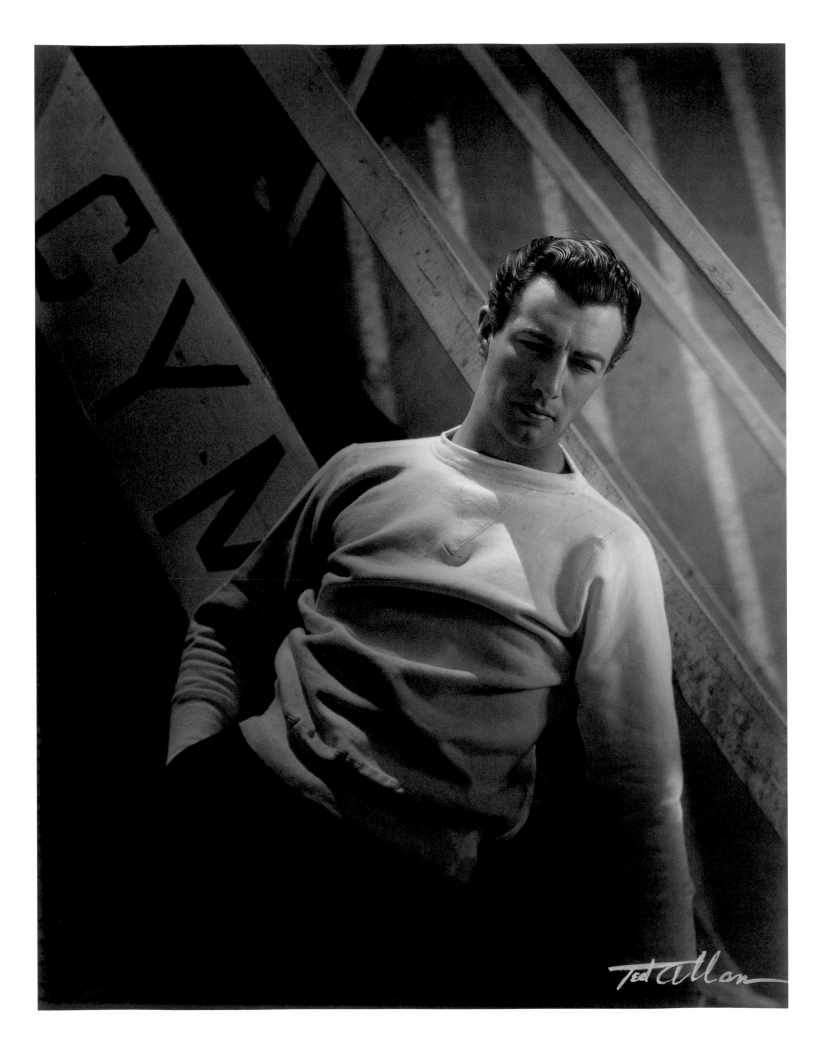

Robert Taylor, MGM. TED ALLAN, 1936

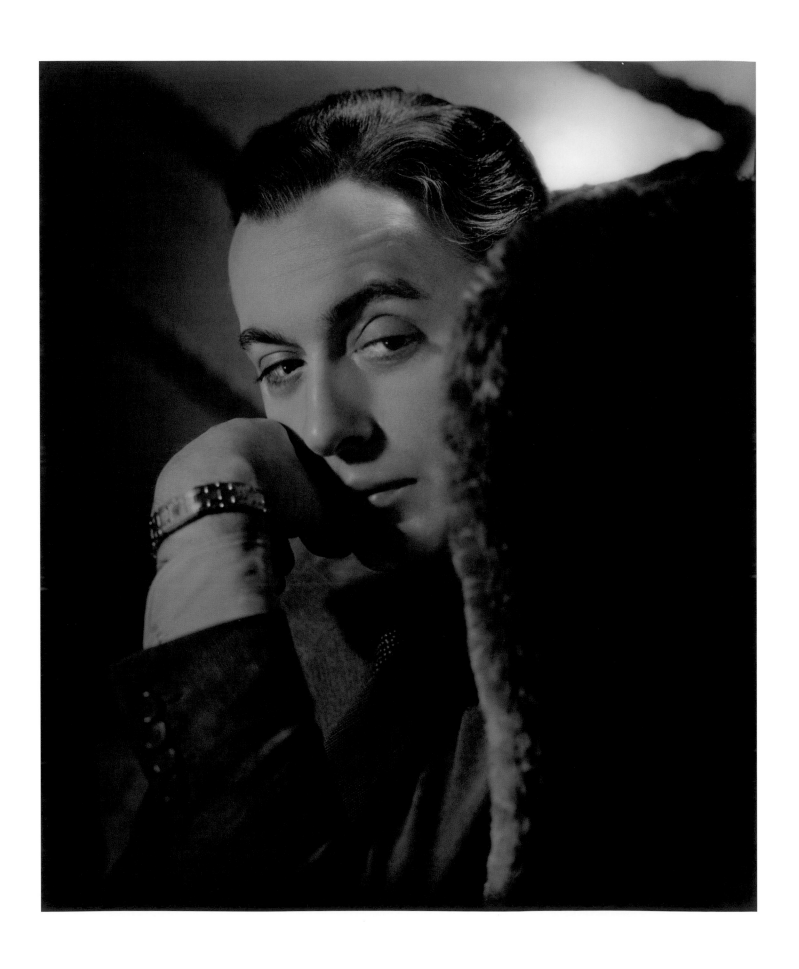

Charles Boyer, MGM. TED ALLAN, 1936 172

Cary Grant, MGM. TED ALLAN, 1936

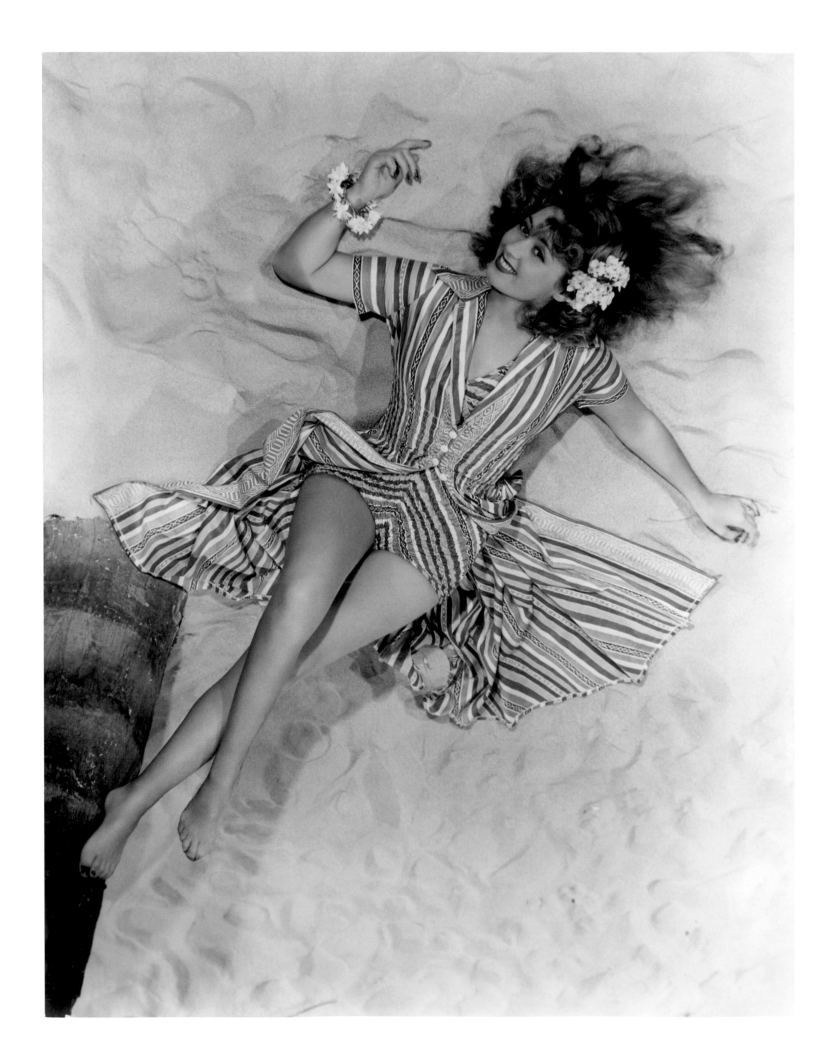

Joan Blondell, Warner Brothers. ELMER FRYER, 1937

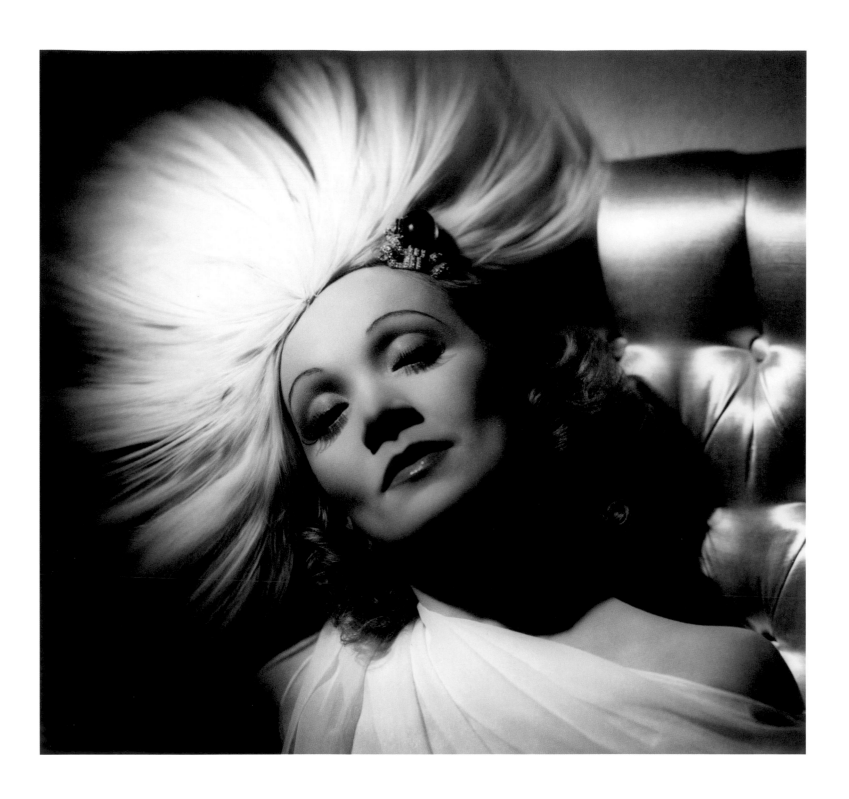

Marlene Dietrich. GEORGE HURRELL, 1937

Myrna Loy and William Powell for *The Thin Man*, MGM. Ted Allan, 1934

Marx Brothers for *A Day At The Races*, MGM. TED ALLAN, 1937

Carole Lombard, Fred MacMurray and Una Merkel for *True Confession*, Paramount Pictures. WILLIAM WALLING, 1937

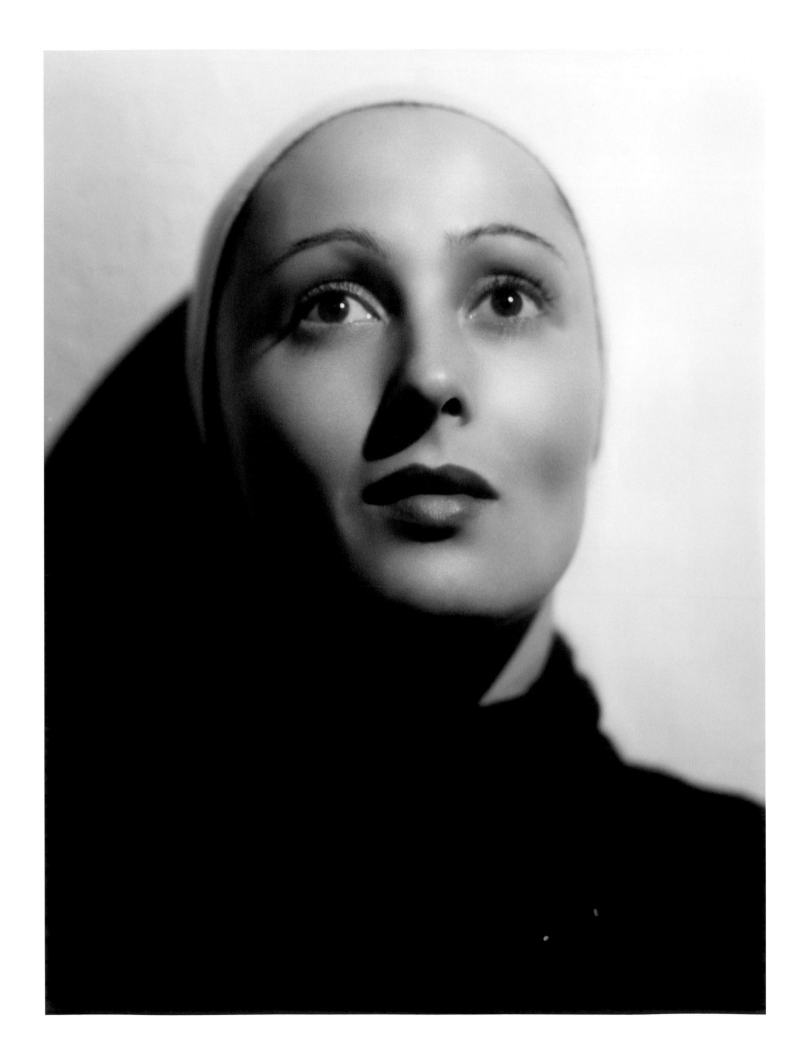

Luise Rainer for *The Good Earth*, MGM. GEORGE HURRELL, 1937

Eleanor Powell with photographer Ted Allan, MGM. UNIDENTIFIED MGM PHOTOGRAPHER, 1937

Robert Montgomery and photographer George Hurrell, MGM. GEORGE HURRELL, 1937

Constance Bennett, MGM. CLARENCE SINCLAIR BULL, 1937

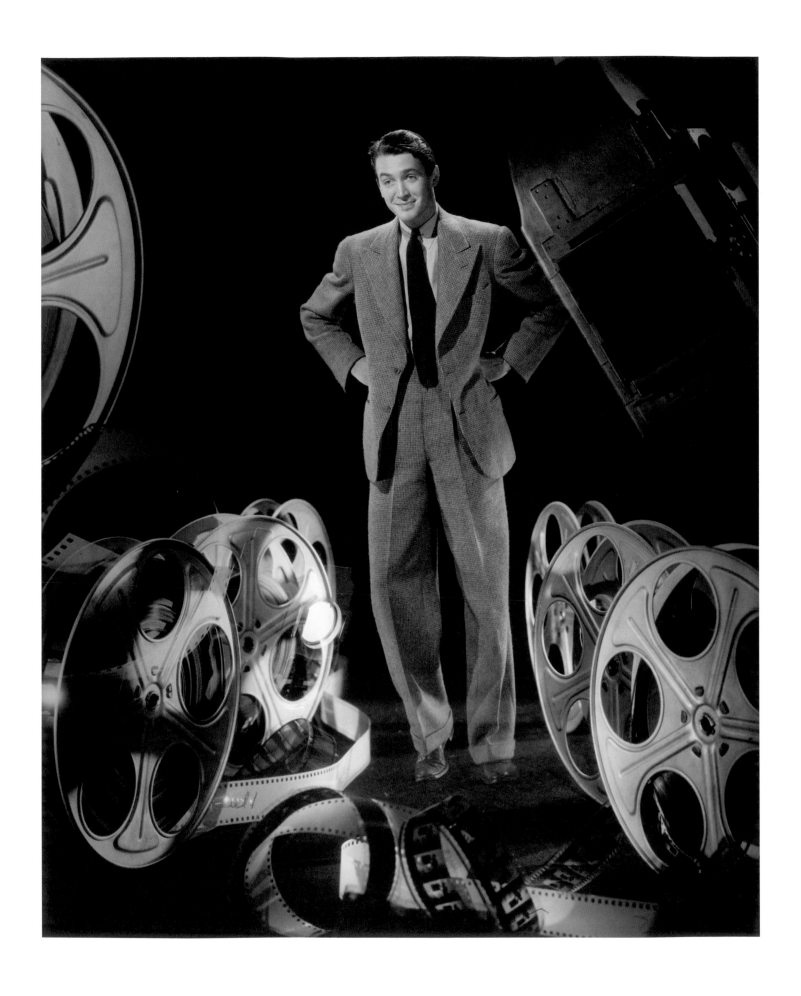

James Stewart, MGM. TED ALLAN, 1938

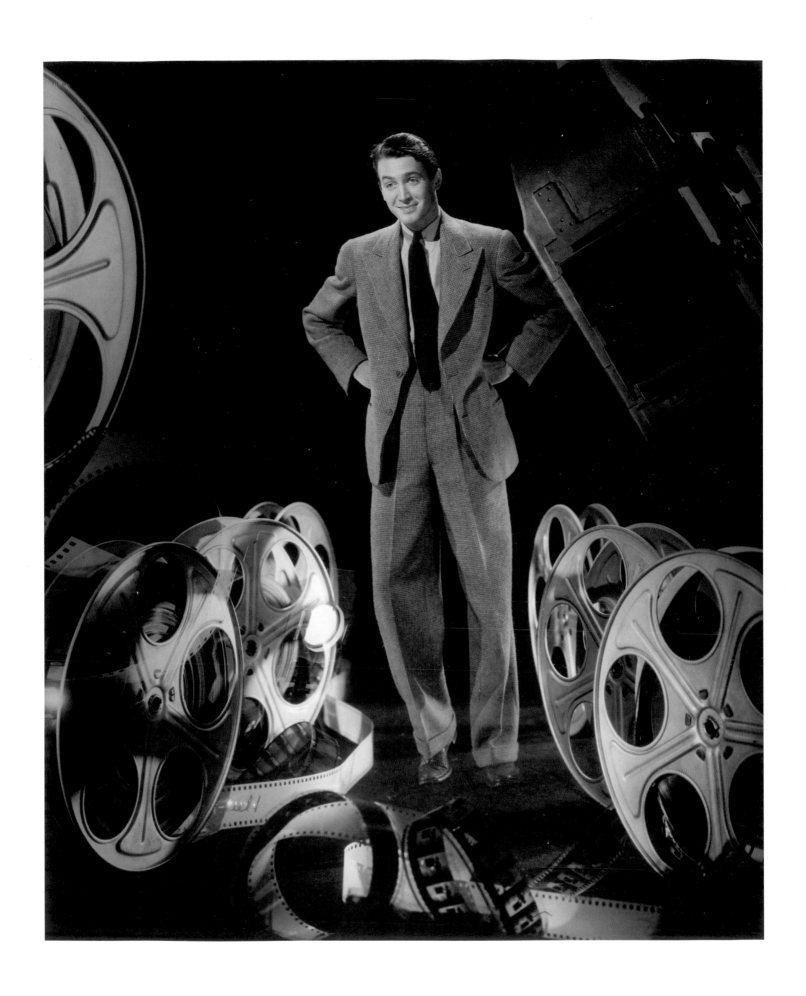

James Stewart, MGM. TED ALLAN, 1938

James Cagney for *Angels With Dirty Faces*, Warner Brothers. SCOTTY WELBOURNE, 1938

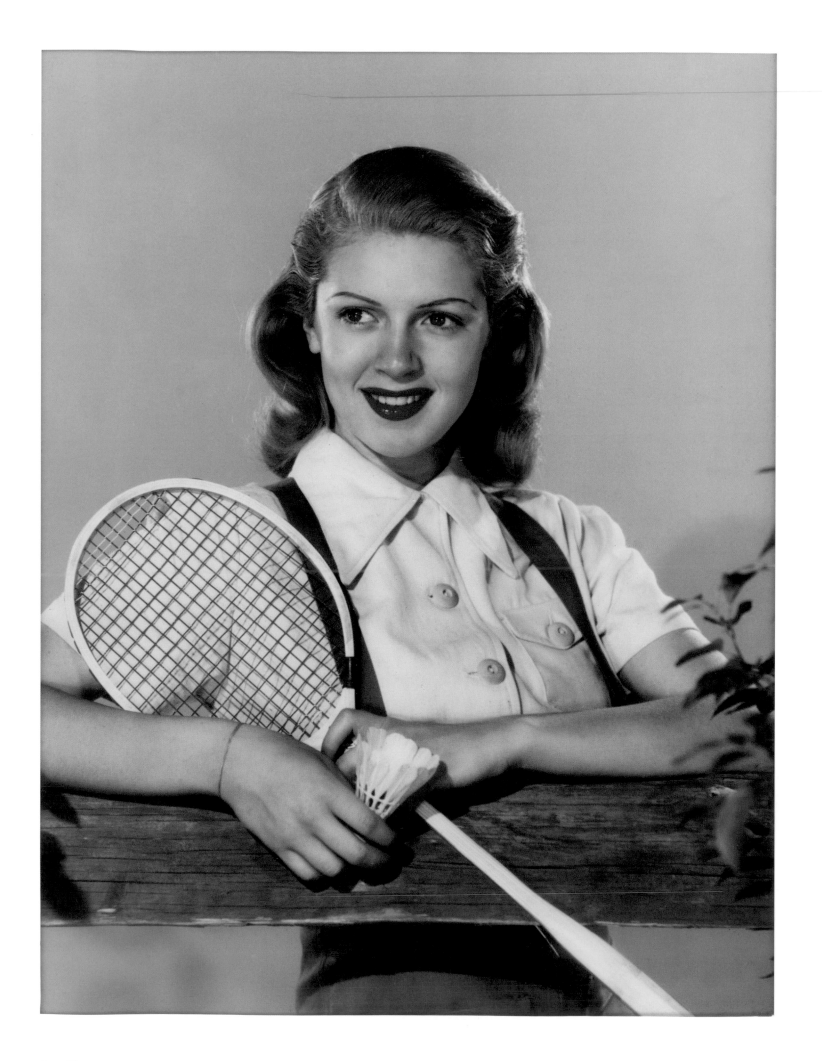

Lana Turner, MGM. CLARENCE SINCLAIR BULL, 1938

Bette Davis for *Elizabeth and Essex*, Warner Brothers. BERT SIX, 1939

Vivien Leigh for *Gone With The Wind*, MGM. ATTRIBUTED TO FRED PARRISH, 1939

William Holden, Paramount Pictures. WILLIAM WALLING, 1939

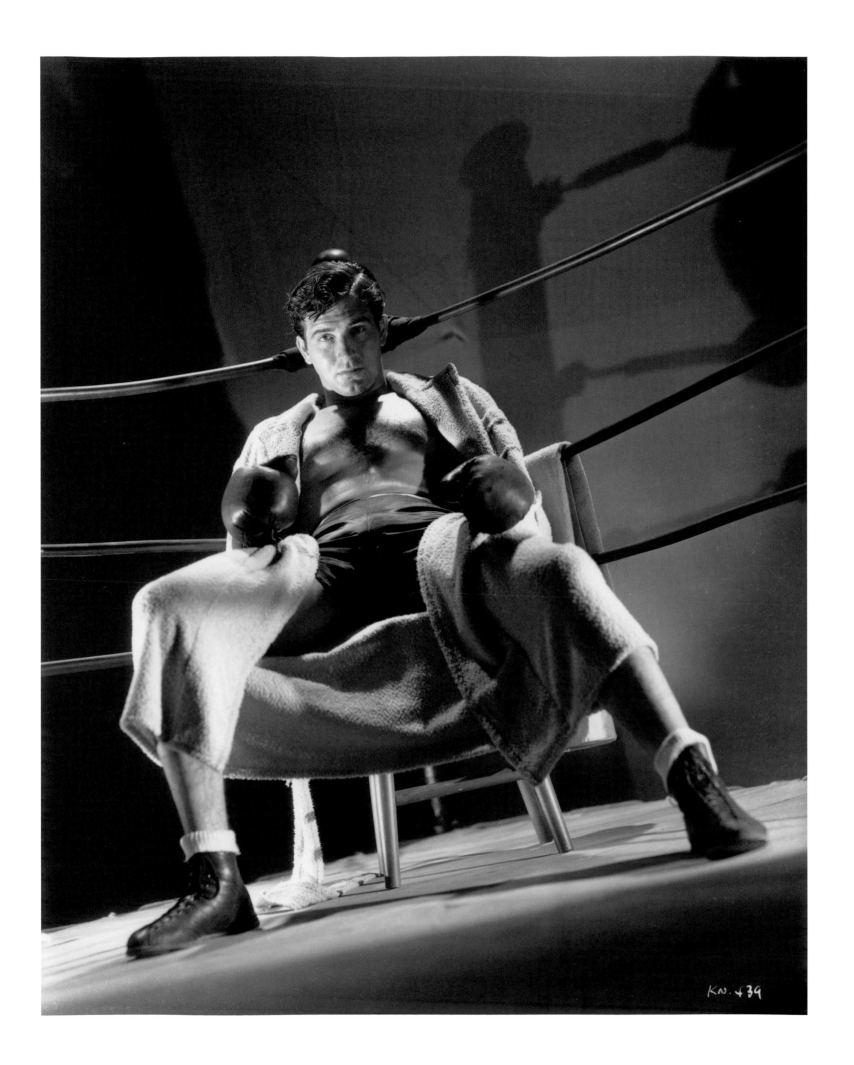

KN.439

191 John Payne for *Kid Nightingale*, Warner Brothers. ELMER FRYER, 1939

Margaret Hamilton for *The Wizard of Oz*, MGM. Virgil Apger, 1939

192

Rita Casino (subsequently Hayworth), 20th Century Fox. GENE KORNMAN, 1939

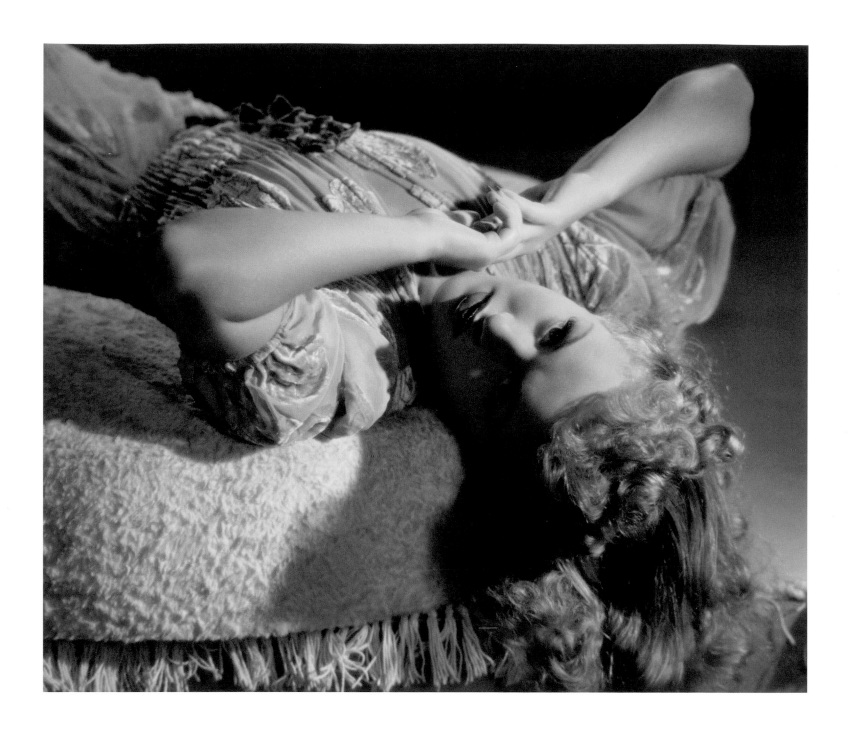

Betty Grable, RKO. Ernest Bachrach, 1939

197 Clarence Sinclair Bull photographing Clark Gable and Vivien Leigh for *Gone with the Wind*, MGM. UNIDENTIFIED MGM PHOTOGRAPHER, 1939

Marlene Dietrich and James Stewart for *Destry Rides Again*, Universal. UNIDENTIFIED UNIVERSAL PHOTOGRAPHER, 1939

Charles Laughton for *Hunchback of Notre Dame*, RKO. ALEX KAHLE, 1939

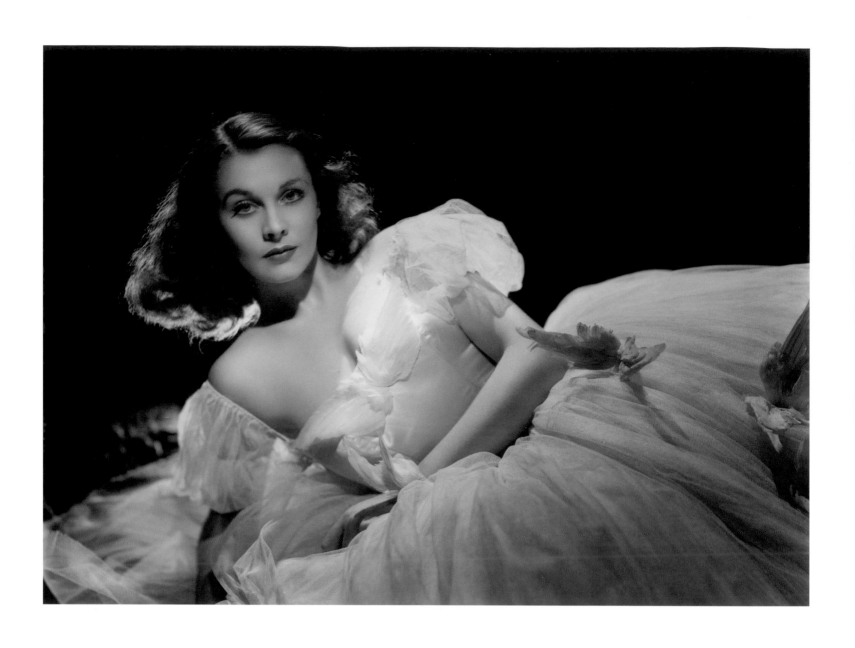

Vivien Leigh for *Waterloo Bridge*, MGM. Laszlo Willinger, 1940

Loretta Young, Columbia Pictures. A.L. 'WHITEY' SCHAEFER, 1940

Orson Welles, RKO. Ernest Bachrach, 1940

Michelle Morgan, RKO.
Ernest Bachrach, 1940

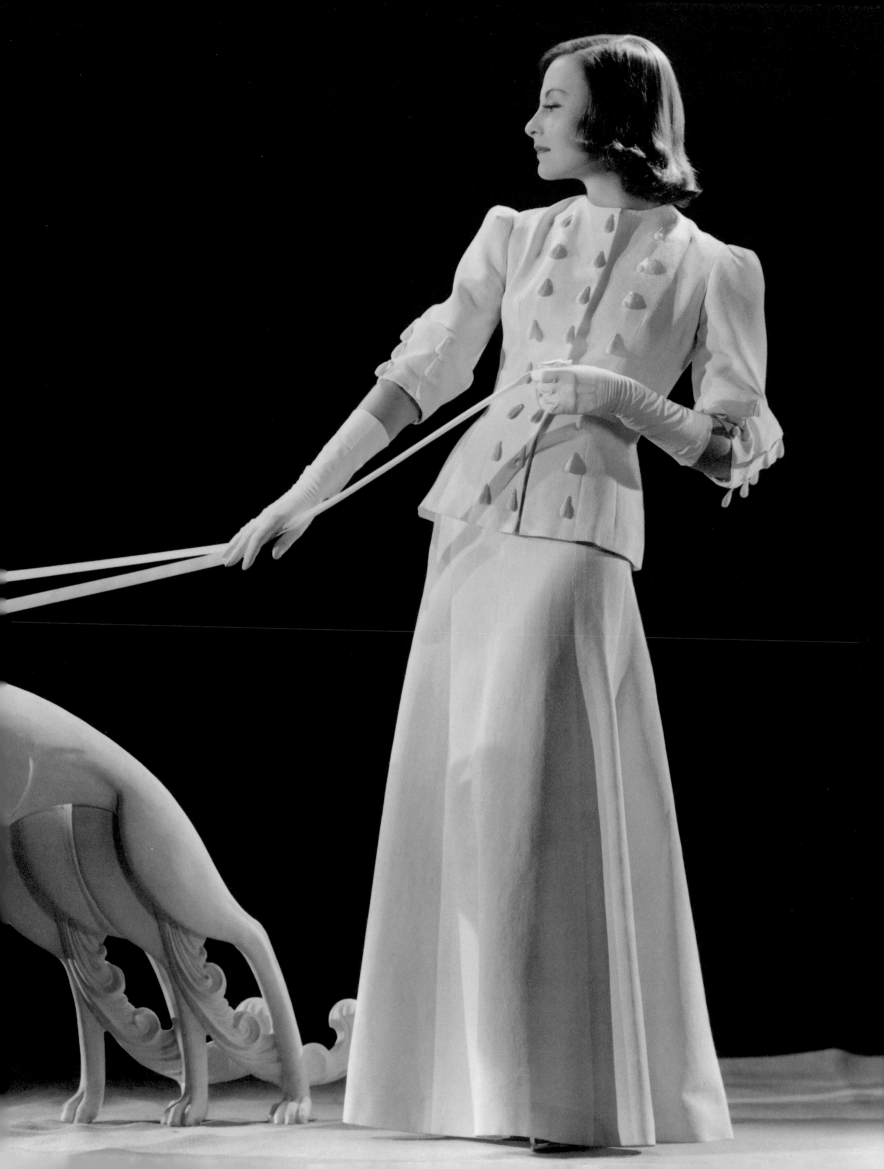

Ronald Reagan for *Knute Rockne All American*, Warner Brothers. MICKEY MARIGOLD, 1940 206

Humphrey Bogart for *High Sierra*, Warner Brothers. SCOTTY WELBOURNE, 1940

Hedy Lamarr, MGM. Clarence Sinclair Bull, circa 1940

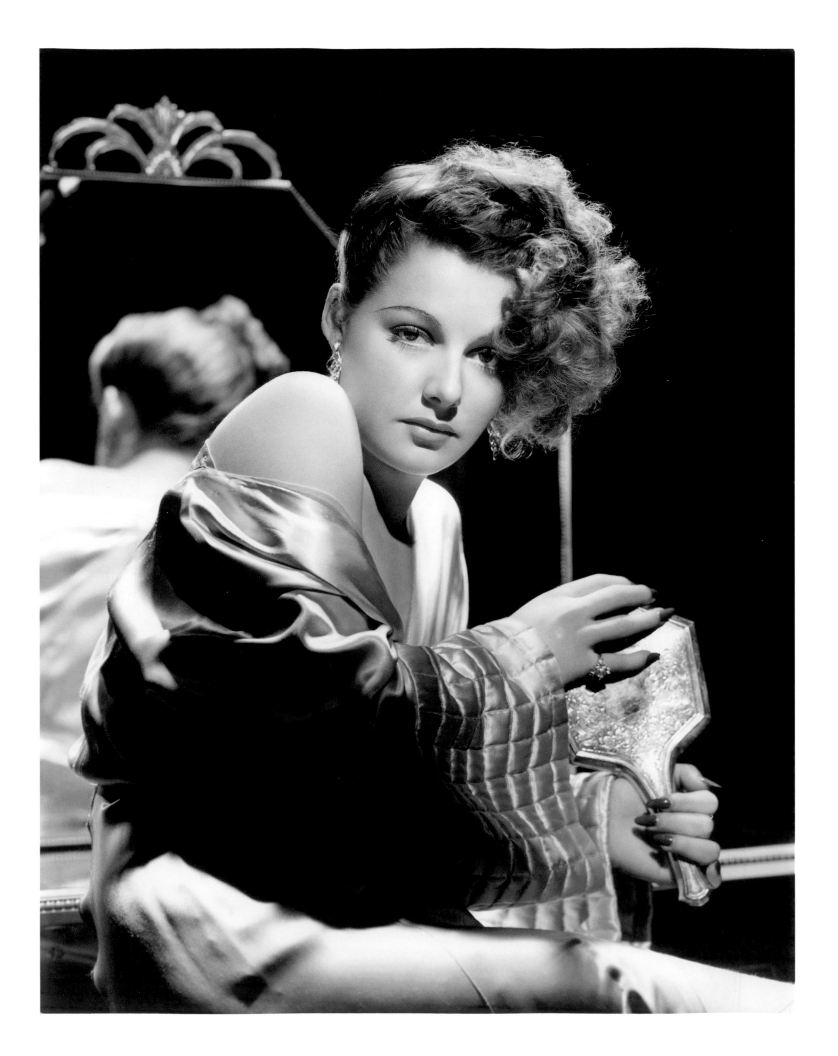

Ann Sheridan, Warner Brothers. GEORGE HURRELL, 1940

Greta Garbo for *Two Faced Woman*, MGM. CLARENCE SINCLAIR BULL, 1941

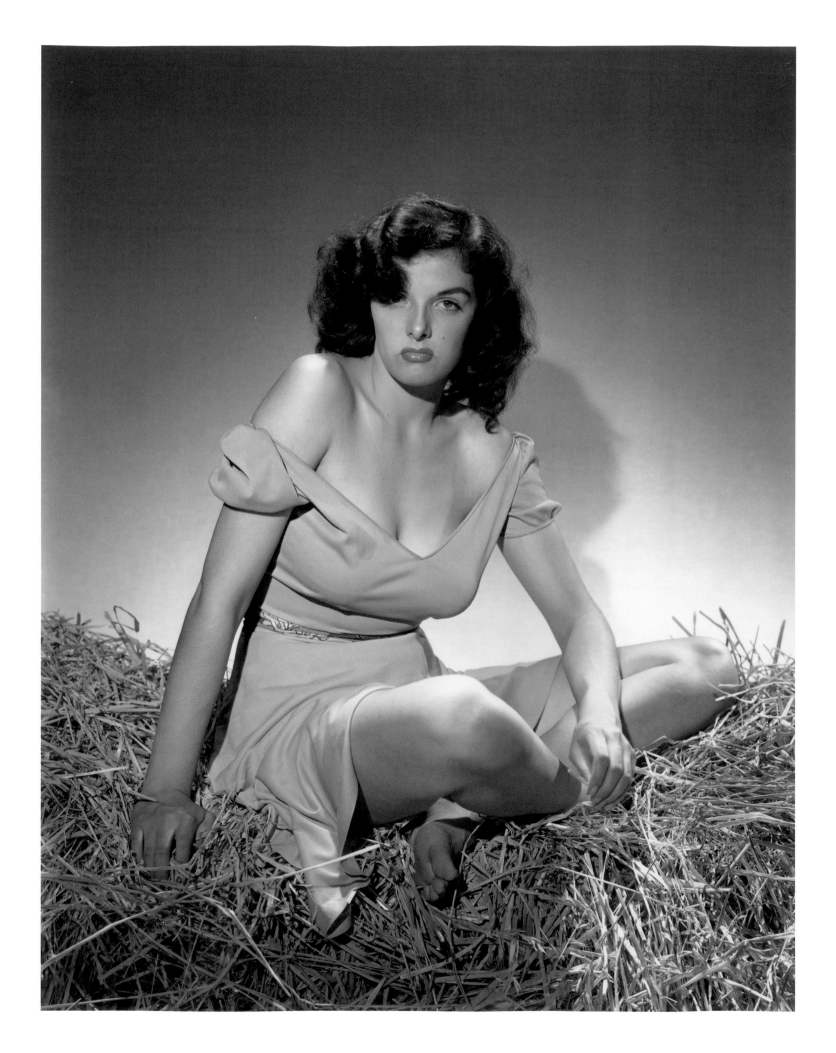

Jane Russell for *The Outlaw*, RKO. GEORGE HURRELL, 1941

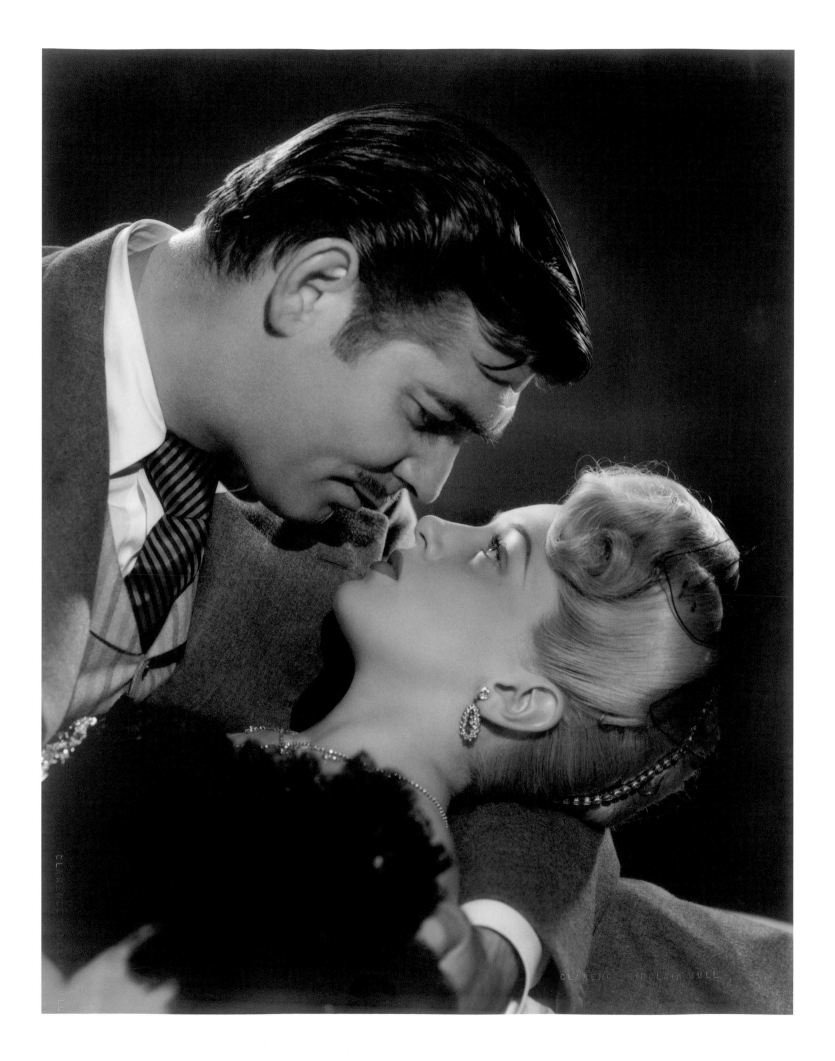

Clark Gable and Lana Turner for *Honky Tonk*, MGM. CLARENCE SINCLAIR BULL, 1941

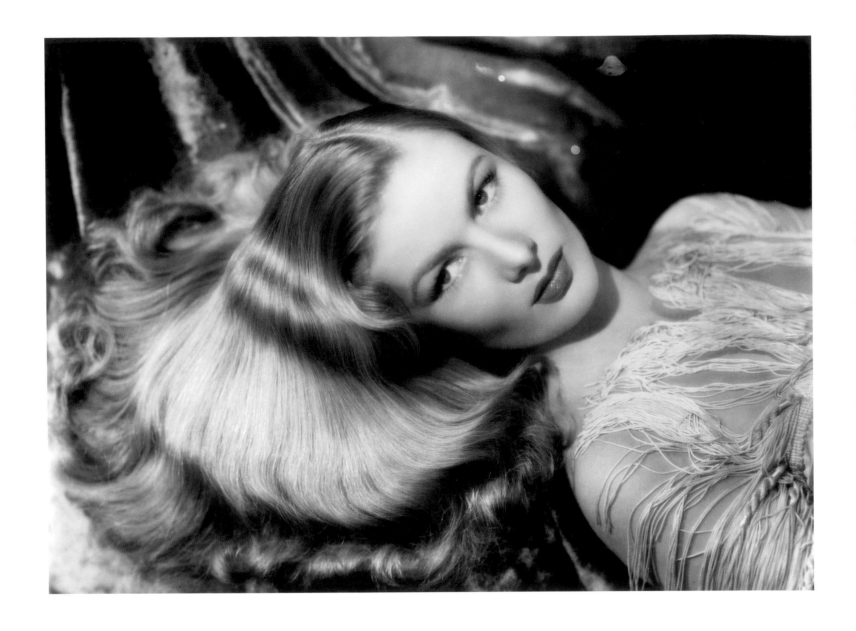

Veronica Lake, Paramount Pictures. GEORGE HURRELL, 1942

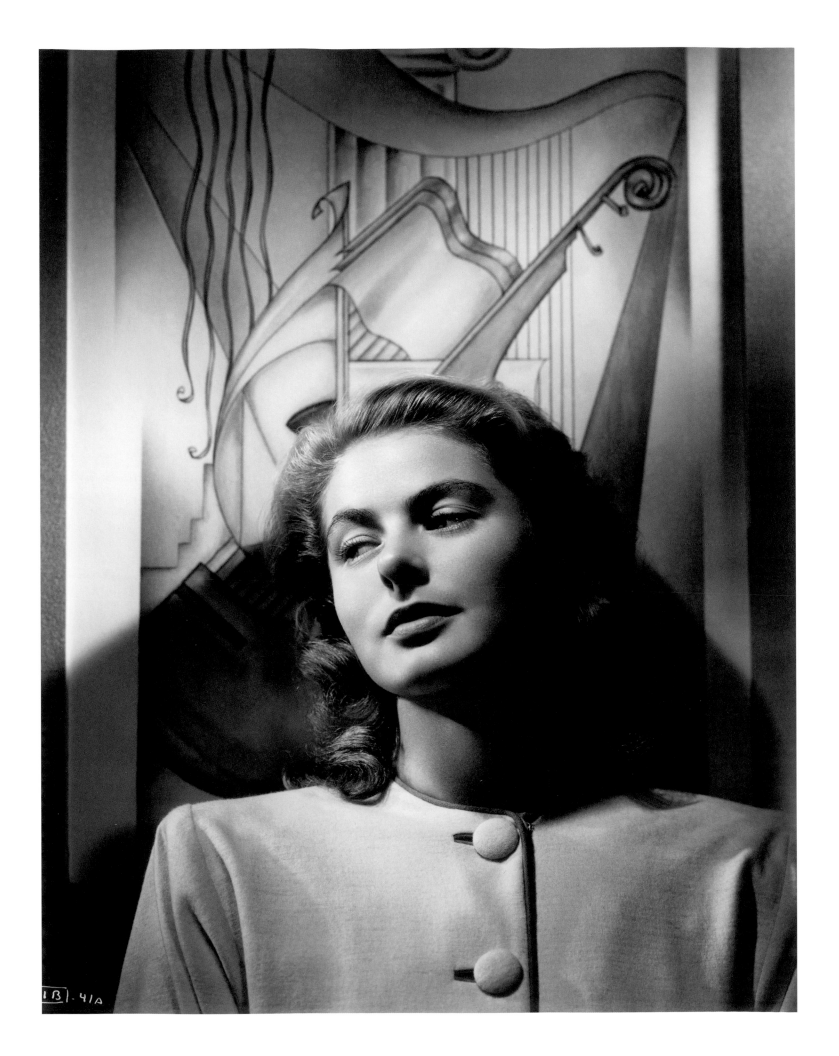

Ingrid Bergman, RKO. ERNEST BACHRACH, 1941

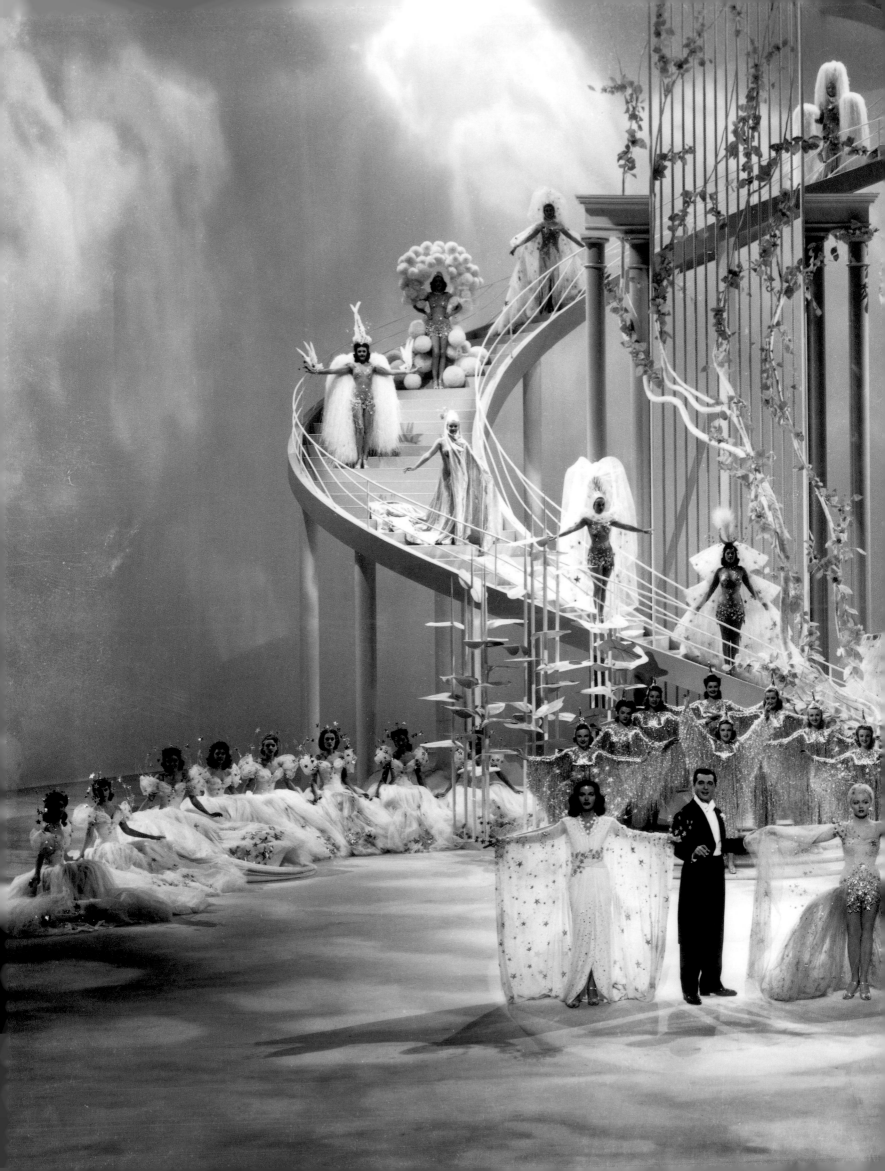

1165-201

Ziegfeld Girl, MGM.
WILLIAM EDWARD CRONENWETH, 1941

Judy Garland and Mickey Rooney for *Strike Up The Band*, MGM. Attributed to Eric Carpenter, 1942

Farley Granger for *The North Star*, Samuel Goldwyn Company. MARGARET BOURKE-WHITE, 1943

Gregory Peck for *Days of Glory*, RKO. ALEX KAHLE, 1943

Farley Granger for *The North Star*, Samuel Goldwyn Company. MARGARET BOURKE-WHITE, 1943

Gregory Peck for *Days of Glory*, RKO. Alex Kahle, 1943

Rita Hayworth for *You Were Never Lovelier*, Columbia Pictures. GEORGE HURRELL, 1942

Betty Grable, 20th Century Fox. FRANK POWOLNY, 1943

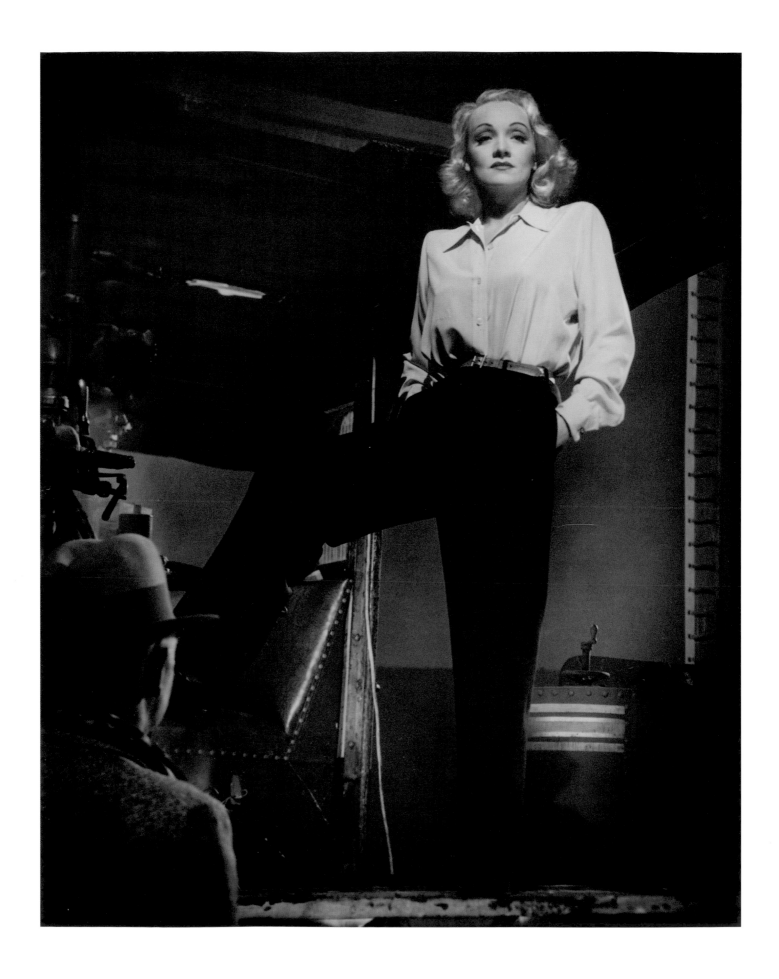

Marlene Dietrich on the set of *Manpower*, Warner Brothers. LASZLO WILLINGER, 1944

Elizabeth Taylor for *National Velvet*, MGM. OTTO DYAR, 1944

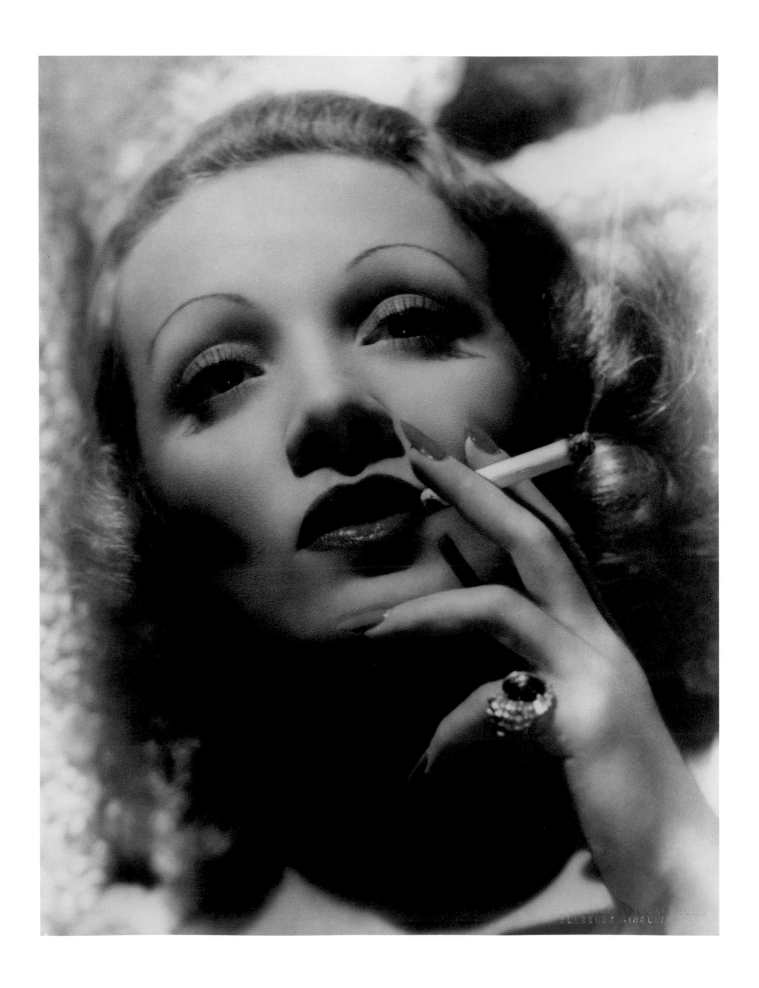

Marlene Dietrich, MGM. CLARENCE SINCLAIR BULL, 1944

Donna Reed for *See Here, Private Hargrove*, MGM. LASZLO WILLINGER, 1944

Carole Lombard for *Vigil in the Night*, RKO. ERNEST BACHRACH, 1939

Rita Hayworth for *Gilda*, Columbia Pictures. ROBERT COBURN, 1946

John Garfield, MGM. Laszlo Willinger, 1946

Ingrid Bergman for *Notorious*, RKO. GASTON LONGET, 1946

235

Greta Garbo. CECIL BEATON, 1946

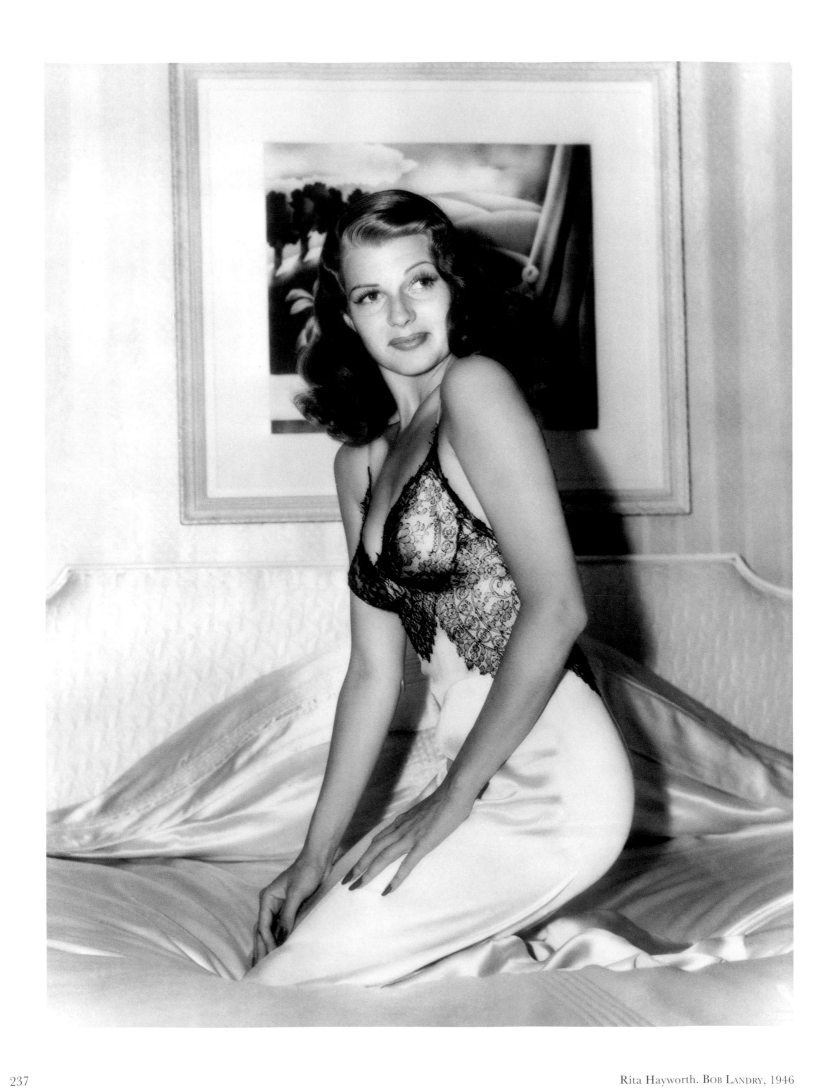

Rita Hayworth. BOB LANDRY, 1946

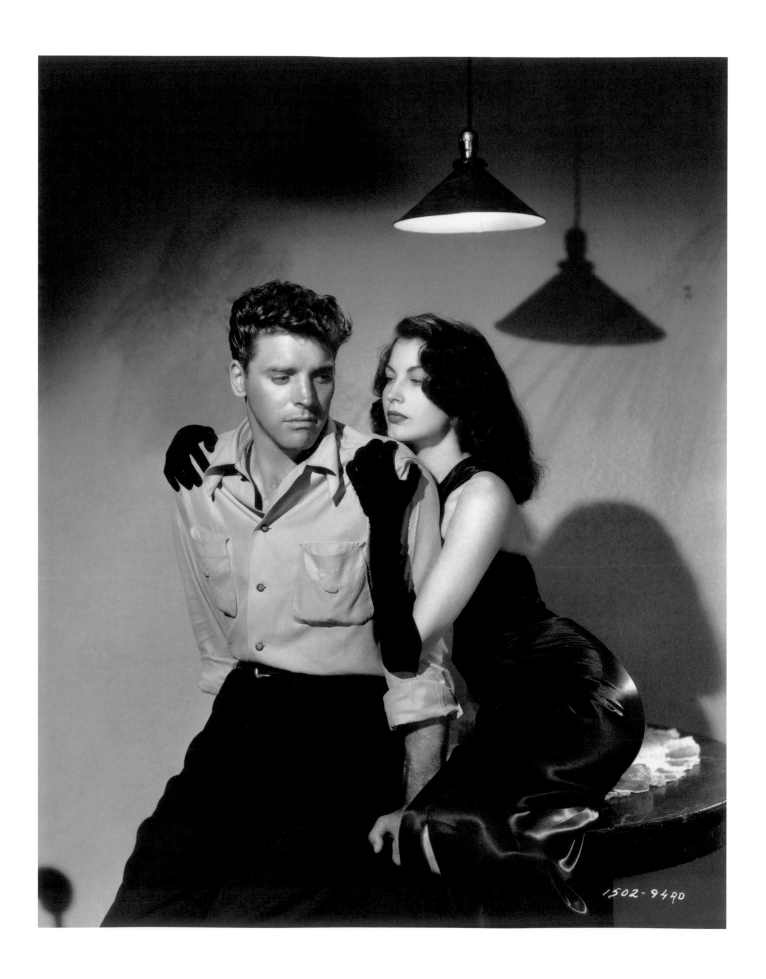

Burt Lancaster and Ava Gardner for *The Killers*, Universal. Ray Jones, 1946

Robert Mitchum, RKO. Ernest Bachrach, 1946

Elizabeth Taylor, MGM. Clarence Sinclair Bull, 1948

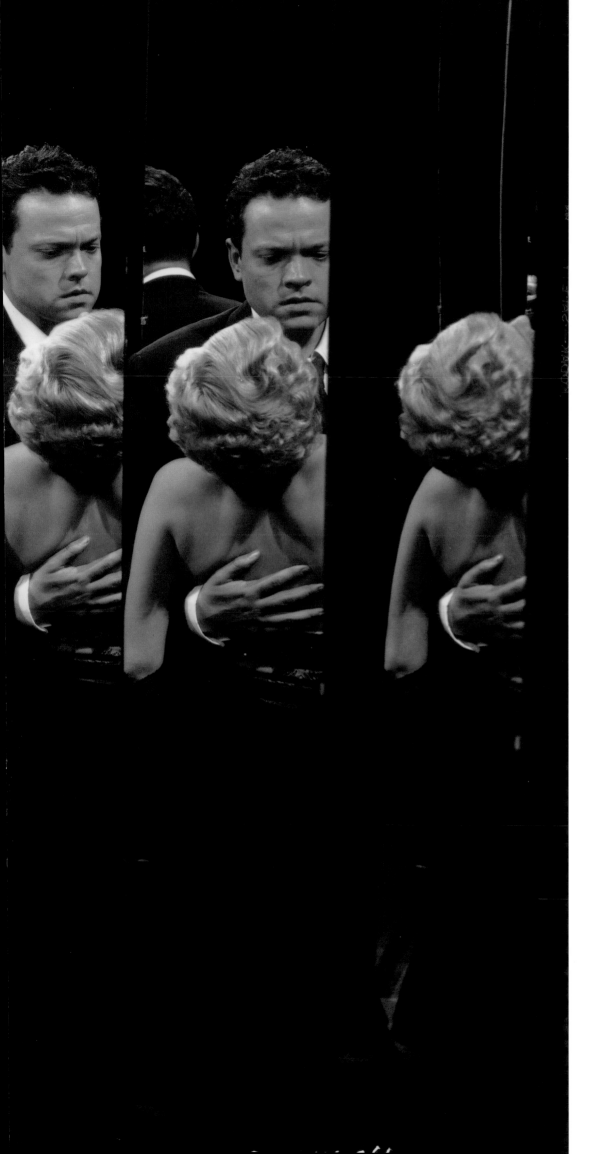

Rita Hayworth and Orson Welles
for *Lady From Shanghai*,
Columbia Pictures.
ATTRIBUTED TO ROBERT COBURN, 1948

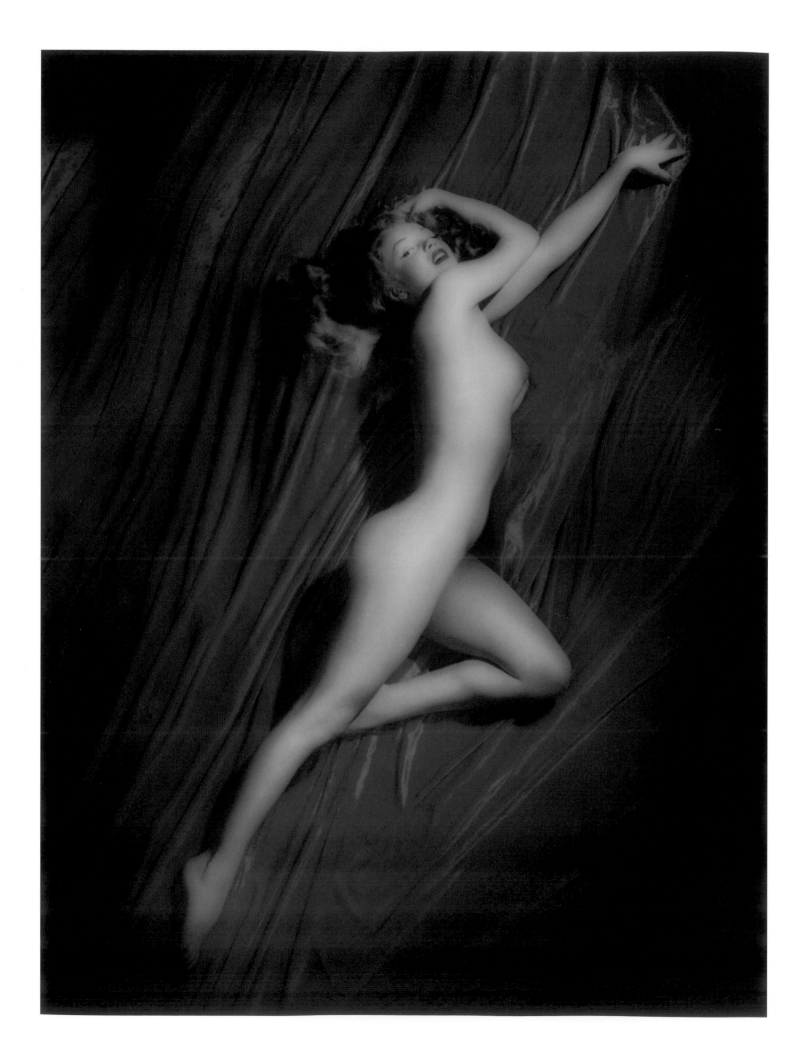

Marilyn Monroe, Los Angeles. Tom Kelley, 1949

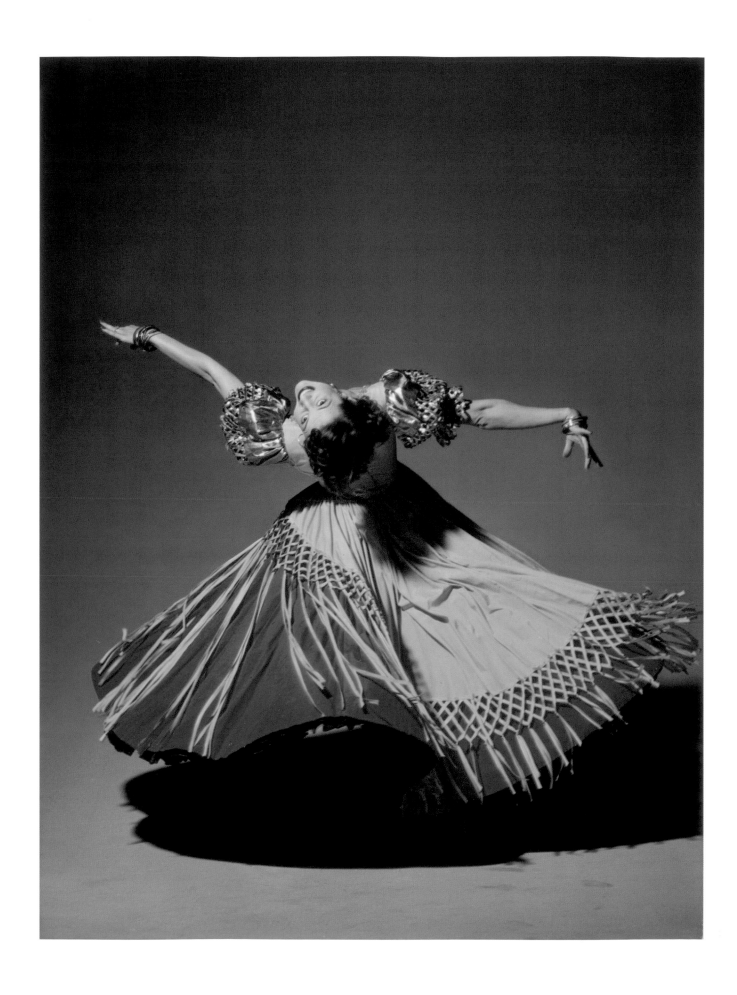

Cyd Charisse for *East Side West Side*, MGM. CLARENCE SINCLAIR BULL, 1949

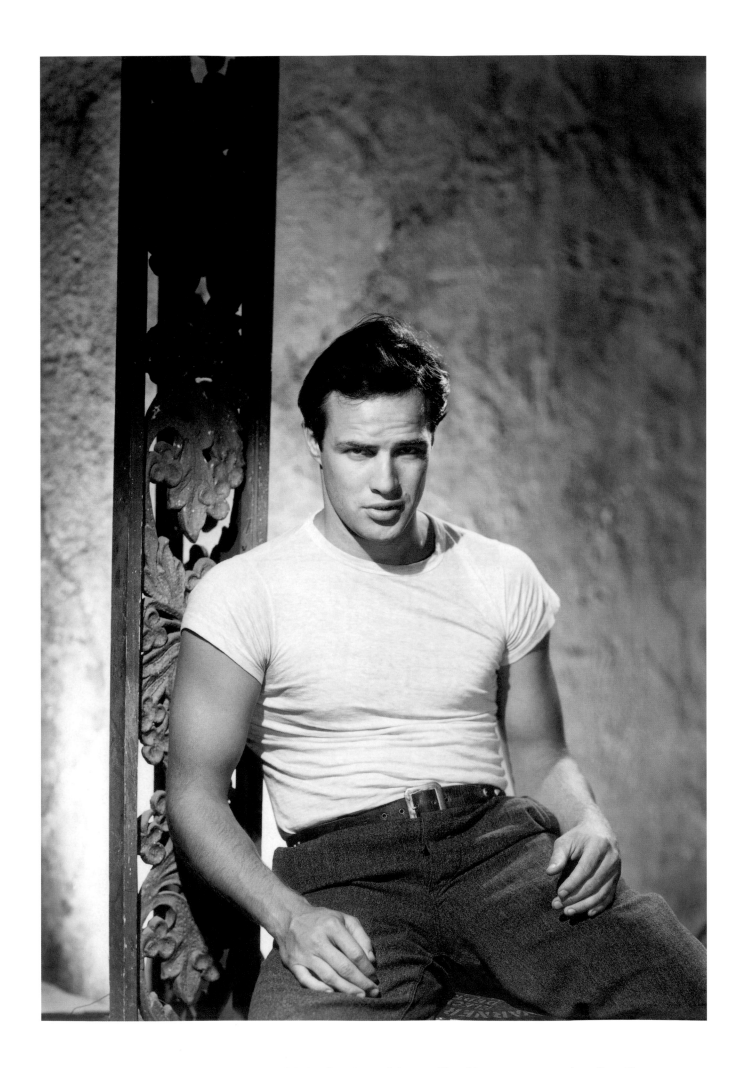

Marlon Brando for *A Streetcar Named Desire*, Warner Brothers. JOHN ENGSTEAD, 1950

Elizabeth Taylor and Montgomery Clift for *A Place In The Sun*, Paramount Pictures. A.L. 'Whitey' Schaefer, 1951

Marilyn Monroe being photographed by Frank Powolny, 20th Century Fox. UNIDENTIFIED FOX PHOTOGRAPHER, 1953

Marilyn Monroe, RKO. Ernest Bachrach, 1952

Marilyn Monroe
for *How To Marry A Millionaire*,
20th Century Fox.
Unidentified Fox photographer, 1953

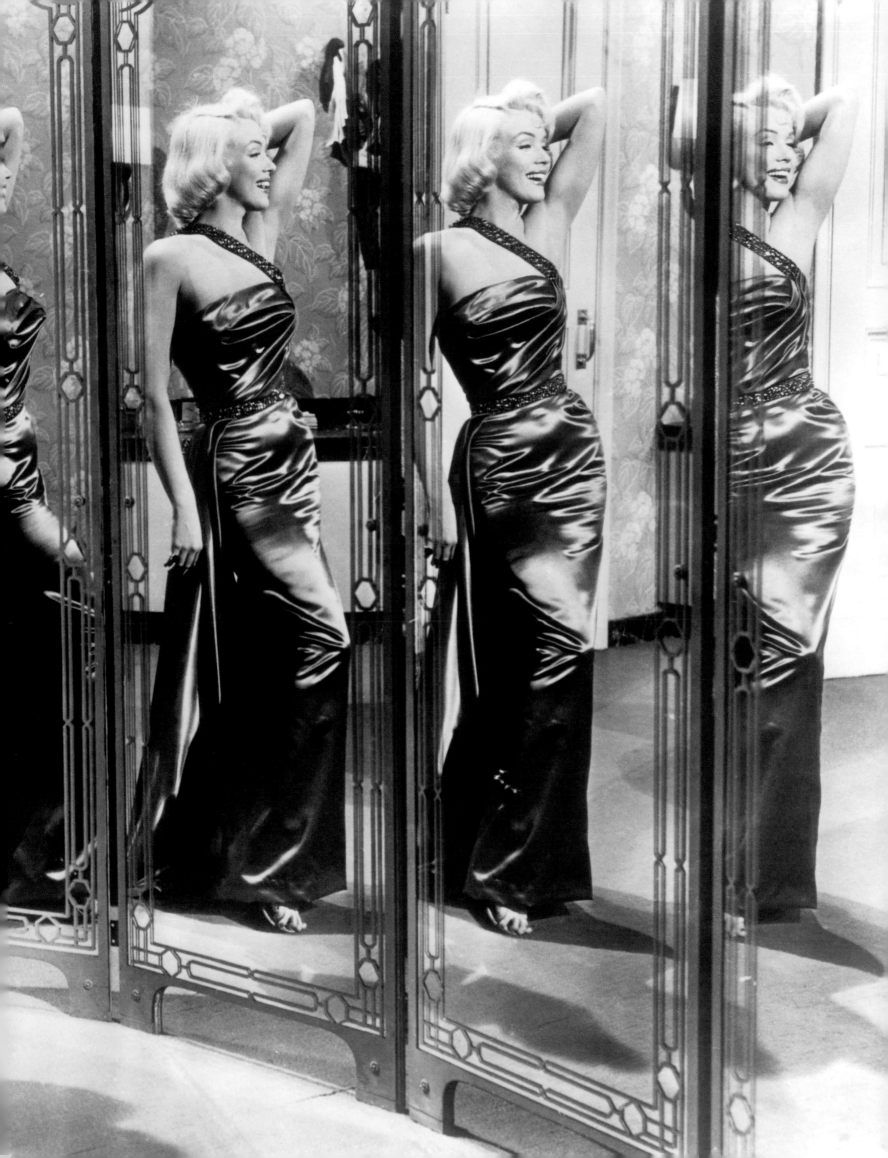

255 Marlon Brando for *The Wild One*, Columbia Pictures. ATTRIBUTED TO IRVING LIPPMAN, 1953

James Dean for *Rebel Without a Cause*, Warner Brothers. FLOYD McCARTY, 1955

Grace Kelly, MGM. Clarence Sinclair Bull, 1956

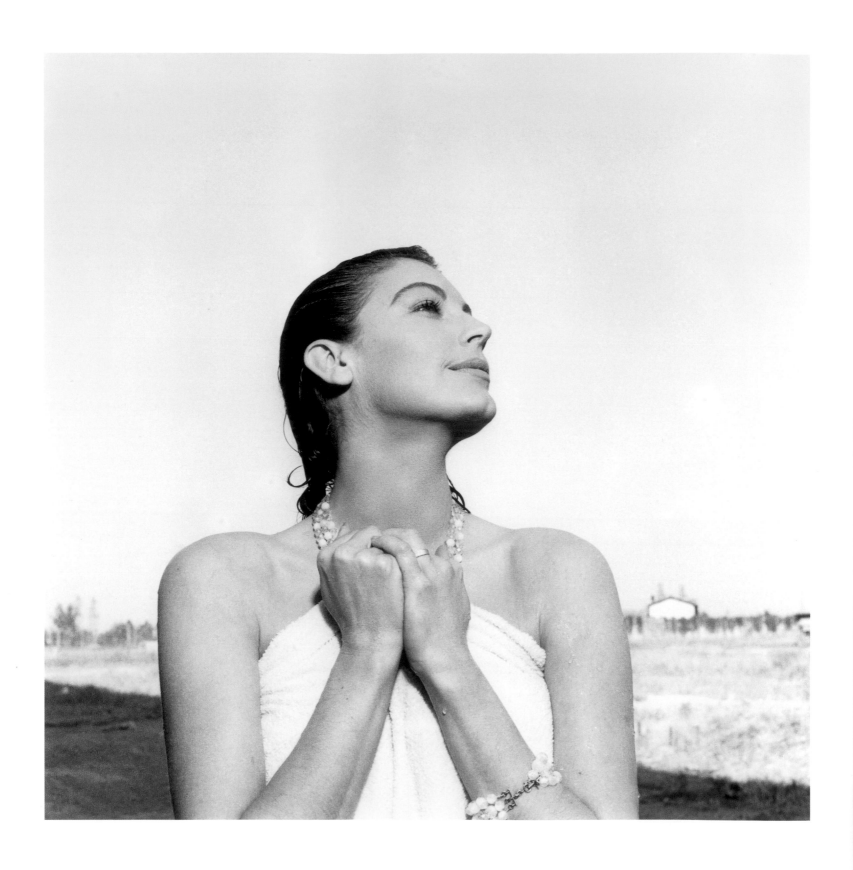

Ava Gardner for *The Little Hut*, MGM. Davis Boulton, 1956

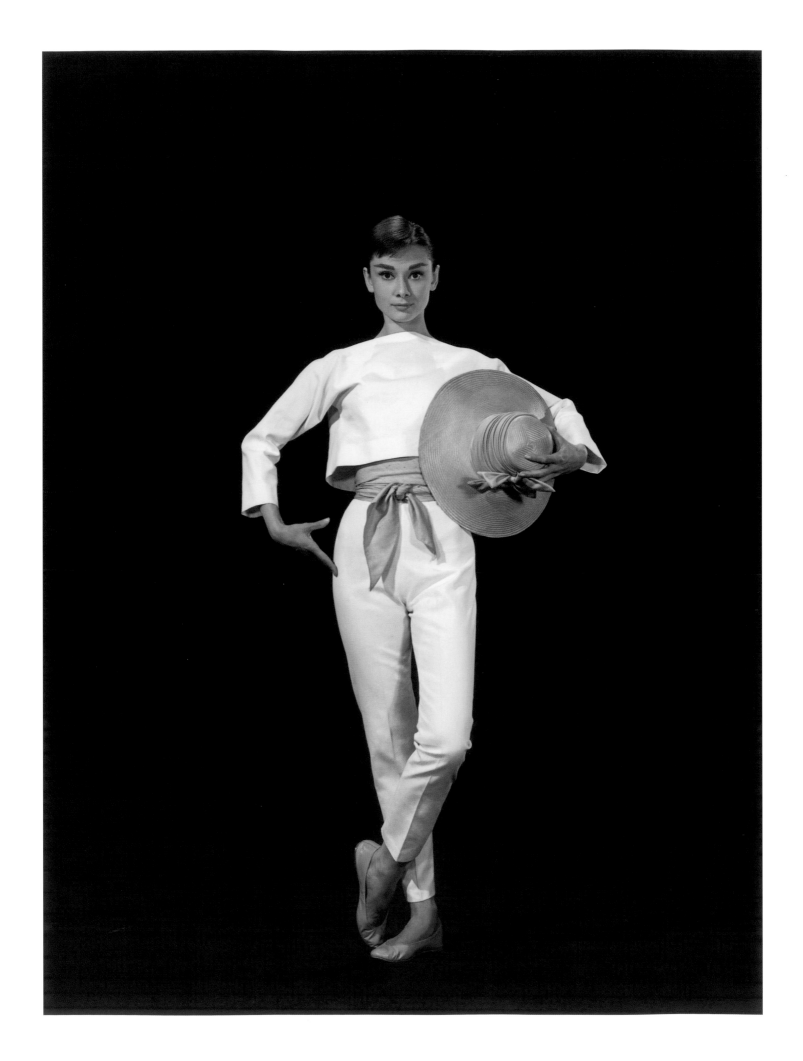

Audrey Hepburn for *Funny Face*, Paramount Pictures. BUD FRAKER, 1956

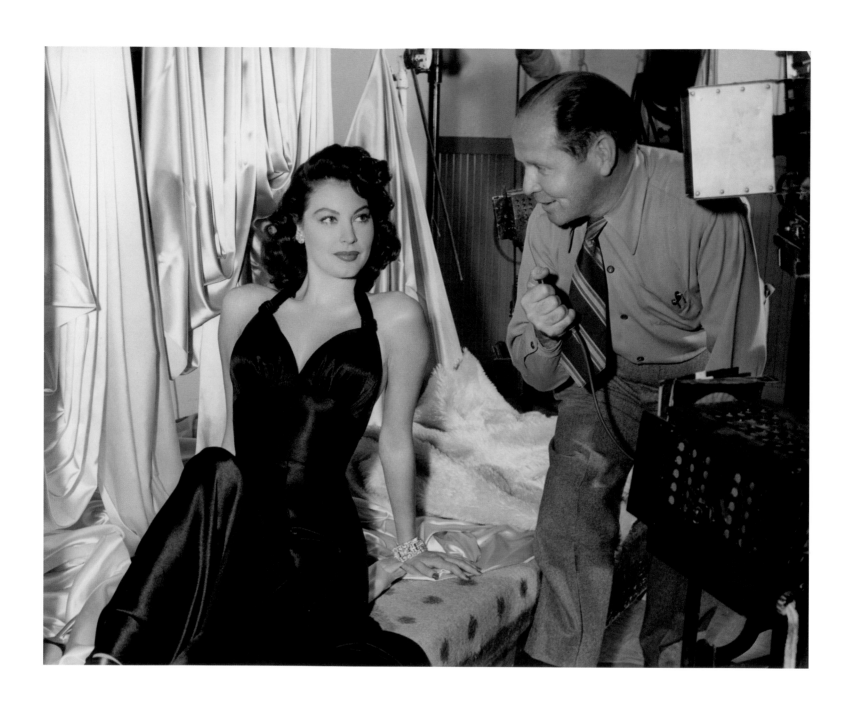

Ava Gardner with photographer Clarence Sinclair Bull, MGM. UNIDENTIFIED MGM PHOTOGRAPHER, 1945

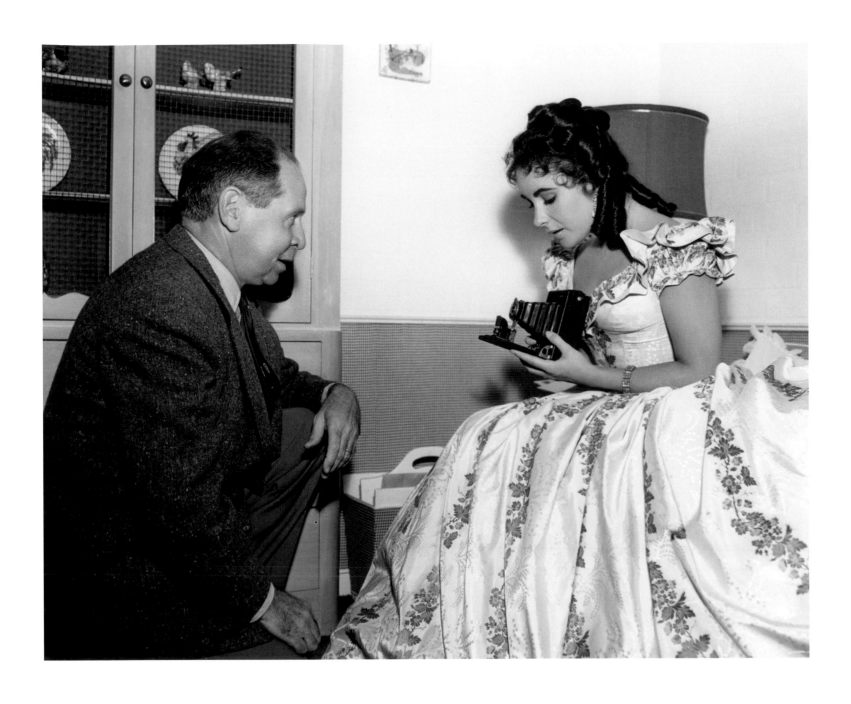

Elizabeth Taylor with photographer Clarence Sinclair Bull, MGM. UNIDENTIFIED MGM PHOTOGRAPHER, 1956

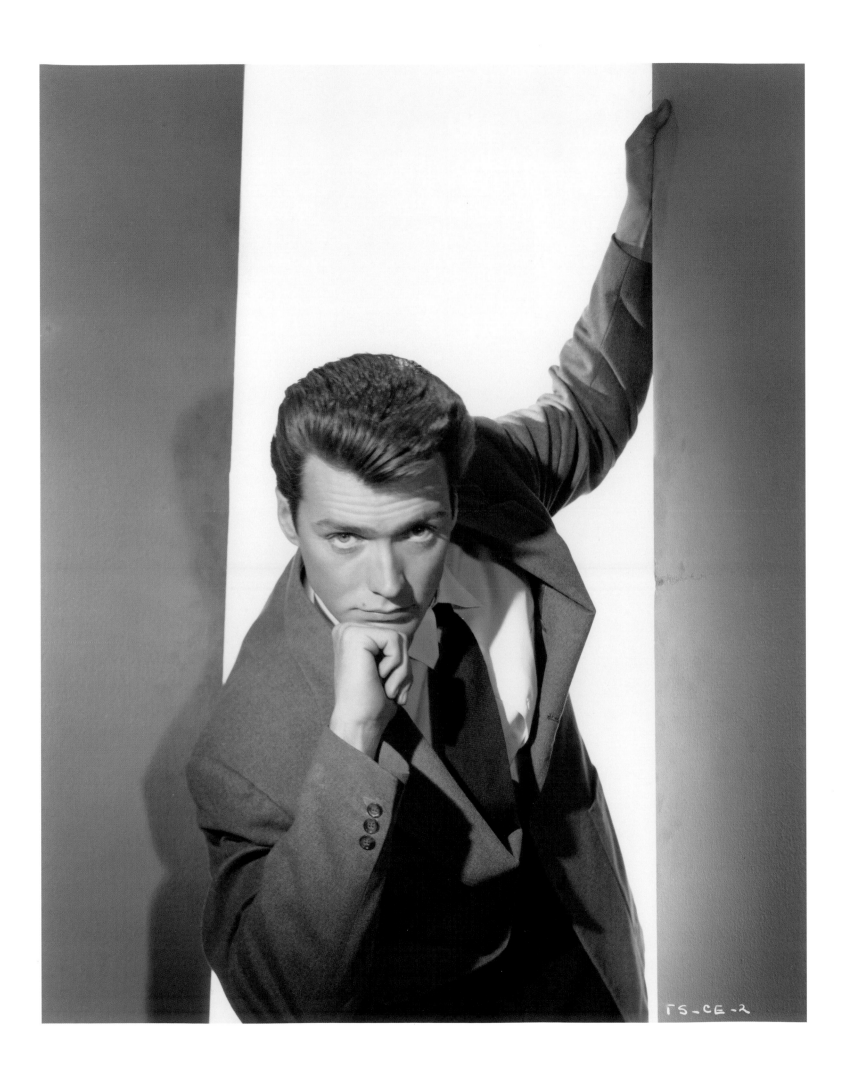

Clint Eastwood, RKO. ERNEST BACHRACH, 1956

Ava Gardner. GEORGE HOYNINGEN-HUENE, 1956

Charlton Heston. YOUSEF KARSH, 1957

ELVIS PRESLEY M·G·M

1241

Elvis Presley, MGM. Virgil Apger, 1957

Alfred Hitchcock with the MGM Lion, MGM. CLARENCE SINCLAIR BULL, 1958

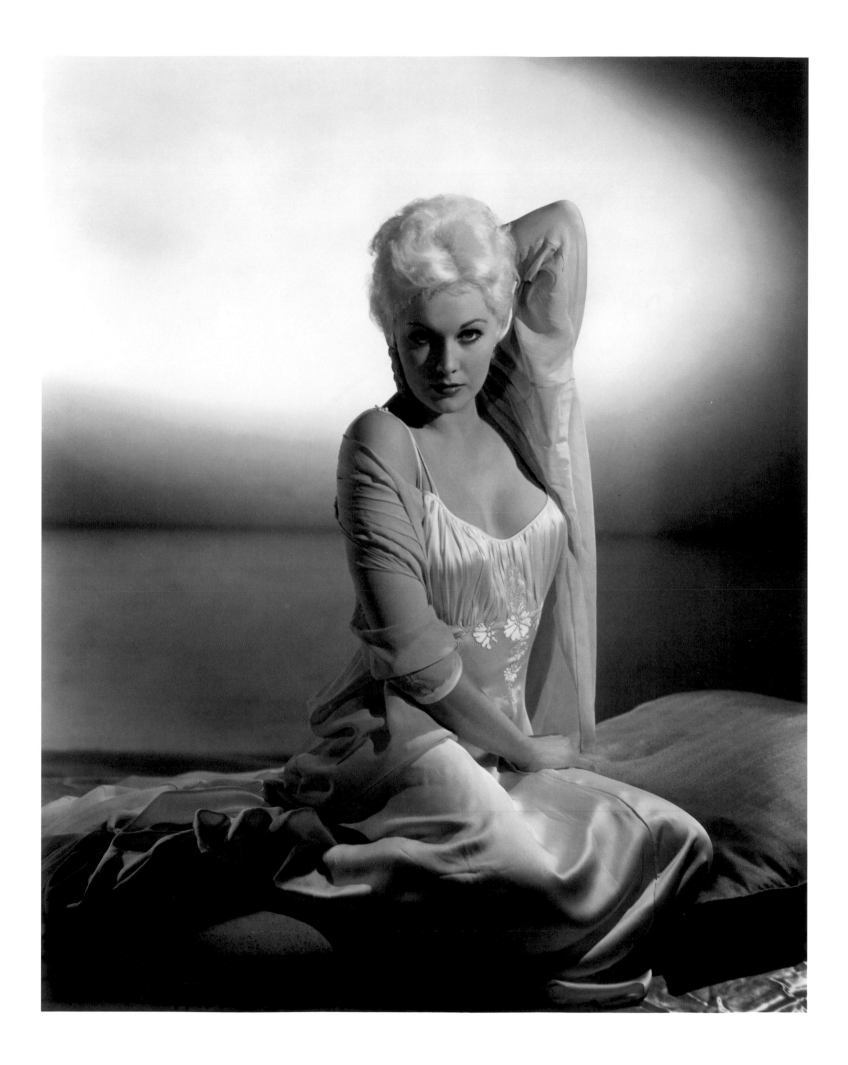

Kim Novak for *Bell, Book and Candle*, Columbia Pictures. ROBERT COBURN, 1958

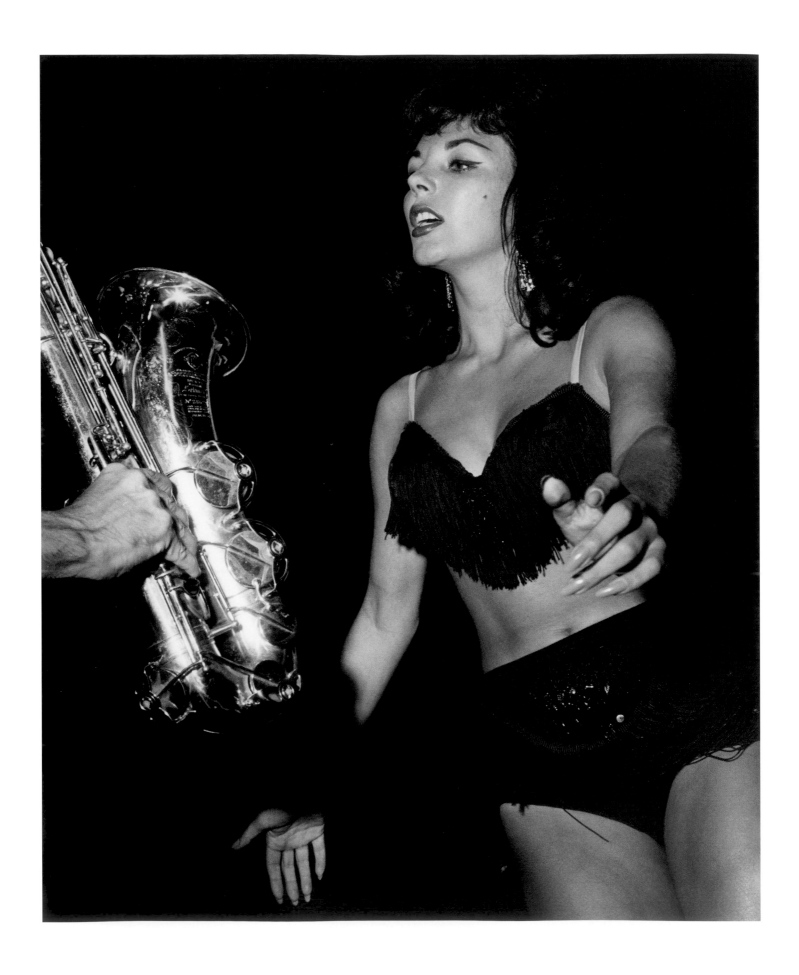

Joan Collins rehearsing dance routines for *Seven Thieves*, 20th Century Fox. LASZLO WILLINGER, 1959

Elizabeth Taylor for *Suddenly Last Summer*, Columbia Pictures. UNIDENTIFIED PHOTOGRAPHER, 1959

Rock Hudson for *Lover Come Back*, Universal. LEO FUCHS, 1961

MG 64480
MGM

Photographer Laszlo Willinger, MGM. Unidentified MGM photographer, 1939

Photographers from Hollywood's Golden Age

The following list names the principle portrait and stills photographers working at Hollywood studios from about 1920 to 1960. Portrait photographers generally worked from a gallery and not on the set, although there are plenty of exceptions to this rule. Stills photographers also made portraits but typically these were taken on the set during a film's production. As in any profession, some photographers changed jobs and worked at more than one studio. The list that follows indicates the studio at which the most important body of a photographer's work was made and – when known – dates of activity.

Metro-Goldwyn-Mayer

Portrait Photographers

 Clarence Sinclair Bull [1924–61]
 Ruth Harriet Louise [1925–29]
 George Hurrell [1930–32]
 Ted Allan [1933–37]
 Laszlo Willinger [1937–46]
 Virgil Apger [1947–69]
 Eric Carpenter

Stills Photographers

 Don Gillum (action)
 Arthur Marion
 Wallace Chewning
 Bert Lynch
 James Manatt
 William Grimes
 Milton Brown
 Frank Tanner
 George Hommel [c1931–39]
 Fred Archer
 Bertram "Buddy" Longworth [1926–29]
 W.E. Cronenweth
 Charles Pollock [c1930]
 Homer van Pelt [1920s]
 Fred Morgan
 Frank Shugrue
 Durward "Bud" Graybill
 Fred Parrish

Paramount Pictures

Portrait Photographers

 Eugene Robert Richee [1921–41]

 A.L. "Whitey" Schafer [1941–51]

 Bud Fraker[1951–60]

 William Walling [c1930–39]

Stills Photographers

 John Engstead [1926–41]

 Otto Dyar [c1925–33]

 George Hommel [late 1920s]

 Elwood Bredell

 Clifton King

 Don English

 Gordon Head

 Sherman Clark [1932]

 Mack Elliot

 Fred Hendrickson

 Kenneth Lobben

Warner Brothers

Portrait Photographers

 Fred Archer [? –1929]

 Elmer Fryer [1929–40]

 Scotty Welbourne, [1940–45]

 Bert Six [1945– ?]

 George Hurrell [1939–40]

 Eugene Robert Richee [1941– ?]

Stills Photographers

 Bertram "Buddy" Longworth [1929– ?]

 Madison Lacy [1933– ?]

 Mickey Marigold [1931–47]

 Irving Lippman

 Mel Traxel

 Floyd McCarty

RKO

Portrait Photographer

 Ernest Bachrach [1929–late 1950s]

Stills Photographers

 John Miehle

 Alex Kahle

 Robert Coburn [1929–35; 1938–40]

 Gaston Longet

 Fred Hendrickson [mid-1930s]

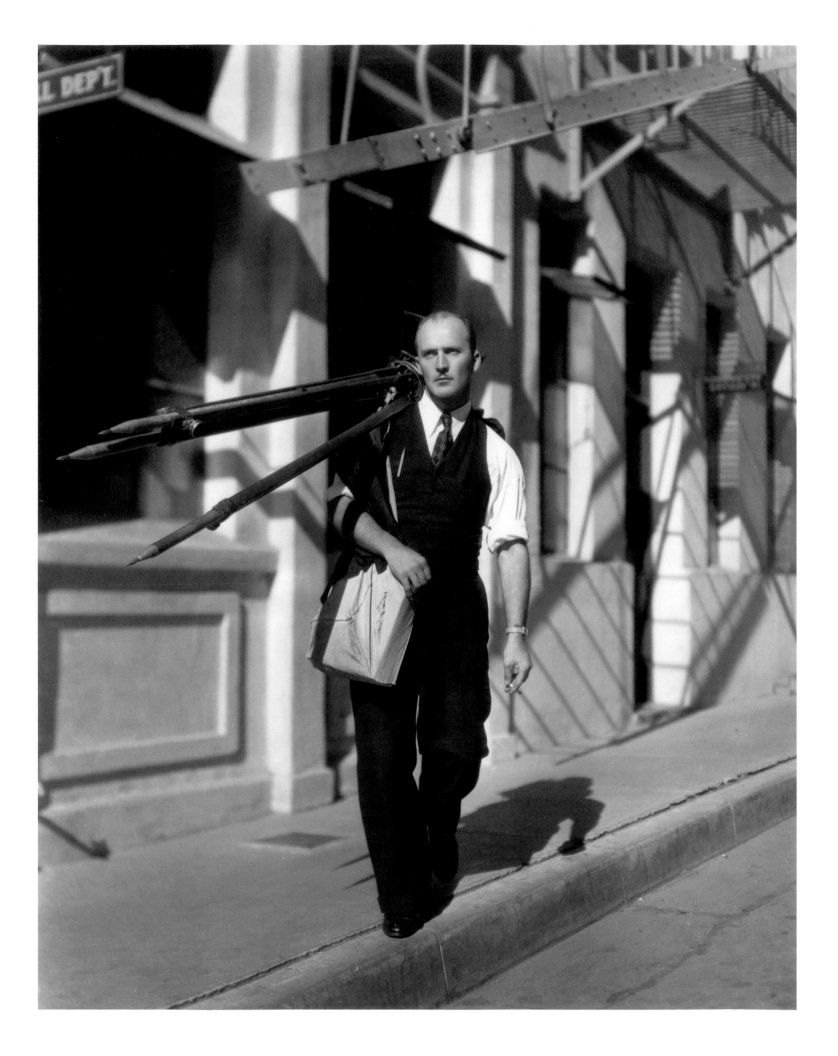

281 Photographer Don English, Paramount Pictures. UNIDENTIFIED PARAMOUNT PHOTOGRAPHER, 1932

©·O·896·P·11

Susan Peters and photographer Robert Coburn, Columbia Pictures. WILLIAM EDWARD CRONENWETH, 1948

20th Century Fox

Portrait Photographers

 Frank Powolny[1920s–66]

 Max Mun Autrey [1925–33]

 Eugene Kornman [c1933–c1953]

Stills Photographer

 Otto Dyar [1933; 1935– ?]

 Milt Gold

Columbia Pictures

Portrait Photographers

 William Fraker, Jr. [c1927–34]

 A.L. "Whitey" Schafer [1934–41]

 Robert Coburn [1941–c1960]

Stills Photographers

 Irving Lippman [1947–56]

 Homer van Pelt

 Bud Fraker [c1934–c1942]

 Earl Crowley

 M.B. Paul

 William Edward Cronenweth

 Ray Jones [1935]

 Al St. Hilaire [1940s]

 Art Marion

 Shirley Vance Martin

Universal

Portrait Photographers

 Jack Freulich [1922–35]

 Ray Jones [1935–58]

Stills Photographers

 Roman Freulich [1920–32]

 Bertram "Buddy" Longworth [1923–26]

 Sherman Clark

 William Walling [1940s–50s]

John Kobal (1940–91)
Bibliography

Raymond Durgnat and John Kobal, *Greta Garbo*, London and New York: Studio Vista/Dutton, 1965

John Kobal, *Marlene Dietrich*, London and New York: Studio Vista/Dutton, 1968

Daniel Blum, *A New Pictorial History of the Talkies* Revised and enlarged by John Kobal, New York: G.P. Putnam's Sons, 1968

John Kobal, *Gotta Sing, Gotta Dance*, London: Hamlyn, 1970

Michael & Clyde Jeavons, *A Pictorial History of Westerns*, Parkinson, London: Hamlyn, 1972; Special Picture Research by John Kobal

Raymond Durgnat and John Kobal, *Sexual Alienation in the Cinema, The Dynamics of Sexual Freedom*, London: Studio Vista, 1972

John Kobal, *Gods & Goddesses of the Movies*, New York: Crescent Books, 1973; General Editor Sheridan Morley; Introduction by Deborah Kerr.

Clyde Jeavons, *A Pictorial History of War Films*, London: Hamlyn, 1973; Special Picture Research by John Kobal

John Kobal, *Romance and the Cinema*, London: Studio Vista, 1973

John Kobal, *Marilyn Monroe*, London: Hamlyn, 1974; Introduction by David Robinson

John Kobal, *50 Years of Movie Posters*, London: Hamlyn, 1974; Introduction by David Robinson

John Kobal, *Spectacular: The Story of Epic Films*, London: Hamlyn 1974

John Kobal, *50 Super Stars*, New York: Bounty Books, 1974; Introduction by John Russell Taylor

John Kobal, *Hollywood Glamour Portraits: 145 Photos of Stars 1926-1949*, New York: Dover, 1976

John Kobal, *Rita Hayworth: The Time, the Place and the Woman*, New York: W.W. Norton & Co, 1977

John Kobal, *Movie Star Portraits of the Forties*, New York: Dover, 1977

Kevin Brownlow and John Kobal, *Hollywood: The Pioneers*, New York: Harper Collins, 1979

John Kobal, *The Art of the Great Hollywood Portrait Photographers 1925-1940*, NY: Knopf, 1980

John Kobal, *Film Star Portraits of the Fifties*, NY: Dover, 1980

John Kobal, *Hollywood Color Portraits*, New York: William Morrow, 1981

John Kobal, *Great Film Stills of the German Silent Era*, New York: Dover, 1981; Introduction by Lotte H. Eisner

John Kobal and V.A. Wilson, *Foyer Pleasure: The Golden Age of Cinema Lobby Cards*, London: Aurum, 1982

John Kobal, *Hollywood: The Years of Innocence*, London: Thames and Hudson, 1985

John Russell Taylor and John Kobal, *Portraits of the British Cinema 60 Glorious Years 1925-1985*, London: Aurum Press, 1985

John Kobal (General Editor), *Legends: Gary Cooper*, Boston: Little, Brown, 1985; Essays by Richard Schickel, *Gary Cooper*; John Kobal, *Photography, Film Stars and Art*

John Kobal (General Editor), *Legends: Ingrid Bergman*, Boston: Little, Brown, 1985; Essays by Morley Sheridan, *Ingrid Bergman*; John Kobal, *Photography, Film Stars and Art*

John Kobal, *People Will Talk*, New York: Knopf, 1986

John Kobal (General Editor), *Legends: Clark Gable*, Boston: Little, Brown, 1986; Essays by James Card, *Clark Gable*; John Kobal, *The Film Star as Photographic Model*; Laszlo Willinger, *On Photographing Clark Gable*

John Kobal (General Editor), *Legends: Joan Crawford*, Boston: Little, Brown, 1986; Essays by Anna Raeburn, *Joan Crawford*; Ross Woodman, *Hurrell's Crawford*

Victor Arwas and John Kobal, *Frank Martin: Hollywood – Continental*, London: Academy Editions, 1988

John Kobal, *John Kobal Presents the Top 100 Movies*, New York: New American Library, 1988

Terence Pepper and John Kobal, *The Man Who Shot Garbo, The Hollywood Photographs of Clarence Sinclair Bull*, London: Simon & Schuster, 1989; Introduction by Katharine Hepburn

John Kobal (Introduction), *Bill Jacklin – Urban Portraits*, New York: Marlborough Gallery, 1990, (28 November – 31 December 1990)

John Kobal. GEORGE HURRELL, 1982

The John Kobal Foundation

John Kobal was very keen to find a way in which he could see his own enthusiasm for portrait photography continued after his death. In 1990 he formed a charitable foundation – The John Kobal Foundation – to which he donated the photographic negatives and fine art photographs that he had collected over the years. The foundation encourages interest in and helps advance the general public's appreciation and awareness of photography and particularly the area which most interested John – the art of portrait photography.

Since John's death in October 1991, the foundation first pursued this aim through the John Kobal Photographic Portrait Award. Presented annually for ten years (1993–2002), the award encouraged new endeavour and acknowledged excellence in the field of portraiture. The award exhibition was hosted by the National Portrait Gallery and was regarded as the most prestigious prize devoted to portrait photography in the UK, drawing each year well over 200,000 visitors to the NPG.

The foundation continues to encourage not only emerging photographers but also new concepts and technical developments in portrait photography. It achieves this through the grant of discretionary awards to photographers and/or photographic galleries or organisations to help towards the costs of undertaking photographic projects, mounting exhibitions and research.

In recent years, the foundation sponsored the John Kobal Book Award in association with The Royal Photographic Society, and has just awarded the first John Kobal New Work Award, a grant to aid the commission of a new photographic body of work, to the internationally renowned Whitechapel Gallery in London.

About the Authors

Robert Dance is co-author of *Ruth Harriet Louise and Hollywood Glamour Photography* (2002, California) and *Garbo: Portraits from her Private Collection* (2005, Rizzoli). He has also written many articles on early Hollywood history and lectured widely.

John Russell Taylor has worked at *The Times* (London) for most of his writing life, as, successively, Television Critic, Drama Critic, Film Critic, American Cultural Correspondent and, for the last thirty years, Art Critic. During his American years he was Professor in the Cinema Division of the University of Southern California, Los Angeles. He has lectured and broadcast extensively, edited *Films and Filming* magazine, and written some sixty books on subjects of film, theatre, art and cultural history, including *Hitch*, the authorised biography of Alfred Hitchcock; *Strangers in Paradise: The Hollywood Emigres* 1933-1950; The Hollywood Musical; and biographies of Alec Guinness, Orson Welles, Vivien Leigh and Ingrid Bergman, among others.

Acknowledgements

This book and the related exhibition relied on the continual assistance and good will of the staff of the John Kobal Foundation, especially Linsday Littlehales and Rachel Perry.

Support was also provided by trustees Terence Pepper and Michael Mack. Some of the photographs appearing in this book were made from vintage negatives from the John Kobal Foundation's rich trove. Thanks to Norman Kent and Paul and Max Caffell at Studio 31, for coaxing such beautiful prints out of the negatives.

Colleagues Robert Loper, David Butler, Bruce Robertson and Mary Desjardins provided important critical insights. Laina Malm-Levine assisted in the preparation of the exhibition. The presence of John Russell Taylor is also felt throughout this publication, not least in his insightful introduction. He was a close friend of John Kobal and graciously shared his time and knowledge.

Karen Sinsheimer, Curator of Photography at the Santa Barbara Museum of Art, first proposed a museum exhibition drawing from the Kobal archive many years ago and has worked closely with the foundation in selecting the photographs exhibited. Her expertise and connoisseurship have proven invaluable. So too was the oversight of all aspects of this project by Simon Crocker, Chairman of the John Kobal Foundation since its inception in 1991. His commanding knowledge not only of the vast resources of the archive but of Hollywood photography and photographers provided a cornerstone to much of what appears in these pages. John Kobal, I suspect, would be delighted with such advocates.

Robert Dance

Published to coincide with the exhibition:
Made in Hollywood: Photographs from the John Kobal Foundation
Santa Barbara Museum of Art, 12 July – 12 October 2008
Knoxville Museum of Art, 7 May – 27 September 2009
Deutsches Filmmuseum, Frankfurt am Main, Winter – Spring 2011
Glamour of the Gods
National Portrait Gallery, London, July – October 2011

First Edition 2008
© 2008 Steidl for this edition
© 2008 John Kobal Foundation for the images
© 2008 Robert Dance and John Russell Taylor for the texts

Edited by Michael Mack
Designed by Joby Ellis
Production and printing by Steidl
Düstere Str. 4 D–37073 Göttingen, Germany
Phone: + 49 551 49 60 60 Fax: + 49 551 49 606 49 Email: mail@steidl.de
www.steidl.de / www.steidlville.com

ISBN 978-3-86521-682-3
Printed in Germany
Front cover: Rock Hudson for *Lover Come Back* (detail), Universal. © LEO FUCHS, 1961
Back cover: Jean Harlow (detail), MGM. GEORGE HURRELL, 1933